Twilight of the Hemlocks and Beeches

Twilight of the

The Pennsylvania

State University Press

University Park,

Pennsylvania

Hemlocks and Beeches

Text and photographs by

Tim Palmer

KEYSTONE BOOKS

Keystone Books are intended to serve the citizens of Pennsylvania. They are accessible, well researched explorations into the history, culture, society, and environment of the Keystone State as part of the Middle Atlantic region.

Library of Congress Cataloging-in-Publication Data

Names: Palmer, Tim, 1948– author.
Title: Twilight of the hemlocks and beeches / Tim Palmer.
Description: University Park, Pennsylvania : The Pennsylvania State University Press, [2018] | "Keystone books." | Includes bibliographical references and index.
Identifiers: LCCN 2017038230 | ISBN 9780271079530 (cloth : alk. paper)
Subjects: LCSH: Tsuga—East (U.S.) | Tsuga—Diseases and pests—East (U.S.) | Beech—East (U.S.) | Beech—Diseases and pests—East (U.S.)
Classification: LCC SD397.T78 P35 2018 | DDC 338.1/74973973—dc23
LC record available at https://lccn.loc.gov/2017038230

It is the policy of The Pennsylvania State University Press to use acid-free paper. Publications on uncoated stock satisfy the minimum requirements of American National Standard for Information Sciences—Permanence of Paper for Printed Library Material, ANSI Z39.48-1992.

Additional credits: pp. ii–iii, hemlock silhouette at twilight, Tionesta Grove, Allegheny National Forest, Pennsylvania; v, looking up to a hemlock in the Pine Creek Canyon of northcentral Pennsylvania; vi–vii, hemlock along the Clarion National Wild and Scenic River, Pennsylvania. Text and photographs by Tim Palmer.

FSC
www.fsc.org
MIX
Paper from responsible sources
FSC® C136333

Dedicated to my parents, Jane and Jim Palmer,

who let me run wild in the woods.

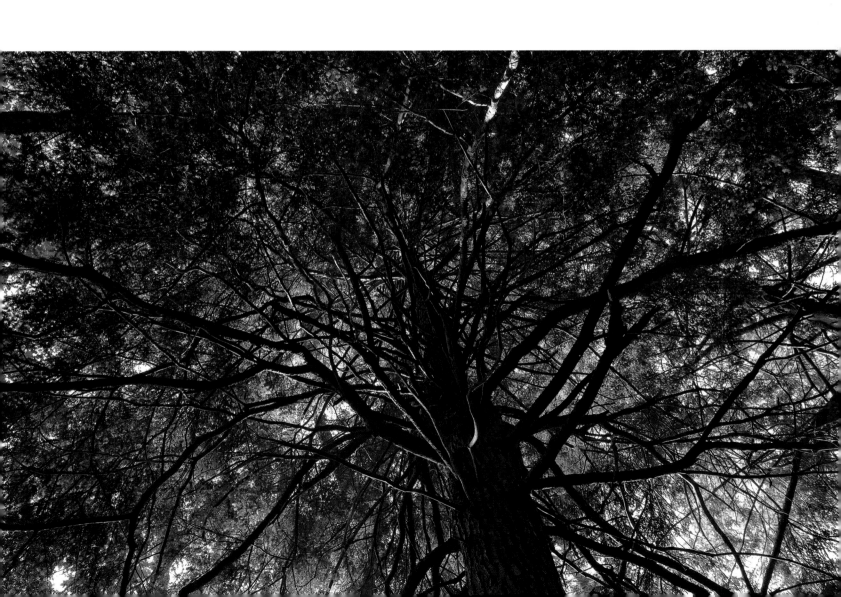

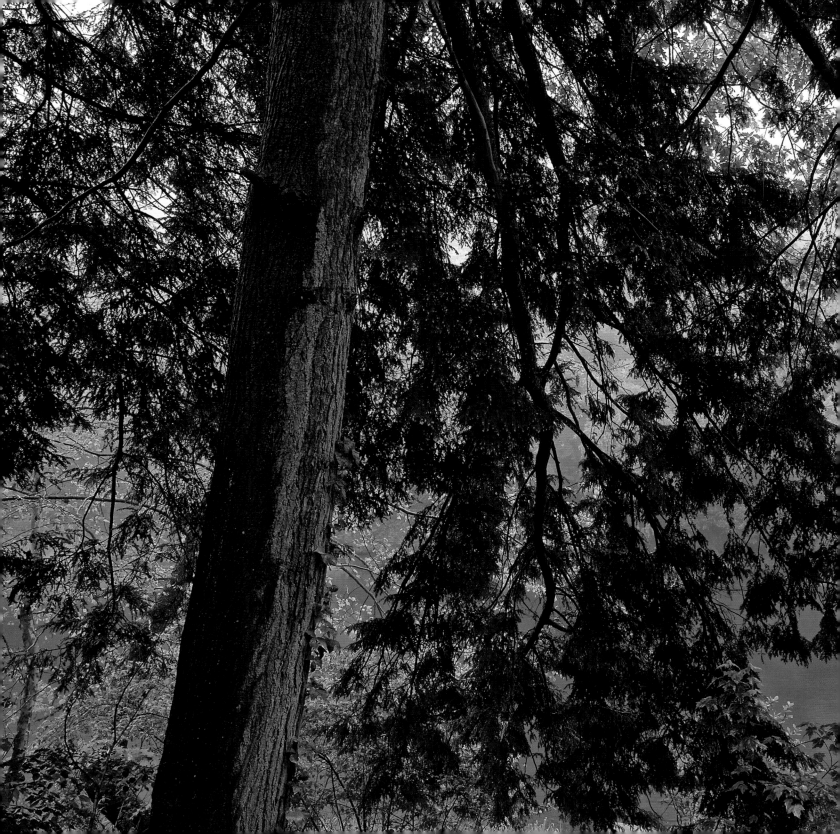

Contents

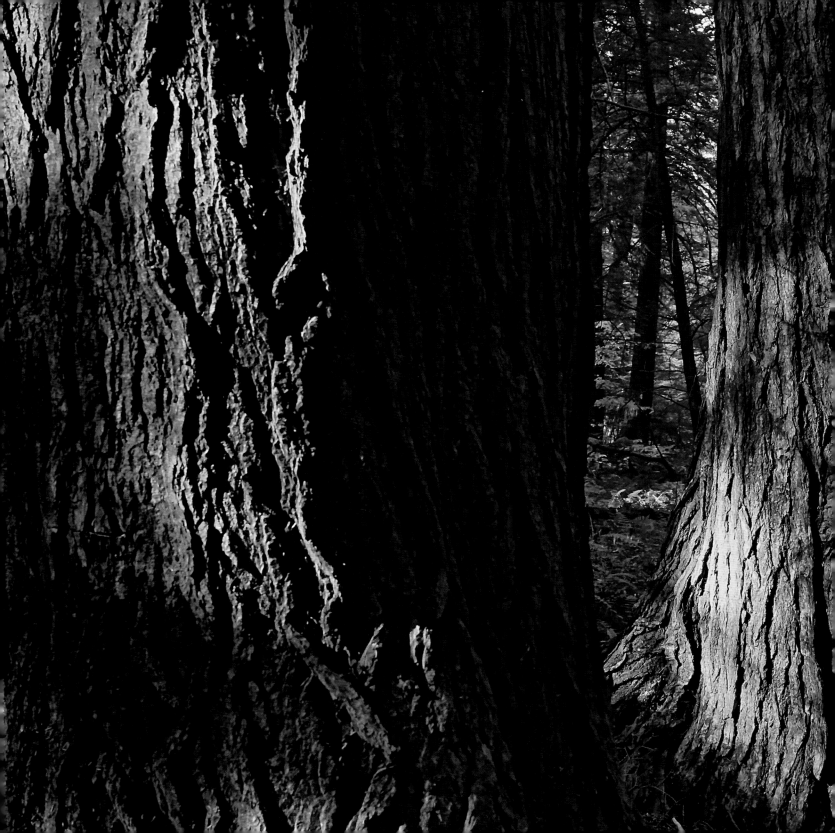

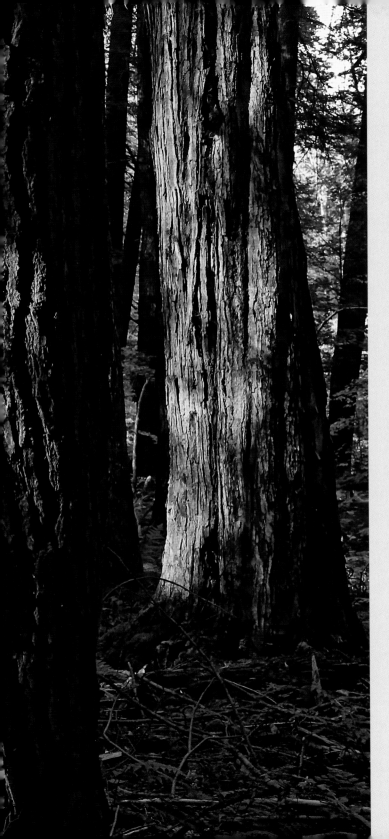

Introduction

Into the Forest

Step into a hemlock grove.

Enter another world.

The hemlock phenomenon can happen at any time of day, but is most vivid and memorable at twilight. Let's choose a summer evening when the Appalachian air settles thick with moisture after a light rain, when the scent of rhododendron wafts flowery along the path. The trill of a wood thrush rings true and clear with the fluted music of time immemorial from a high branch somewhere in the distance—a deep, tall, green distance beyond the first monumental rows of hemlock columns and into the web of countless high limbs overhead that together arc like the ceiling of a cathedral. Like a ceiling, like a cathedral, but *alive*.

In moments like that, the rest of the world disappears.

If you're willing to go—to enter not just the grove, but also its welcoming spell—this casual step into the forest can take you to another realm. At its foundation lie rock, soil, and invisible microbes too small for our acquaintance, but it extends impressively to the massive girth of skyscraping ancient trees along our trail.

Ancient hemlocks have shaded the forest floor at Laurel Hill State Park in Pennsylvania for hundreds of years and created their own ecosystem and microclimate.

From the first page of this book to the back cover, all my efforts to describe and photograph these trees are a bit futile. The essence of the hemlock and beech forest is not about a thing, or even a life, but about a feeling conveyed as you walk among the trees. You *have* to go.

There in the hemlock grove, everything appears to be different. Everything *is* different. On a hot day, I sigh with cool refreshment under the emerald canopy. Hemlocks create more shade than any other plant occurring across their wide geography. As little as 1 percent of light makes its way from the treetops through the dense crop of needles to the forest floor. Because of that, the temperature drops as much as ten degrees in the canopy and another five at ground level.[1] Yet on starry winter nights the hemlock grove is warmer than its surroundings, owing to the protective web of limbs and foliage that traps the earth's warmth. Hemlocks moderate the climate around them.

I'm not normally attracted to darkness, especially in the middle of the day. But here in the grove, with muted light, everything appears paradoxically more vivid. Green is greener. Responding to the hemlock's filtering of light on sunny days, on cloudy days, and even in the black-and-white moonlight of the night, my eyes adjust to see more. The scents of foliage, duff, and soil register more vitally as organic.

My footsteps are muffled by the softness of the needle-filled mattress underfoot, giving extra spring to my stride. The forest's silence opens possibilities for imagination otherwise too often hobbled by a junkyard of noise around us. My senses open to all that surrounds me, and something in my heart does the same. The trees absorb not only water fallen from summer's thunder-heads and carbon extracted from the atmosphere, but

also emotions that I'm eager to shed: impatience, worry, stress.

I'll even go a step further: the deep shade calls up a sense of reverence. In the trees' scented atmosphere, life is serene, soothing, protected. Standing among hemlocks, I can imagine the earth before we humans were born, a land governed by itself in wildness beyond anything we now know. *Primeval.*

Ancient forests of many kinds can call up foggy memories such as these from deep in our genetic code and from our long-forgotten heritage on the blue-green planet, but hemlock forests do this resoundingly well. The archetypal enchanted forest of fairy tales might well have been set here. The dense cover overhead, the snags of dead limbs, the corrugation of bark in lines that lead the eye upward, and the shafts of sunlight angling back down all speak of another age when the woods held delights, mysteries, and paths to wisdom that are, in today's world, crowded out by trivia and swamped by the irrelevant, the pathetic, the narcissistic. Standing among hemlocks, I'm reminded of America's first great wildlands preservationist, John Muir, who wrote, "The clearest way into the universe is through a forest wilderness."[2]

With all those successful old lives around me— their limbs graced above and their roots entwined below—I'm drawn back to the evolutionary legacy of our deep past and also forward to a future where one might expect utter tranquility, given the qualities evident as we walk down that forested path on our memorable summer evening. There, in the twilight, the ancient grove seems as permanent as anything in life.

Yet it's not.

Most hemlocks will not be with us for long.

With the sunlit forest reflected in Clear Creek—a tributary of the Obed Wild and Scenic River in Tennessee— hemlocks overhang the cool waters.

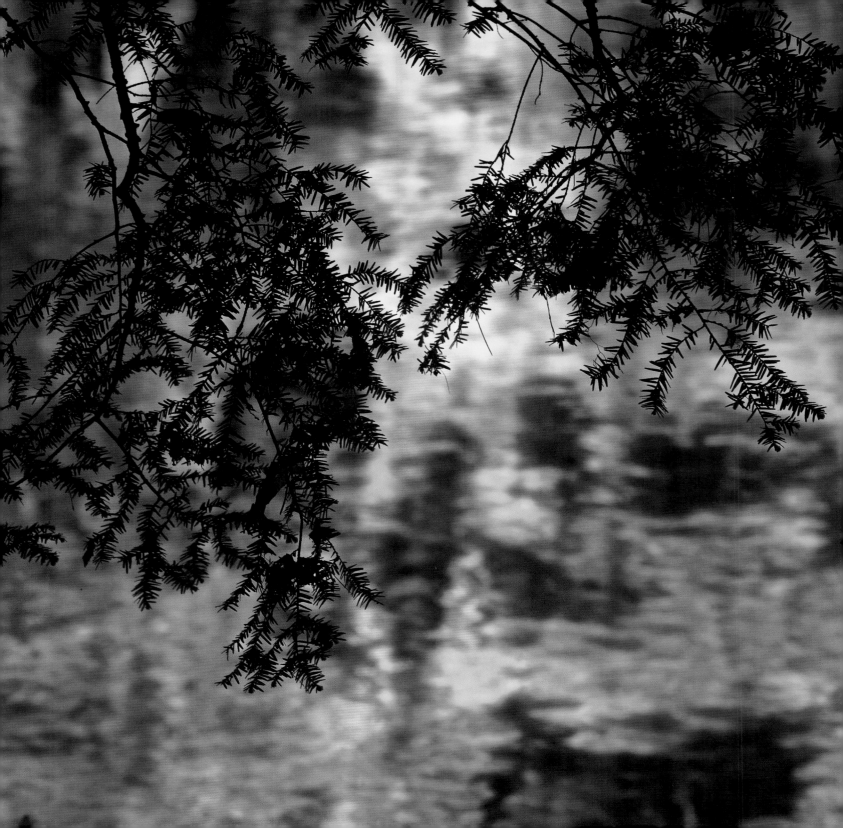

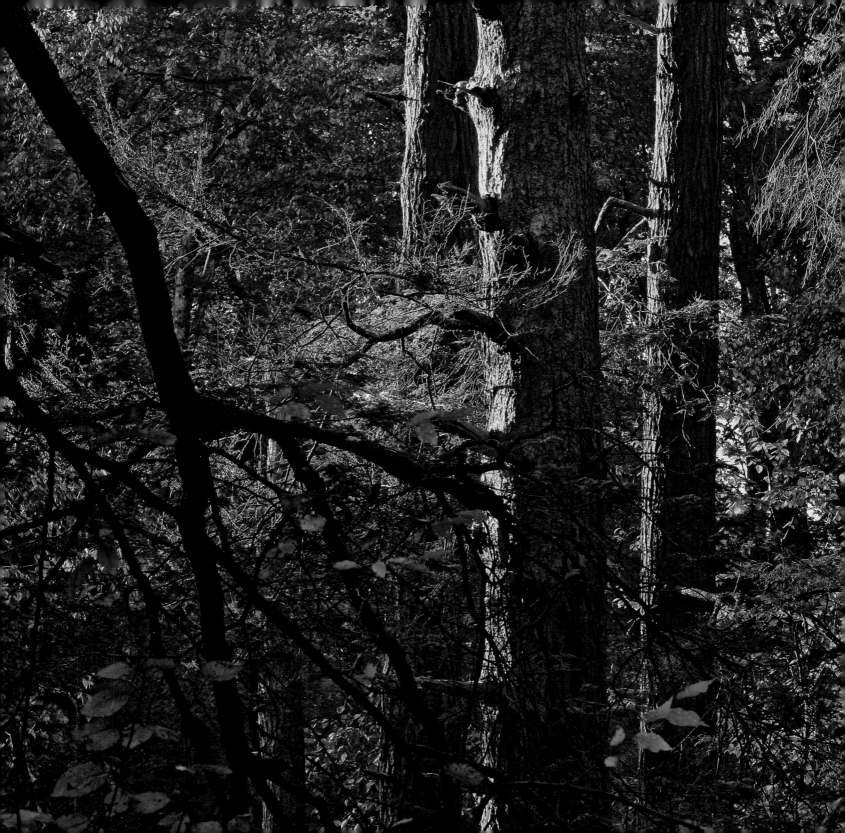

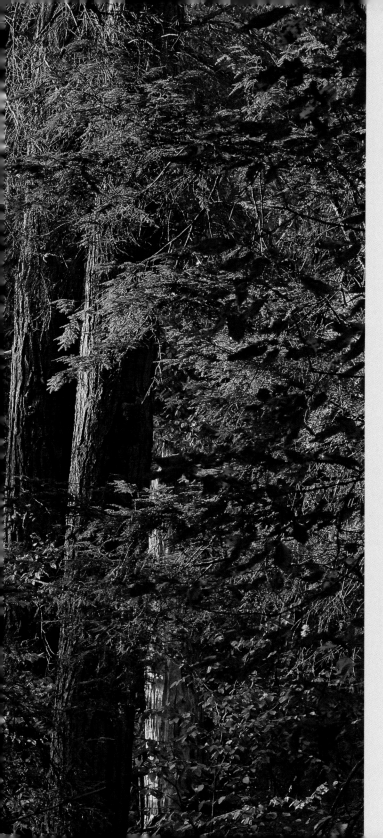

Chapter One
Twilight of Another Realm

Step into a hemlock grove, and do it now, while you still can.

Though these trees remain among the tallest, the oldest, and by many accounts the most beautiful in eastern America, they are plagued by an alien, imported insect that's decimating the great groves in a doomsday trajectory. Thus far, nothing can be done to halt the advance of the hemlock woolly adelgid, *Adelges tsugae*. This tiny insect from Asia is transforming and immeasurably diminishing countless forests east of the Mississippi. At this writing, it has eaten its way through half of America's inventory of eastern hemlocks. As the ecologist David Orwig predicted in the *Journal of Biogeography*, "Hemlock woolly adelgid infestation will lead to unprecedented hemlock loss."[1]

Hemlocks, of course, live not alone. They've thrived over a timeless evolutionary span in community with other life. A principal partner in their journey has been the American beech tree, and a finer forest complement and companion can hardly be imagined.

Hemlocks at Cathedral State Park, West Virginia.

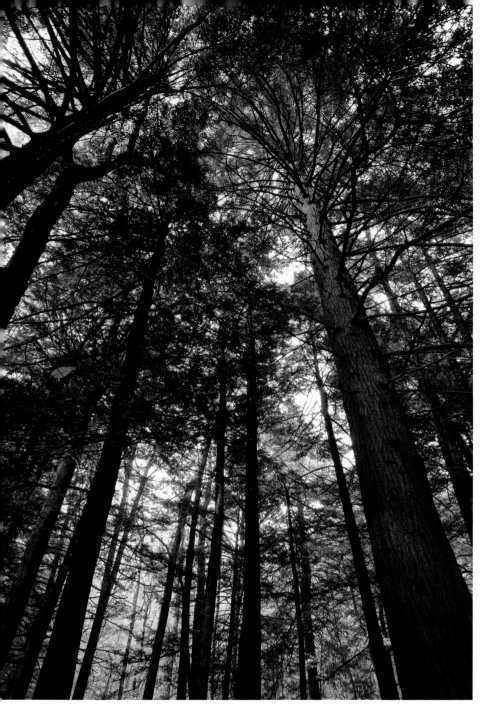

Hemlocks tower over the trail at Linn Run State Park, southwestern Pennsylvania.

Twilight of the Hemlocks and Beeches

While hemlocks are dark and soothing—even a bit somber, depending on your mood—the beech is exactly the opposite. Its smooth, silvery bark pops like the finely articulated brush stroke of a painter who highlights a backdrop of darker intrigue. Beech leaves of translucent yellow-green catch light beaming down or angling in backlit brilliance, and they transmit rather than absorb it. They delight anyone who notices that the trees seem to have their own precious source of radiance—sunshine caught in countless elliptical leaves even when the sky cannot be seen through the hemlock canopy farther overhead. In autumn, beech leaves dazzle in yellow, orange, and bronze, parallel veins and mottled mosaics of color that linger into winter after other trees have shed their dried foliage to stand bare. Beeches serve a host of animals with their nutritious nuts.

Following profoundly different optic and photosynthetic strategies, hemlocks and beeches both harvest the light of the forest with expert efficiency, and so both thrive in deep shade. The hemlock ranks as the most shade-tolerant of all North American trees, and the beech could claim second place.[2] That makes them both "climax" species, capable of reproducing beneath the shade of their ancestors, while other trees cannot. This tolerance, along with a propensity for well-drained soils that frequently line streams, means that hemlocks and beeches often grow in close association, shoulder to shoulder, with a tenure of decades and centuries.

This pairing makes the ongoing plague of exotic pests doubly tragic, because many beeches are also fatally afflicted. Beginning in Nova Scotia and working its way south and west, the alien scale insect

Cryptococcus fagisuga has infested beeches through much of their range, boring billions of minute holes into the trees' smooth, sensuous bark. That alone would not be particularly troublesome, but the openings probed by the scale insects and the resulting wounds in the bark are invaded by fungi of the genus *Neonectria*, which feed on and kill the trees' thin and essential layer of phloem, which is just inside the bark and carries essential nutrients downward from the foliage. The fungal infection progresses to a leprosy of blisters and lesions, constellations of cracks, and open wounds that can encircle and kill the trees within a few years.

With both the hemlocks and the beeches of eastern America being devastated by these exotic pests, an ecological and aesthetic pandemic of epochal significance is under way. The trees face their demise in the course of several short decades—a mere blink in the fifty million years since the emergence of the hemlock family from its proto-species worldwide. Intensive efforts are now being made to avert this demise and, as Pennsylvania's *Eastern Hemlock Conservation Plan* states, "There is an opportunity to save eastern hemlock from widespread elimination." But the same report recognizes that even aggressive intervention will not prevent the hemlock forest from "being reduced to a fraction of what it was."[3]

Much of this forest's value, and also a significant part of the enchantment felt in walking through our ancient grove on a summer evening, stems simply from the fact that hemlocks and beeches are trees. We live in a world of trees—everywhere common yet unconditionally wondrous woody plants guarding the earth, feeding the earth, and making life as we know it *possible* on earth.

Trees consume or "inhale" carbon dioxide from the atmosphere and "exhale" oxygen—exactly the opposite of what we and other animate creatures do with every breath. Put another way, we inhale what trees exhale, and vice versa, and I'm hard-pressed to imagine a relationship more intimate or dependent than that.

We need trees.

With their root masses, they protect the soil by holding it in place against the never-ending forces of water, wind, and gravity. Trees support a whole range of life, from deer that evade winter's deep snow under the arboreal umbrella, to fish that require trees' shade to keep the water cool. Nuts, seeds, leaves, twigs, bark, and roots of trees feed an entire forest community. Cavities in trunks and broken tops of weatherworn snags offer homes to animals and birds—from bears to voles, from eagles to nuthatches, from bats to ducks to squirrels. Especially squirrels! These chattering bushy-tailed acrobats of the canopy are the quintessential occupants of the trees.

Through photosynthesis—at once miraculous, mysterious, and essential to the rest of life—trees create food for their own towering growth. In the process, they transform invisible carbon dioxide gas, inhaled from the atmosphere, into solid carbon that constitutes wood. For every pound of wood produced, the tree extracts a pound and a half of carbon dioxide from the air.[4] In this way, trees come as close as one might imagine to making something out of "nothing." If you want to watch creation occur in its most fundamental form, cast all myths and other accounts aside, and right here, right now, just watch a tree.

Its transformation of carbon from gas into solid substance helps to remediate the crisis of global warming.

This is because the trees' sequestering of carbon in countless woody trunks and limbs counteracts our industrial-age obsession with doing just the opposite: by burning fossil fuels, cutting down forests, and exploiting carbon-rich soils, we convert solid or liquid carbon into gaseous carbon dioxide that concentrates in the atmosphere. This traps heat and causes the "greenhouse" effect responsible for planetary warming and related havoc.

We would be hard-pressed to live without trees, and all of them are important. But those of the hemlock grove are special.

Countless individuals and groves across the wide range of these celebrated conifers are already gone. Many hemlocks that appear in this book have—since I took their picture—become fallen punky boles and rotten crowns now mulched into soil by armies of micro-decomposers. Though the hemlock and beech are not likely to go extinct anytime soon, total loss of their forest type is under way, or is projected for many regions within a few short years or decades.

Memories of these trees and the visions of their elegance are treasured by the people who have known them. But memories fade and are ineffectively bequeathed to following generations. The next best thing, photographs can remind us of the beauty that has long graced eastern America from the Piedmont almost to the prairie, and from Canada almost to the coastal plain as it flattens toward the Gulf of Mexico.

Capturing these photos, just in the nick of time, became a passion of mine as I traveled throughout the East, beginning in the 1990s when I realized what was happening, and through photo excursions for my 2008 book, *Trees and Forests of America*, and continuing through an outing just yesterday to an exquisitely beautiful woods, forever memorable but now imprinted in my mind even more vividly because of the photo I took.

Certainly, everyone who takes the care and the time to notice can tell that our hemlock and beech forest, let alone the entire American environment, is changing. But, as a photographer, I found myself intimately and inseparably connected to this reality. Scenes I photographed twenty or forty years ago look different today. Passing through life *without* a camera, I might notice something or I might not. *With* a camera, I'm sharply attuned to the looks of all that's around me and, by association, to the health of our forest and land. With a bit of discipline on my part, the camera becomes an extension of my eyes and brain, a personalized conduit for news, information, and inspiration. While I found astonishing beauty in many forests where I searched for hemlocks and beeches, the underlying news was not good.

In fact, a grim future haunted my search daily. Yet I somehow approached the mission of capturing worthy images of these forests by braiding a sense of despair with a concentrated dose of gusto for the task at hand. Part of my emotional endurance and ironic enthusiasm for this unusual quest I owe simply to my being an optimist, even when irrationally so. I enjoy life and the world I see, along with the experiences within my reach, however ephemeral. After all, life every day is a passing breath that expires too quickly and must be savored for what it is. In fact, there is reason to hope that the hemlock and beech forests will not completely disappear, and we'll consider the brighter possibilities in chapter 5. In any event, regardless of hope, or despair, or alternating currents of the two, I found myself eager to produce a

book that might bring to others the essence of this landscape at a pivotal moment in its history.

Furthermore, beyond the trees' tragic dispatch of bad news lies a greater message that has the power to inform and engage, to motivate and transform. Even in the twilight of their time, these trees can inspire us to care more for the natural world that remains.

While heartbreaking losses are inevitable, much can be done to better care for the forests that endure. We can do our part to instill resilience in a time of global change. Through personal and political means, we can aspire to correct three centuries of wrongs in our relationship with all the great American forests whose air we breathe, whose lives we share, and whose beauty we need for both the strength and the joy to travel onward.

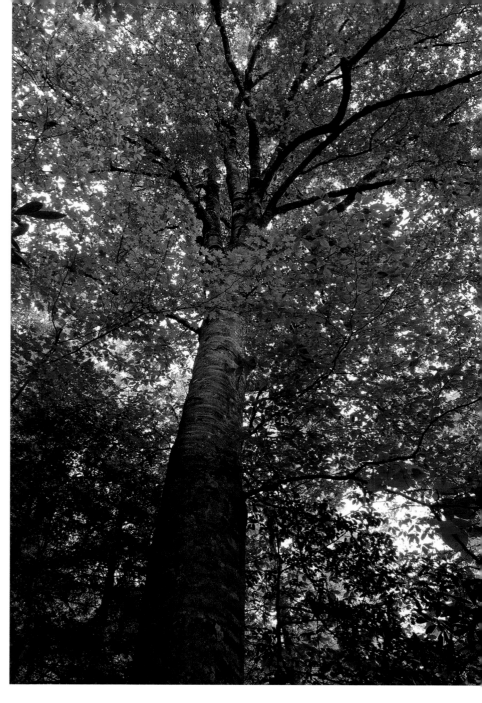

Beech trees reach for light at the top of the canopy, Big South Fork National River and Recreation Area, Tennessee.

Twilight of Another Realm

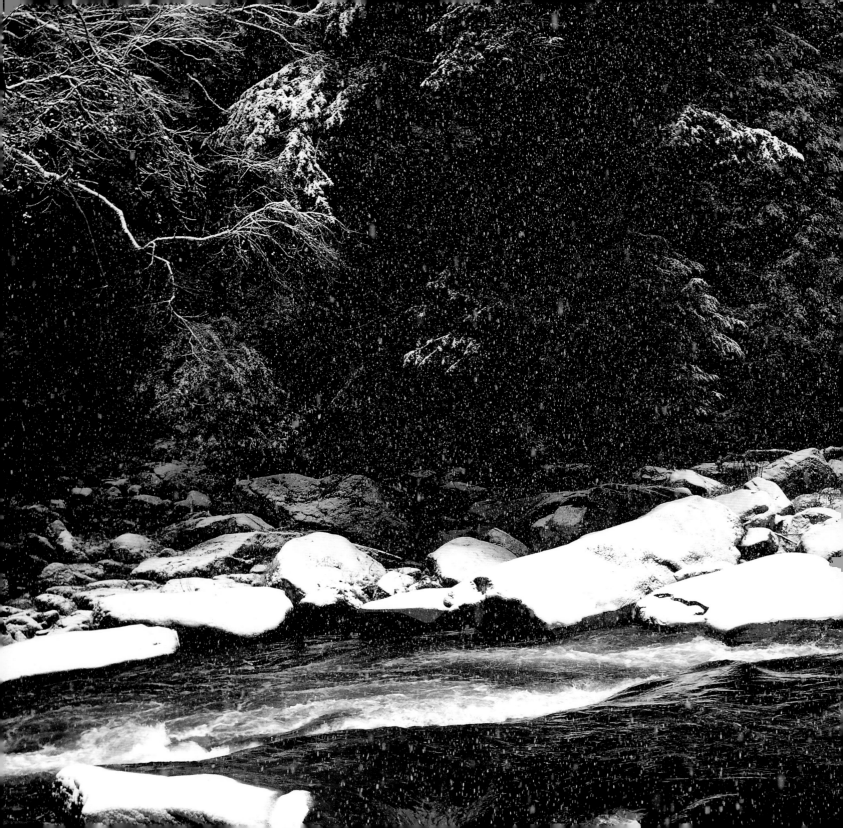

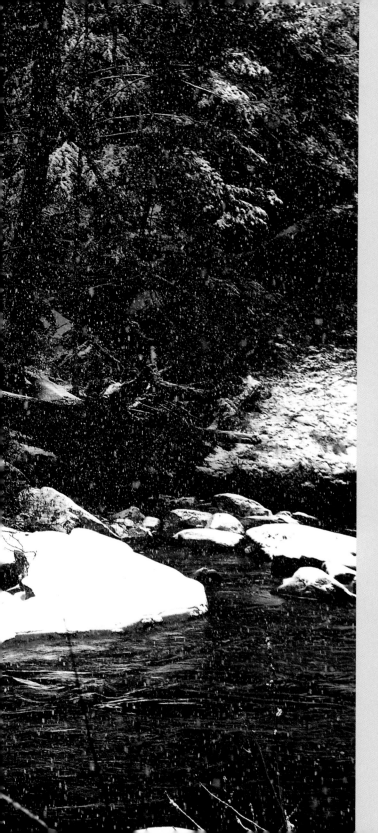

Chapter Two

The Woods We Have Known

At an early age, I knew that the hemlock was my favorite tree. This might have stemmed simply from the fact that its needles stayed green throughout the long, gray Pennsylvania winters. Yet I knew that my affection somehow drew from deeper connections, tighter ties, stronger emotions and convictions.

On hikes from my home in the Appalachian foothills, I found hemlocks tucked into abrupt topography that Bradys Run had carved into slopes and hollows winding down toward the Beaver River. Few other evergreens grew in that part of the country, and so the hemlock sightings were special, like a wood duck's whistling flight or like a great horned owl staring down sternly, big-eyed on a limb up above.

With my horizons later extended by the family car, I discovered McConnells Mill State Park. This pocket of wildness amid dairies and strip mines was saved by the Western Pennsylvania Conservancy, which bought two thousand acres in 1942 as one of the earliest land-trust projects in the nation and later turned it over to the state for a park. It emblematizes a type of eastern landscape that ranks as one of our most cherished: the hemlock gorge.

Fresh snowfall dusts the gorge of Slippery Rock Creek, McConnells Mill State Park, western Pennsylvania. Hemlocks thrive in the cold winters of the Northeast.

The full height of a mature hemlock can be seen above the Hemlock Trail in Acadia National Park on the coast of Maine.

Clambering over house-sized rocks there was initially the big draw for me and my adventure-starved high school pals, but I soon realized that the hemlocks gripping those rocks on the boulder-maze floodplain of Slippery Rock Creek created a mood and a beauty that resonated more deeply. I agree with Robert Lemmon, author of *The Best Loved Trees of America*: "I shall always count it a privilege to have been raised in hemlock country."[1]

Later, I fell under the spell of the great trees in Cook Forest State Park, one of the finest hemlock groves anywhere. Some trees there have been growing since before a wildfire swept through in 1644. While the Pacific Coast's redwood, Sitka spruce, and Douglas fir also convey a feeling of cathedral-like grandeur, the hemlock has no equivalent in the East.

My appreciation of hemlocks grew in oddly practical ways when by chance I learned that small dead limbs readily split when broken, the staccato crack exposing ignitable kindling even during the rain or snowstorms that frequently marked my boyhood outings into ever more distant woods. I wasn't above trying to bring a piece of wildness home with me, so I transplanted both hemlock and beech saplings to line the long driveway of our family home. The young trees grew up while I did, and they enriched our lives every day.

It took me longer to realize that beech trees, too, were special. In many ways, they resemble other large deciduous trees, easily slighted as common where I grew up. But during my college years, with eyes opened by the study of landscape architecture, I noticed that the bark of the beech was far smoother than all others, sensual in its curves and

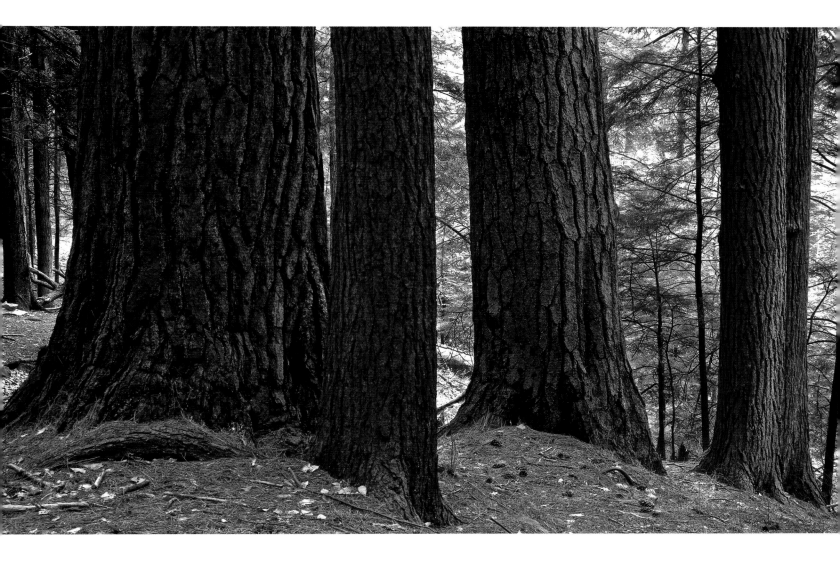

upward-forking limbs. It makes you want to touch it, feel it. In springtime, the leaves emerged tender and bright, darkening to luminous green through summer, then flaming yellow-ocher, vividly sharp in the crisp north-eastern autumn. The landscape architecture curriculum at Penn State University included learning to draw with a soft carbon pencil, and with this eye-opening tool

in hand, and with living trees posing like patient and arresting models, I realized that the beech also has a special structure. Rather than generically curving up and out, the way, say, an oak does in its muscular workhorse mode, the limbs and especially the outer twigs of the beech grew in a delightful form, with somewhat straight lines repeatedly broken by slight angles, all yielding an

Cook Forest State Park, Pennsylvania, is home to one of the finest hemlock groves in the East. A lone white pine presides on the left.

The Woods We Have Known

artistic, architectural quality that my pencil loved. The buds—long, thin, and sharp—have the same degree of refined articulation. Clinching my attraction, the beeches often grew among hemlocks, and the silver trunks and brilliantly colored leaves made a perfect complement to the dark conifers. The aesthetic synergy of the two trees reminds me that a forest's sum is greater than its parts.

After college, I bought a neglected century-old farmhouse in the mountains of northern Pennsylvania. Once I ripped off the tattered asphalt shingles that armored it from head to toe, hard-core Appalachia style, I saw that the timelessly sturdy structure was made of hemlock—a plank house of boards two inches thick, pounded vertically into place with hand-forged nails against stocky eight-by-eight framing—a homey fortress made with five times the lumber that anyone would even think about using today. The tumbledown barn was also hemlock, and I disassembled every splintery piece for recycling in my house and for a cabin I built. I cut the barn's beefy, axe-hewn beams into twelve-foot lengths so I could drag them as squared-off logs into place by myself. I notched them to corner fit, and the new walls climbed high. My plan was to begin my career as a writer inside that little cabin made of hemlock.

Going back at least a century and a half, living hemlocks have captivated more than their share of American writers and artists. In 1847, Henry Wadsworth Longfellow cast the opening lines of *Evangeline* in a hemlock forest, immortalizing the same mood that many still feel today: "This is the forest primeval. The murmuring pines and the hemlocks, / Bearded with moss, and in garments green, indistinct in the twilight."

A full lifetime later, Robert Frost, in "Dust of Snow," recognized hemlock branches' propensity to bend and drop new winter accumulations before their weight increases enough to break the limbs—a serendipitous moment that gave the snow-doused but gamely appreciative poet a welcome "change of mood."

Others have praised the hemlock's virtues more directly. Andrew Jackson Downing—America's first great landscape architect and the editor of *Horticulturist* until his untimely death—wrote in the 1858 publication *Rural Essays* that the hemlock was "beyond all question the most graceful tree grown in this country." In *The Silva of North America*, Dr. Charles Sprague Sargent, first head of Harvard's Arnold Arboretum, noted, "No other conifer surpasses the hemlocks in grace and beauty."[2]

In 1948, the great bard of American trees, Donald Culross Peattie, wrote in more depth. "Not in newsprint and cheap wrapping paper does Hemlock serve us best, but rather rooted in its tranquil, age-old stations. . . . Soon even talk of the tree itself is silenced by it, and you fall to listening."[3]

The current Peterson Field Guide *Eastern Trees* informs us that "the delicate silvery foliage and small, pendent, perfectly formed brown cones of the hemlock make this one of our most beautiful forest trees." Lavishing similar praise on hemlocks in his pathbreaking 1995 book, *The Dying of the Trees*, Charles Little wrote, "Dim, silent, and cathedral-like, they are sylvan treasures unlike any other in the Eastern forest."[4]

Dr. Joseph T. Rothrock, the "father of Pennsylvania forestry" and head of the state forestry agency in 1886, wrote, "If Pennsylvania were to select one tree as characteristic of our state, nothing would be better than the hemlock." Eventually following his lead, the legislature

designated the hemlock the commonwealth's official tree, and on June 22, 1931, Governor Gifford Pinchot—no stranger to the woods, as former first chief of the U.S. Forest Service—signed the proclamation.

"*Whereas, The hemlock is still today, as it was of old, the tree most typical of the forests of Pennsylvania; and*

Whereas, The hemlock yielded to our pioneers the wood from which they wrought their cabin homes; and

Whereas, The hemlock gave its bark to found a mighty industry, and

Whereas, The hemlock everywhere lends kindly shelter and sure haven to the wild things of the forests; and

Whereas, The lighted hemlock at Christmas time dazzles the bright eyes of the child with an unguessed hope, and bears to the aged, in its leaves of evergreen, a sign and symbol of faith in immortality; now therefore,

Be it enacted that the hemlock tree be adopted as the State tree of Pennsylvania."

Beeches, too, have been heartily admired. In his classic horticultural text *Trees for American Gardens*, Donald Wyman stated, "Among deciduous trees, there is nothing quite as majestic or as graceful as the beech."[5]

When easterners think of hemlock, they usually mean *Tsuga canadensis*, the eastern hemlock, which is the principal species east of the Great Plains. But another, the rare Carolina hemlock (*Tsuga caroliniana*), grows on scattered high peaks of the southern Appalachians, altogether probably covering no more than a thousand acres, according to Eastern Native Tree Society founder and hemlock aficionado Will Blozan. *Caroliniana* favors harsh rocky ledges rather than the moist ravines of its

more plentiful cousin, and it bends to the blasts of wind on isolated perches. Its needles lie not neatly flat on their twigs but rather bristled, disorderly. It's typically smaller than *canadensis*—much smaller—but a few have grown to incredible four-foot thickness in North Carolina.

The American West claims two other spectacular native species. The western hemlock (*Tsuga heterophylla*) thrives in the Coast, Cascade, and Northern Rocky Mountain ranges from sea level to seventy-five hundred feet. Drenching precipitation spawns giants 150 feet tall, sometimes reaching 215, and five feet across or even more. Western hemlocks are clearly larger than eastern hemlocks, but that's not much noticed because both species are large relative to many of the trees around them.

Upslope in our western terrain, the mountain hemlock (*Tsuga mertensiana*) ornaments the five-thousand-foot-to-timberline zone from coastal Alaska through California's Sierra Nevada and also high peaks in Idaho and Montana. Though some grow to a hundred feet tall and three feet thick in sheltered conditions, the most memorable mountain hemlocks are contorted by wind and snow into sculptural masterpieces. Farther up, at timberline, prostrate *mertensiana* krummholz grips tight to rocks and cliffs—centuries-old bonsai between patches of snow lingering all summer long.

Six species of hemlock are found in Japan, China, Taiwan, and the Himalayas, and another one, on Ulleung Island off Korea, is currently being classified genetically as a separate species.

The fascinating story of hemlocks' evolution has been pieced together by entomologist and evolutionary biologist Dr. Nathan Havill of the U.S. Forest Service. Using three tools—DNA analysis, fossil records, and modeling of the connections between continents in the

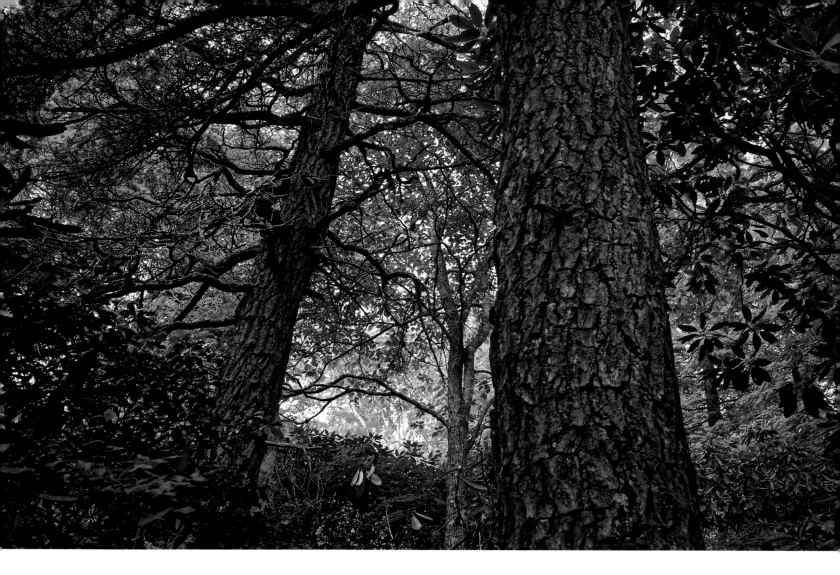

Growing to unusual height and girth at this rocky outpost in the southern Appalachians, Tsuga caroliniana guard a ridgetop east of Highlands, North Carolina.

deep past—he described the proto-hemlock as a single ancestral species of the northern hemisphere, united across earth's northern latitudes between 50 and 90 million years ago. As the continents separated, distinctive species evolved where hemlocks became isolated in western North America, eastern North America, Europe, and Asia. The European species went extinct during glacial advances that stranded the trees in overly arid southerly climes. The others survived.[6]

Fossil records show that the first speciation was the mountain hemlock, 42 million years ago, followed by the western hemlock and then the eastern hemlock, 30 million years ago. Curiously, the Carolina hemlock is genetically closer to a Japanese *Tsuga* than to the

Twilight of the Hemlocks and Beeches

eastern hemlock of shared geography. The Carolina's unexpectedly circuitous genetic path appears to be linked to the now extinct European species, which had apparently sustained some Asian DNA that endures in *Tsuga caroliniana*. While fascinating in their own right, these evolutionary relationships have implications for the eastern hemlock's fate, covered in chapter 5.

In a geographic range centered in Pennsylvania, eastern hemlocks have thrived from Nova Scotia southward to northern Alabama, and from the coast of Maine westward to central Kentucky, flirting with the prairie's edge at Mille Lacs in central Minnesota as recently as the 1930s but now regressed back to Hemlock Ravine Scientific and Natural Area just south of Duluth, where they are barely hanging onto an eroding hillside. The northernmost extend into Quebec. The southernmost hemlock was reported by Charles Sprague Sargent in 1884 at Clear Creek Falls in Alabama, but it was flooded by a hydroelectric dam in 1961.

These conifers were found on 19 million acres and were dominant on 2.3 million. Throughout the Appalachians, hemlocks have historically accounted for 5 to 10 percent of the total forest—not as plentiful as oaks and maples, but significant, given some 455 competing species of trees in this biome. In Vermont—with the year-round green of a mountain range that was named for this color—hemlocks are the third most prevalent tree. In the South, they are far more scattered, though within cool pockets of terrain the productive climate has yielded historic records for height, girth, and mass. Unfortunately, that same balmy weather contributes to the plight of today's southern hemlocks, as we'll see in chapter 4. Among all eastern tree species, few

have the wide geographic spread of either the hemlock or the beech.

The American beech, *Fagus grandifolia*, is the only New World member of a large beech family. Seven species grow in Asia, one in Eurasia's Caucasus Mountains, and one in Europe—similar to the American but darker, with wavy-edged leaves. The European species is faster growing than the American, more pollution tolerant, and easier to propagate, and it does not send up root sprouts—all making it more manageably domestic as a lawn tree. Many ornamental cultivars, including copper, cutleaf, and weeping forms, have been hybridized and proudly exhibited in yards, public parks, and capitol grounds. Beech trees belong to the rambling family Fagaceae, which includes oaks. All enclose their seeds within protective casings: acorn cups, bristly chestnut shells, and similar beechnut burs.[7]

The range of the American beech overlaps closely with that of the eastern hemlock, except that it extends farther south to the Gulf of Mexico, farther southeast to Georgia's coast, and farther southwest to Missouri, Arkansas, and Texas. The tree is most prevalent in New York's Adirondack Mountains and has a strong presence throughout the Northeast, though fine stands and large trees have been found almost everywhere throughout the range. As with hemlocks, the largest are found outside the heart of the range, especially in the Ohio and Mississippi bottomlands and on western slopes of the southern Appalachians.[8] Like hemlocks, beeches favor moist, well-drained cove forests and northern slopes, but they also thrive in the fertile soils of limestone valleys, and they mix widely with other trees.

Hemlocks and beeches are both "generalists," excelling in varying soil and topography.[9] They belong to

a midslope community rather than to high peaks, and to rock ravine communities—quintessential home of the hemlock. Seedlings of both are damaged if the soil dries out. Guarding against this, hemlocks maintain their own damp microclimate; less evaporation occurs under their canopy than under broad-leaved trees.[10] Thus, among all trees in the East, hemlocks come the closest to generating their own weather—a great advantage to any species but a luxury bestowed on few. However, the trees and their weather constitute an egg-and-chicken relationship that makes it hard for hemlocks to restart once eliminated; aspiring seedlings outside established groves are denied the favored microclimate that their ancestors created.

Hemlocks and beeches can account for up to 85 percent of the biomass of some forests, though it's usually much less. After the heavy harvest of hemlocks ended in the early twentieth century, the greatly diminished acreage of these conifers slowly increased as a climax forest.[11] In western reaches, such as shaded foothill pockets in Ohio, hemlock groves still expand their footprint, with young trees advancing in the ripple line of cone fall and the partial shade radiating out from older trees. But this does not occur where the woolly adelgid has become established.

In the dry, cold heights of California and the West, bristlecone pines are renowned for their life spans of five thousand years, but in the East, hemlocks are among the oldest trees, sometimes standing for five hundred years. One stump, reportedly showing eight hundred growth rings, was noted by Professor E. D. Merrill, director of the Arnold Arboretum in 1946.[12] When I recently stood among Methuselahs of the Longfellow Grove in Cook Forest, Pennsylvania, I considered the plausible germination date of a venerable tree: the year 1500. That would make it a 276-year-old giant when the Declaration of Independence was signed. Similarly ancient, beeches can live four hundred years. Like hemlocks, they start slowly. One might not produce seeds until it is forty years old or ten inches in diameter.

Eastern hemlocks commonly grow to seventy feet and eighteen inches across. But under good conditions they stretch to one hundred feet, with record heights soaring above 160 and diameters of three and even six feet. Once above the canopy around them, the hemlocks gain girth but little additional height, at that point seeming to know that the advantage of extra sunlight is undercut by added exposure to wind and lightning.

An unprecedented survey, the Tsuga Search Project, by Will Blozan and Jess Riddle of the Eastern Native Tree Society, documented the size of the largest hemlocks still standing in 2007. The two men no doubt bushwhacked more trails looking for hemlocks than anyone before or since. A tree named Usis, four to five hundred years old when it died, was the tallest ever recorded, at 173.1 feet high and five feet thick. Only four hemlocks over 170 feet were found. Seventy-five hemlocks, all in the southern Appalachians and mostly within Cataloochee Valley in Great Smoky Mountains National Park, topped 160 feet before succumbing to the adelgid.[13] A monarch in North Carolina named Cheoah, now chemically treated for adelgids, is the tallest and largest surviving eastern hemlock, nearly 159 feet with a five-foot diameter.[14] At 156 feet, the tallest known hemlock outside the Blue Ridge province of the southern Appalachians stands in Savage Gulf State Natural Area, Tennessee, and is being treated to combat adelgids. In the north, Pennsylvania's tallest hemlock tops 145 feet, and the tallest one in Massachusetts is 136.

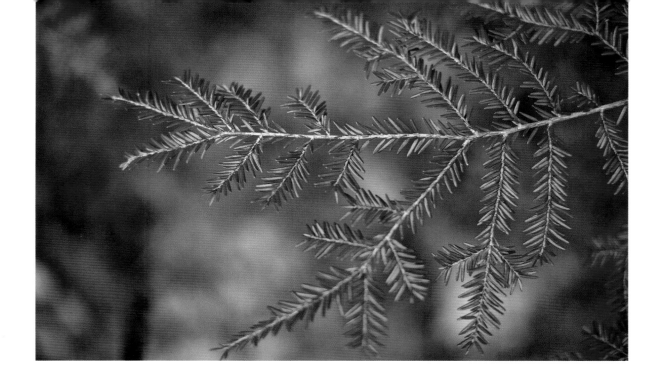

Though white pines grow taller, the eastern hemlock is the largest eastern evergreen conifer in volume of wood, reaching fifteen hundred cubic feet, compared to twelve hundred for very large eastern white pines (the coniferous but deciduous bald cypress of southeastern swamps can grow larger and live for thirty-five hundred years).[15]

Beeches typically grow to sixty or eighty feet, with diameters of two or three feet. One tree near Anne Arundel County, Maryland, tops 112 feet.

Though among the largest trees in the East, the hemlocks' needles are among the smallest of all tree foliage. Flat, blunt, and three-eighths to five-eighths of an inch long, they are arranged in flat splays along pliable, delicately thin twigs. The needles' minute size is what gives hemlocks such fine texture—making them appear somewhat amorphous from a distance, or, as Longfellow wrote, "indistinct in the twilight."

The needles are appreciated differently up close. Their upper surface shines glossy green, as if polished with furniture wax. Two rarely noticed thin whitish stripes lie underneath each needle. These are where the stomata lie—microscopic openings that allow the needles to exchange gasses and photosynthesize. Surprising, if you've not looked closely in springtime, tiny mutant-looking needles of new growth run lengthwise along the tops of the twigs between the primary rows of needles, as if to green every possible surface with chlorophyll, which may indeed be the modus. They seem to wear off later in the year. The rest of the foliage typically lasts three years before the old needles sprinkle the ground and new growth occurs.

Beech leaves, on the other hand, are thin, airy, translucent, three to six inches long, elliptical, coarsely toothed, and remarkably similar to those of the

The diminutive but densely packed needles of hemlocks brighten any winter scene and resist moisture loss with their glossy shine. The needles can photosynthesize year-round to produce nutrients for the trees. This hemlock flourishes at Ohio's Beaver Creek State Park.

American chestnut, which a century ago was functionally exterminated by an exotic blight similar to the beeches' current plague, but worse. In autumn, the beeches' leaves turn yellow, with green persisting a while along the veins in psychedelic two-tone but then ripening to smooth orange and later drying to durable bronze. Through much of the winter, shriveled leaves cling to twigs of understory saplings long after the foliage of other trees, except for a few oaks, has fallen.

The beech leaves are a photosynthetic marvel that enable the tree to thrive in dim light under hemlocks. Among hardwoods, only sugar maples come close in shade tolerance. Both specialize in making the most of every errant sunbeam. Beech leaves do this through rapid-response stomata, which open immediately when touched by sunlight, thereby tapping atmospheric carbon dioxide and processing it into food resources for new growth. Bursts of stomatal activity occur at the slightest opportunity, off and on in currents of receptivity that other trees cannot match.[16]

When hemlock needles fall, they accumulate into a dense but resilient mat, sometimes a foot or more thick, that resists full rot, with organic detritus storing carbon dating back hundreds if not thousands of years.[17] This contrasts sharply with deciduous trees' thin layer of leaf litter, which by springtime disintegrates into little more than biofilm. The acidic hemlock needles resist breakdown and form a crusty veneer of nutrient-poor soil that, along with the suppressive shade of hemlock crowns, prevents the growth of most other plants. This enables us to stroll freely among the great trees in their central and northern ranges (a brushy understory entangled by rhododendron and dog hobble typically characterizes the disappearing

hemlock groves of the South). Some young hemlocks, however, do take root.

The seeds develop inside oblong, wind-pollinated cones that don't appear until the trees' fifteenth birthday or later. The little cones are a mere five-eighths or so of an inch long and soft compared to prickly pinecones. They fall near the tree or catch a short ride on the wind. Seeds embedded within the cones typically remain viable for only a year or two, limiting their ability to wait out longer sieges of hostilities. Further, the hemlocks cannot reproduce by root shoots or other cloning means, the way chestnuts and beeches do. Historically, this didn't matter, as the durable groves produce seed year after year, century after century. However, if the adults die or otherwise fail to produce seed, the lack of stored viable seeds means that the grove soon loses reproductive ability.

Confronted with a crust of needles on the ground, hemlock seeds within mature groves often germinate best on decomposing stumps or in rows atop rotting "nurse" logs. Here, stilt-like roots wrap themselves around the underlying logs as the aspiring young hemlocks suck up nutrients from the dead tree but also probe for deeper soil beneath. Few other eastern trees engage with nurse logs, as the time it takes for the log to decompose enough to host the commensally germinating trees on their backs also allows for other trees to grow up around the log, resulting in shade that suppresses most species. But not hemlocks.

While hemlocks require germination by seeds, beeches grow both from seeds and from root sprouts called coppice. This occurs where trees have been cut or roots even slightly dinged, with resulting "panic attacks" of new sprouts by the dozens or even hundreds seeking

CLOCKWISE FROM TOP LEFT

Freshly emerging beech leaves burst from their buds along the path to Jordan Pond in Acadia National Park, Maine.

At Linn Run State Park, Pennsylvania, a young beech shows that chlorophyll persists in the leaves' veins but soon yields to brilliant yellow and gold as the frosty nights advance.

Some beech leaves remain on the trees through winter's first snowstorms. Here in New York's Catskill Mountains, they brighten the deep freeze of daybreak in December.

Fallen beech leaves in green, gold, and bronze texture the ground among the mossy roots of a hemlock along the Clarion River, Pennsylvania.

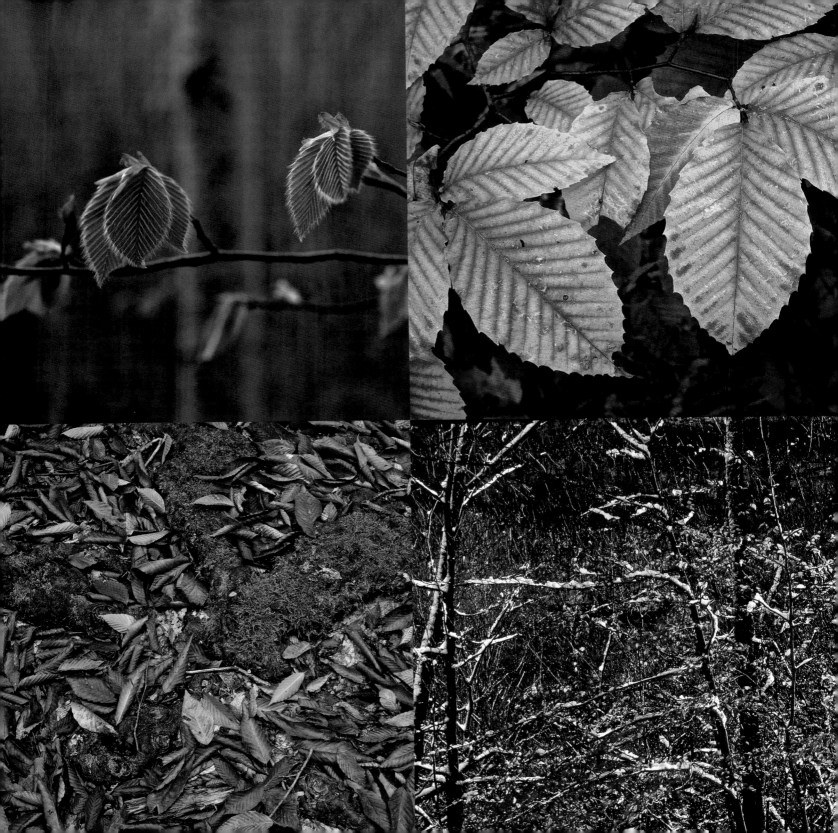

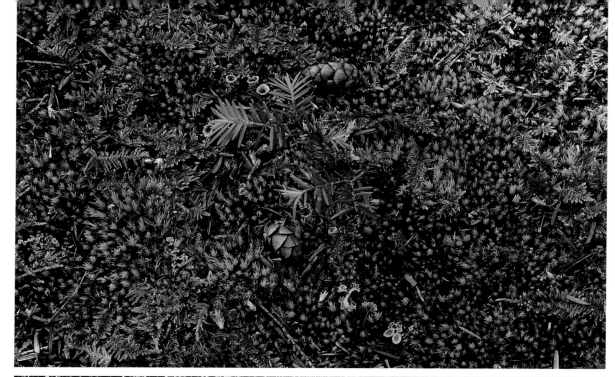

ABOVE

Adapted to extreme shade like no other tree in the East, a new generation of hemlocks has germinated. Two cones—always of miniature size—and a pair of tender seedlings share this soft bed of summertime moss in Black Moshannon State Park, central Pennsylvania.

BELOW

Young beech trees germinate from seed and also sprout prolifically when roots are damaged. However, where beech bark disease is present, most of the sprouted saplings will not endure to become large trees. While the old beeches of impressive girth have nearly all succumbed, this thicket of young trees covers a mountainside above Nancy Brook in New Hampshire.

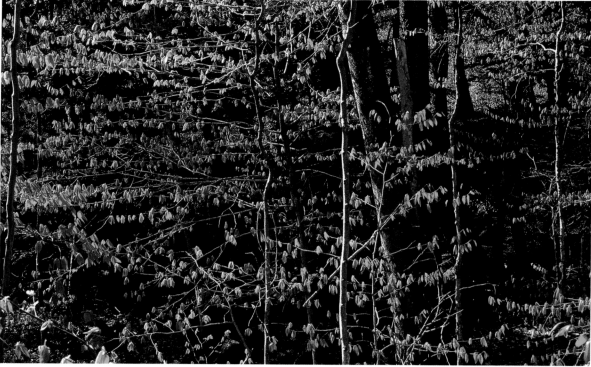

Twilight of the Hemlocks and Beeches

light. According to Dr. David Houston's observations, the most capable sprouts grow from small, pencil-thick roots that extend to the edge of the drip line from foliage above. Here, they get more sunlight. Thickets become so crowded that foresters call them "beech brush" or, in lesser moments, "beech hell." Density can reach the level of virtual groundcover, blocking other plants out. But sprouts are short-lived, and their vigor often diminishes before they reach four inches in diameter—also before generating seed that would lend genetic variability.

From modest, wind-pollinated flowers, seeds of the beech grow within three-sided nuts enclosed in spiny burs, maturing in September or October. Especially critical to wildlife, beeches yield the only true nuts in the northern hardwood forest, and they also extend north of acorn-bearing oaks.

Though they were once important to people, few of us ever get to taste beechnuts anymore. Rutherford Platt described them as "sweet, edible, deliciously oily as though buttered," and he explained their scarcity: "Squirrels, deer, and blue jays get to them first."[18] Roasting the nuts allows the bitter skin to be rubbed off. Though absent from markets today, beechnuts were once sold in volume, ground into flour, and added to cornmeal for bread. The tree's inner bark is said to be edible, and young leaves are tasty while still soft; *Fagus grandifolia* means "edible large leaves," and *Fagus* derives from the Greek *fagito*, to eat. (By the way, Beech-Nut chewing gum has nothing to do with beechnuts.)

The bark of the eastern hemlock is dark gray, with faintly reddish or purplish tones, often tinted green by algae. As the tree grows, the conifer's protective skin—like that of most trees—dies, cracks, and expands to make room for accumulating tissue underneath. The vertical lines of fissured bark on mature hemlocks are similar to those of old-growth white pines, which often share the same terrain.

Beech bark, in contrast, is among the smoothest in North America. The beech is one of only a few species whose bark does not die and crack while expanding to accommodate growth inside, but rather grows in artistically coordinated tandem with underlying tissues. This gives beeches the irresistibly smooth surface that makes you want to touch and caress it. Or, with appeal of a different sort, beeches attract young boys wielding pocket knives and carving their initials. The vandals even extend to grown men: the inscription "D. Boone 1776," apparently still legible on a three-hundred-year-old tree in Tennessee, is thought to be an authentic living signature of the legendary frontiersman.[19]

Inside their vertically corrugated bark, hemlocks grow slowly, especially in the deep shade created by mature and domineering relatives overhead. Constrained in the understory, century-old trees might boast a hard-earned but extremely modest diameter of one inch. In contrast, fast-growing tulip poplars can bulk up with an inch of thickness per year. But a hemlock's growth can accelerate tenfold following a windstorm that takes out a big tree or two and throws the forest's shutters open to sunlight.[20] Thus an aspiring hemlock might humbly endure a staid century unnoticed, then shoot up into the canopy when an opening occurs and, over the grand sweep of time, become a giant in spite of its modest beginnings. To anthropomorphize, these trees are models of patience.

The roots of hemlocks, like shade-loving beech, maple, and birch, are shallow, thin-skinned, and therefore prone to fire damage. But fire—frequently the stand- and

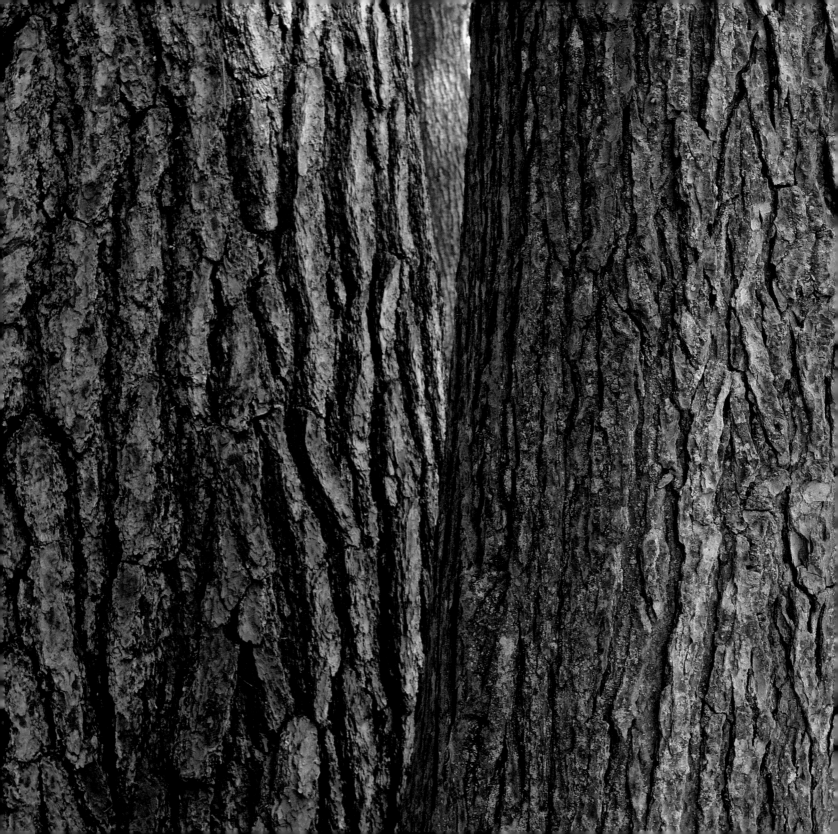

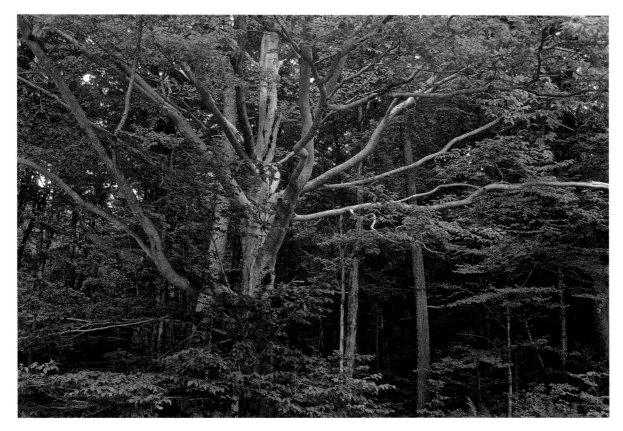

A smooth-barked beech tree shades the banks of the Clarion River in Pennsylvania.

OPPOSITE

Algae tint the golden-brown corrugated bark of a mature hemlock on the right and a white pine on the left at Alan Seeger Natural Area in central Pennsylvania.

species-replacement agent in forests—rarely occurs in hemlock groves owing to the moisture, shade, and coolness in the microclimate of the trees' own making.

Nor do snow and cold take the wintertime toll that can afflict other eastern trees. As Robert Frost whimsically recounted, hemlock limbs bend and shed their load of snow, and amenably sag, rather than break, with the weight of ice. The same flexibility has the tree's leader drooping slightly; while other conifers boast rigid tops unambiguously pointing at the sky, the hemlock leader's tentative nod makes this tree easy to spot even in an Appalachian grove's distant profile.

However, the dark foliage is covered for a time by snow, which with sunlight melts and drips to the ground. As a result, accumulated snow within a hemlock grove is typically half as deep as it is beneath hardwoods, whose bare limbs intercept and melt nominal snow. The evergreen groves thus offer shelter to deer, which abhor deep and unconsolidated snow owing to their pointed hooves, which break through, "postholing," as we say when it happens to us. The ungulates also find relative warmth in hemlock groves at night.[21] All that said, the snow that does pile up beneath hemlocks is heavily shaded and lingers into spring,

The Woods We Have Known

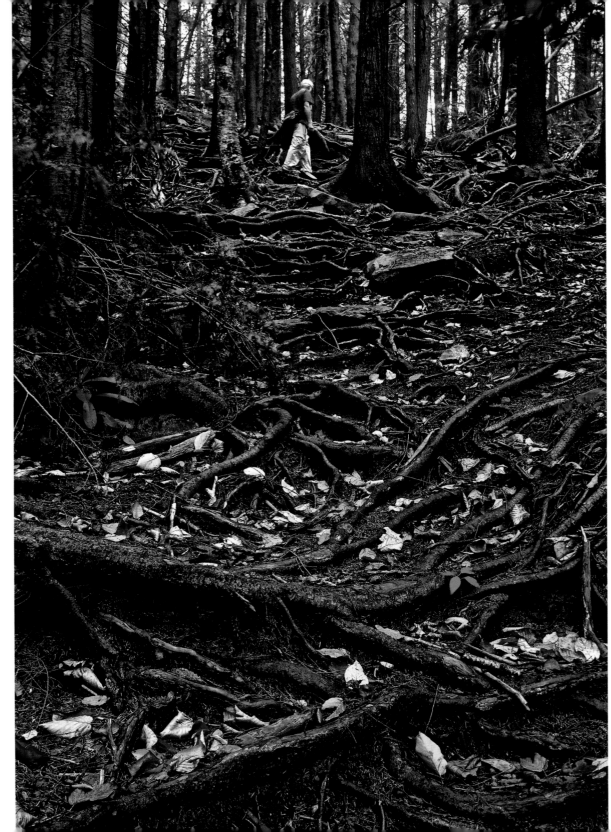

Roots of both hemlocks and beeches are shallow, and the trees are thereby prone to fire damage, drought, and windthrow, though they usually grow in pockets of topography largely protected from blazes, dryness, and storms. Here, hemlock roots mesh to create a solid carpet on steep terrain at Blackwater Falls State Park, West Virginia. A thin veneer of soil and forbs has been worn away by hikers, exposing the armorlike network of roots that guards against further erosion. Tree roots on steep slopes such as this literally hold the mountain together.

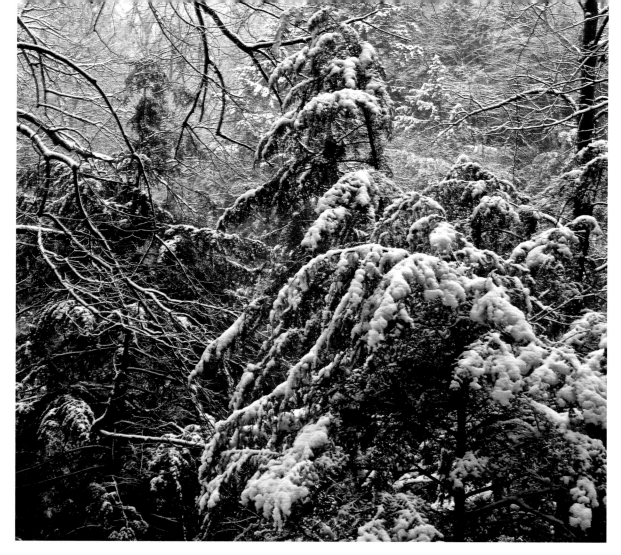

A light accumulation of snow is enough to bend hemlock boughs and tops. Rather than break as the load accumulates, they nod and soon drop their load to the ground here at McConnells Mill State Park, Pennsylvania.

extending the neighborhood's moist chill longer, which is welcome to a cadre of creatures, including trout swimming in local streams.

As another winter adaptation, hemlock needles are chemically enhanced with "antifreeze." Green with chlorophyll year-round, they're capable of photosynthesizing in the dead of winter; if the temperature barely tops freezing, they can capture light and produce

additional food in those lean months. These trees can "garden" for themselves in January without the help of a greenhouse.[22]

Having shallow roots, hemlocks are vulnerable to windthrow, which, next to adelgids, has become the most common cause of old-growth mortality in the post-logging era. Hurricanes that periodically ravage the East Coast have decimated whole groves, including

parts of Cathedral Pines in Connecticut, Cook Forest in Pennsylvania, and Swallow Falls in Maryland. However, the hemlocks' preference for sheltered, stream-bottom sites and enfolded pockets of north-facing terrain protects them from most winds.

With such effective defenses, generations of hemlocks have followed one another in continuous cover since before colonial times, and some groves may date back a remarkable two thousand years, according to ecologist Margaret Davis and others.[23] And even longer: David Orwig of the Harvard Forest showed me rare vernal ponds where researchers have unearthed pollen sediment indicating uninterrupted occupation by hemlocks for an astounding nine thousand years.

Going back even further in time, the last continental glacier peaked more than eighteen thousand years ago, obliterating all forests in its southbound path to the limits of meltwater outwash in southern New York and northern Pennsylvania, and westward in an uneven line extending to northern Iowa. Treeless hills, mountains, and plains stretched south from the glacial front as tundra not unlike that found in Alaska today. When the climate warmed and the ice receded, newly exposed barrens were colonized by mosses on glacial grit and then on a thin but deepening layer of windblown soil called loess. Boreal forest took root, and remnants of it still cling to cool, high Appalachian ridges as thickets of spruce and balsam fir. Then came larches, birches, and white pines, followed by hemlocks. This conifer's seeds rarely fall more than a hundred feet from their source, and so the hemlocks crept northward slowly, covering only nine hundred miles in five thousand years, arriving in New England about ten thousand years ago.

In evolutionary terms, the beech was more tropical.[24] Less inclined to spread north, it trailed the hemlock by two thousand years, but eventually caught up.[25] The shade tolerance of both species enabled them to infiltrate existing forests that faster-advancing trees had already established. Curiously, pollen records indicate that before continental glaciers, beeches ranged across the North American continent but recolonized only in the East; increasing western aridity roadblocked the moisture-loving trees at the Great Plains.

Intriguing core samples of mud taken from lakebeds contain pollen that indicates a near-complete die-off of well-established hemlocks fifty-five hundred years ago. Ecologist Wyatt Oswald and colleagues attribute this to a cooler climate and drought, possibly coupled with insect or pathogen outbreaks.[26] Through a hiatus lasting fifteen hundred years, local and disjunctive populations of hemlocks survived, and from those remnants the forests began to recover, growing once again into the striking and abundant groves that European settlers encountered.

While we now face new and widespread attrition of hemlocks succumbing to adelgid, the good news hidden in the ancient pollen cores is that the species was capable of recovering from a drastic reduction in the past.

The bad news is that it took two thousand years.

In more recent prehistory, the Mohawk called the hemlock "onen'ta'onwe," according to Kerry Hardy in *Notes on a Lost Flute.* Cambium was used as a base for breads and soups, or mixed with dried fruit and fat to make pemmican. Throughout the hemlock's range, native peoples used these trees for tanning hides,

making baskets and tools, and as medicine to treat many ailments.[27]

With his crew suffering from scurvy and disaster at hand, the French explorer Jacques Cartier, at the site of Quebec City, asked the Iroquois tribe under a chief named Donnacona for help and was promptly given tea brewed from evergreen needles. It had an astonishingly rapid healing effect, according to Cartier's journals. That particular tribe called the tree *annedda*, and debate continues regarding which species it was. Some references point to white cedar. However, according to Glen Blouin's writing on the medicinal uses of trees, etymological evidence points to eastern hemlock as Cartier's "tree of life." Blouin further credits the Frenchman's 1536 account as the "first documented use of indigenous North American medicine."[28]

In a pitiful and shameful epilogue to this story, Cartier later enticed Donnacona aboard ship, weighed anchor, and sailed back to France, hoping the chief's testimony about New World wealth would leverage support from the king for another exploratory voyage. The generous chief died there, a victim of the explorer's fund-raising attempt.

Scurvy cure or not, hemlock tea is high in vitamin C, and settlers commonly steeped the needles and bark. Some accounts say they named the tree after poison hemlock because the crushed foliage smelled like the plant of Socrates's demise. E. D. Merrill of the Arnold Arboretum, however, astutely reported that the tree was thought to be a spruce, and because its finely textured foliage vaguely (very vaguely) resembled poison hemlock, it was called "hemlock spruce." Botanists later determined that our tree was not a spruce, but the former adjective "hemlock" morphed into a noun.[29]

Coming later, the genus's scientific name, *Tsuga*, is Japanese and means "mother tree,"[30] an etymology one might embrace for any number of reasons.

Early settlers did not seek out the hemlock for lumber as they did white pine, oak, and ash trees. Hemlock's stone-hard knots chipped metal saw blades, and the coarse grain was prone to ring shake—a structurally irksome separation lengthwise along growth rings. When used for fuel, hemlock spits annoyingly, and can throw sparks from an open fireplace, putting homes at risk. Yet tall, straight, workable, and plentiful on the frontier, the wood was widely used as barn siding. Natural tannin preserved the boards in humid environments, and to this day hemlock siding can be seen in the increasingly rare but picturesque golden-brown hay barns of enduring farmsteads. The wood was also used for boxes and, as industry belched its acrid way across the Appalachians, for railroad ties because it was thick enough for the requisite seven-by-nine-inch timbers and held spikes well.[31]

The hemlock's comparatively low status as lumber did not prevent its brutal exploitation. The leather business boomed as Americans walked in leather shoes, rode on leather saddles, and crafted all manner of leather strapping, padding, and upholstering. Hemlock bark, with 7 to 12 percent of its weight in tannin, became a choice resource, and hungry bark hunters gleaned up to a ton from a single tree from 1820 to the turn of the century. They felled and skinned every hemlock they could find, often leaving the logs to rot.[32] Synthetic tanning started after 1900, but, without reprieve, remaining hemlocks were hauled to pulp mills for newsprint even though the tree's fibers were second-rate because of their shortness.

Like many natural resources, hemlocks followed the familiar path from extreme abundance, to exploitation, to utter scarcity, though this fate was not inevitable. Knowing the value of woodlands, Pennsylvania's founder, William Penn, had presciently called for the preservation of one in four acres of his estate as forest. But this edict—like other communal reforms thought out by the socially conscious Quaker—was blithely ignored by the loggers and businessmen of the day.[33] At the peak of Pennsylvania logging in the 1890s, hemlock yielded more than 1 billion board feet per year as an industrial crop.

Like hemlock, beech was not as desired for lumber as white pine, oak, and ash were, but it was good for turning on lathes and steam bending. Heavy, hard, and tough, it was used for flooring, containers, furniture, veneer, and tool handles. As fuel, it burned hot. Where beeches grew plentifully, settlers recognized them as indicators of fertile limestone soils—a prompt to girdle or cut the trees down and clear the way for corn and pasture without even using the wood.

Tracts shorn of their forests were left to burn, either deliberately or accidentally from the sparks of coal-fired locomotives or carelessness, which dried out the soil, making it especially difficult for hemlocks to regenerate. This, along with the readiness of hardwoods and white pines to thrive in full sun, meant that few of the cutover hemlock stands regrew. Further retarding recovery, clear-cutting and fires eliminated available nurse logs, and then deer, in growing numbers among hardwood seedlings, browsed young hemlocks as fast as they appeared. Of the East's original 950 million acres of all types of trees, only 1.5 million acres were spared from cutting between the *Mayflower*'s landing and today,[34]

and the proportion of the original hemlock and beech forest that was cut was probably similar. Pennsylvania State Parks reports that old growth covering 99 percent of the state 250 years ago was reduced to less than 0.1 percent today—one tree in a thousand.

However, with the reduction of logging and the protection of scattered tracts as parks—set aside especially in gorge settings—hemlock and beech forests eventually began to recover, and notable groves became highlights of our public woodlands estate as the 1900s advanced. The aesthetic appeal of hemlocks, in fact, was probably why many of our eastern parks were protected— McConnells Mill in Pennsylvania, Watkins Glen in New York, and Hocking Hills in Ohio, to name a few. In the modern era, these trees have also been among the most desired evergreens for planting as hedges, screens, or garden accents. Though it seems like pathetic underuse, hemlocks in recent years have been logged for chipping as commercial landscaping mulch because of the wood's acid content.

In modern times, beeches likewise have been ranked among the best shade tree ornamentals, and until recently were considered as "pest- and disease-free as any tree you are likely to find," according to Robert Lemmon. He praised the beech as "sturdy refinement personified." In *North American Trees*, Gerald Jonas credits beeches as "spectacular shade and specimen trees."[35]

Of rising importance today, carbon is stored in live hemlocks and beeches, where it's sequestered in solid form instead of rotting or burning into carbon dioxide— global warming's principal "greenhouse" gas. The deep crust of needles constituting hemlock soil is likewise packed with carbon. Forest losses worldwide account for 15 percent of greenhouse gas emissions, second only

to the burning of fossil fuels. Hemlock trees typically live longer than hardwoods and rot more slowly, making their carbon storage more enduring. Ecologist Aaron Ellison points out that standing hemlocks represent a long-lasting reservoir of carbon; when eliminated, a full century is required for the regrowing forest to match today's level of sequestration.[36]

Vital as they are to us, the highest importance of hemlocks and beeches may be their value to other species. Special conditions that hemlocks impose benefit specific plants and animals. Understories include rhododendron, witch hazel, Canada mayflower, partridgeberry, viburnums, ferns, and club mosses. In Shenandoah National Park, four rare plants live under hemlocks: speckled alder, American fly honeysuckle, alderleaf buckthorn, and finely nerved sedge. The park's biologist recognized that "there is no other tree that can fill the functional niche of hemlock."[37] Though they generally do not grow beneath a closed canopy of hemlocks, other trees are scattered throughout an emerging hemlock forest: white pine, red oak, sugar maple, and yellow birch. Beech trees grow in dense hemlock groves and also among oaks, hickories, ashes, birches, sugar maples, black cherries, spruces, and balsam firs, while in the South they associate with sweetgums, southern magnolias, ashes, and oaks.

Forty-seven mammal species use hemlock forests, and ten of them strongly favor hemlocks for shelter or food.[38] Deer and snowshoe hares browse foliage. Porcupines eat the bark. The rare fisher dens in old hemlock and beech trees.[39]

The fat content of beechnuts is five times that of corn, and they have twice the protein of acorns. They are prime food for bears, deer, martens, fishers, porcupines, raccoons, foxes, cottontail rabbits, squirrels, and smaller mammals.[40] Production of this nut crop, or "mast," is episodic—fruitful in some years but not others, and tending to be heavy every sixth or eighth autumn. When beeches produce well, oaks might not, and vice versa, so wildlife depends on both.[41] Red-backed salamanders are common in leaf litter beneath beeches, and red efts (newts) live under fallen wood.

Ninety-six bird species use hemlock-beech forests.[42] Hemlocks alone are important for Acadian flycatchers, black-throated green warblers, and uncommon Blackburnian warblers.[43] Hemlock seeds are eaten by crossbills, juncos, pine siskins, and other birds in winter. Beechnuts are eaten by turkeys, grouse, wood ducks, and blue jays, whose caching disperses the seeds far beyond the trees' unaided ability. Researcher David Houston told me that he has many times watched a raucous jay pick a beechnut from high in the canopy, tap it to get a staccato "click," indicating viability, and proceed to gather twelve more seeds in its expandable throat. Then it would fly to an evergreen, a large rock, or some other memorable feature that's recognizable in winter, drop the seeds in a pile, and proceed to bury them one by one beneath leaf litter—ideal conditions for germination next spring. The jays return to eat some but not all of the cached and "planted" seeds.

As a lamentable footnote to wildlife history, the widespread cutting of beeches in the nineteenth century contributed to the passenger pigeon's extinction. The fatty nuts were staples for the legendary flocks that migrated in sky-darkening numbers. In "The Causes of Extinction of the Passenger Pigeon," E. H. Bucher argued that the felling of beech trees to clear farmland, and the resulting dearth of nuts, may alone have been sufficient

to bring about the pigeon's unparalleled demise.[44] Donald Culross Peattie reflected eloquently on the dual decline of the passenger pigeon and the beech. "So together they fell, bird and tree, from their supreme place in the history of American Nature. For after the Beech forests were swept away by the man with axe and plow, the fate of the passenger pigeon . . . was sealed. As much by the disappearance of Beech mast as by mass slaughter were the shining flocks driven to extinction." Peattie noted that in America's classic portfolio of bird paintings, John James Audubon chose to perch the passenger on a beech limb, bird and tree immortalized together as we will never see again.[45]

Hemlocks have served not just creatures on the ground and birds in the air but also fish in the streams. Evergreen shade keeps water cooler than deciduous trees can do. Having needles enameled in gloss, hemlocks also transpire less water in summer, resulting in higher stream flows than are found in comparable creeks through hardwood forests. Birches, which typically replace hemlocks, use 15 percent more water.[46] With their dense canopy and spongelike detritus in the root zone, hemlock groves also absorb runoff and buffer peak flood flows.[47]

Preferring the coolness and steadier runoff of the conifer-shaded streams, colorful native brook trout were once called "hemlock" trout. Craig Snyder and other researchers found them four times more abundant in hemlock streams than in others.[48] Though important to the trout and some other wildlife species, the same streams are relatively poor in total productivity of biomass because shady conditions reduce algal production, limiting food for freshwater invertebrates critical to the food chain.[49]

Likewise, while certain aquatic and terrestrial species depend on the hemlock forest, its overall biological diversity compared to many deciduous forests is low owing to shade, acidic soil, and the domineering presence of hemlocks and beeches. Although diversity has become the holy grail of ecological assessment, ecologists David Foster and Aaron Ellison maintain that hemlocks are even more important as a "foundation" species, defined as "an abundant plant or animal that controls the characteristics of an ecosystem and exerts far greater influence than its simple numbers may imply."[50] Foundation species "create, define, and maintain entire ecological systems."[51]

These scientists also point out that, biological diversity aside, hemlocks maintain *landscape* diversity: while a typical view in the East shows a vast expanse of broad-leaved trees, hemlock groves and the life they support stand out as exceptional—islands of conifers in a sea of deciduous forest.

Wanting to see them and their distinctive communities of life, I set out to photograph these stunning but imperiled trees from Canada to the Gulf of Mexico.

Linn Run in Pennsylvania benefits from hemlock shade that keeps the stream cool for aquatic life, including native brook trout—so closely associated with these sites that they were once called "hemlock" trout. Thousands of Appalachian streams enjoy the chill of perpetual hemlock shade but now face the menacing dual hazards of global warming and the loss of their hemlocks to the woolly adelgid.

Twilight of the Hemlocks and Beeches

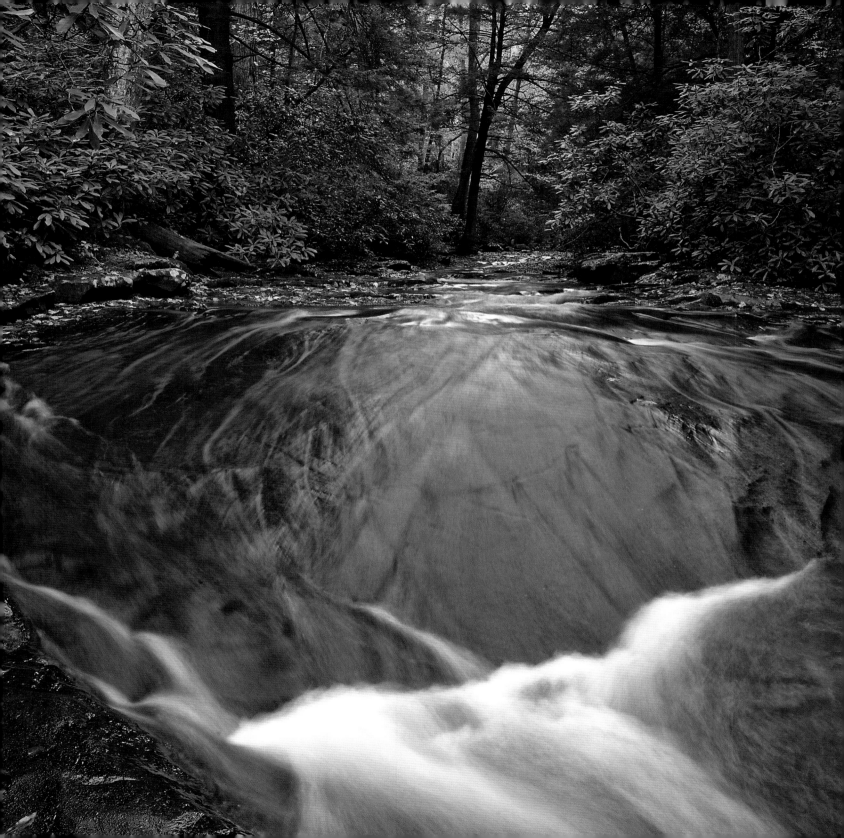

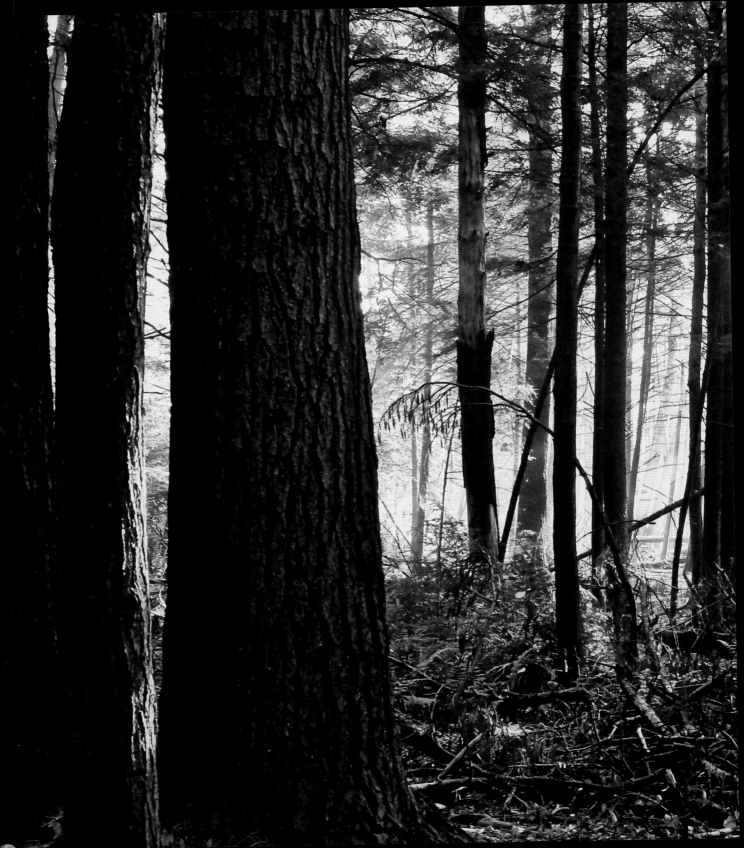

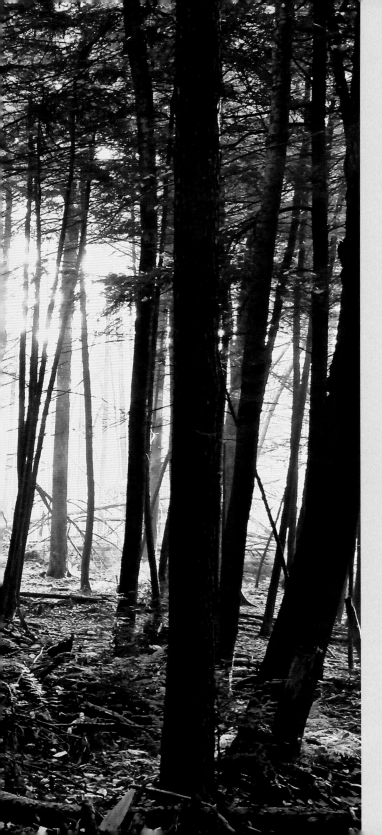

Chapter Three
Visions of Hemlocks and Beeches

Wanting to see hemlocks and beeches in the elegant but fading glory of their time, I started in the wooded heartland of my native Pennsylvania and journeyed out to other valleys and mountains in twenty states to photograph the most striking of these great trees before they are gone.

I traveled to renowned groves in national and state parks and also to unknown Appalachian hollows. I worked ahead of the pests' and pathogens' fatal line of advance, often recording pictures of trees that were infected but still impressive in their grip on life.

I missed some of the best, such as the venerated hemlock bottoms of Ramsey's Draft, northwest of Staunton, Virginia—nothing but dead snags when I arrived in 2008. Likewise, the hemlocks of Sweet Root Natural Area in central Pennsylvania—once magnificent, now gone. The sculptured giants I remembered seeing in Shenandoah National Park's White Oak Canyon, when I hitchhiked there as a teenager in 1966, were moldy mounds of dirt when I returned with my camera. Great trees, but all dead or dying, lined the Chattooga River of Georgia and South Carolina in 2016. Most of the great beech groves of New England were reduced to thickets of sprouts when I toured there in recent years. The

Hemlocks at sunrise, Swallow Falls State Park, Maryland.

impressively robust old beeches of northern Pennsylvania were mostly a memory, their wreckage rotting on the ground. In 2013, I encountered the waxy whitewash of *Cryptococcus* as far west as Grand Island, Michigan, where beeches on borrowed time overlooked the oceanic Lake Superior at the far northwestern limits of their range.

But beyond the pathogens' advancing fronts, I found hemlocks and beeches thriving with vigor that I stubbornly wanted to believe would last. I wanted them to live! Denial comes in many forms, including a seductive disguise called hope. Yet I knew better, and I took pictures as a farewell gesture.

Though I searched principally for only two species of trees, the possibilities and the varieties of views proved endless. With my camera, I aimed to record these forests within the context of their assorted terrains, their intricate ecology, their contrasting seasons, and their daily moods of weather. I wanted to see the trees in all their individual splendor of forms and shapes, of colors and textures in trunks, limbs, and leaves, all continuously variable.

Not the least of my photographic challenges: it's difficult to see the trees for the forests. An undisciplined camera makes little recognizable sense out of the bewildering complexity that characterizes the eastern woods. So I looked for telling details that would "read" on the printed page. I waited for luminous moments as the sun beamed through a gap in the canopy to strike and warm a chosen hemlock or beech. I looked for patterns: a row of sturdy trunks here, a bouquet of backlit leaves there. I tramped the woods in springtime's bloom, summer's growth, autumn's gold, winter's chill of white. I searched for new perspectives—from the ground, from climbable branches, from hillsides, from cliff tops.

Hemlocks presented a special photographic challenge because their needles are so fine that they blur together from even modest distances, turning foliage into a single green mass. Their darkness often worked best artistically as a background to the brighter beech, the jagged edges of rock, or the soft flow of a stream bubbling at the roots.

A nagging problem in photographing tall trees is that I found myself always looking up. Of course! It's inevitable, yet it's troublesome because perspectives are skewed, the tops of trees disappear beyond the lower shield of foliage, and, worse, a white sky in the tree's background creates glare that underexposes what I want to show. I found one solution by using a mild telephoto lens and standing far enough back from the tree to look straight ahead rather than acutely up, undergrowth permitting. I also sought forests hidden in deep gorges—the classic lairs of hemlocks—where I could look straight across the gulf to the heights of trees on the other side.

While the woolly adelgid and beech disease had already killed many trees and afflicted many more, I've included only a few photos of those problems. One or two are enough to show the grim outcome. The portfolio here is not intended to document that unfolding tragedy, but rather to celebrate what remains unafflicted, to document what these trees have been, and to forecast what they might someday again become in the centuries ahead.

By the time this book is published, some of the trees that I photographed will have died, their habitat morphing to a new forest of black and yellow birches and also sugar maples, red maples, and white pines. Those new woodlands will be valuable and nourishing, but they'll lack the special essence of life and beauty found only with the hemlocks and beeches that I set out to capture in the photos that follow.

Visions of Hemlocks and Beeches

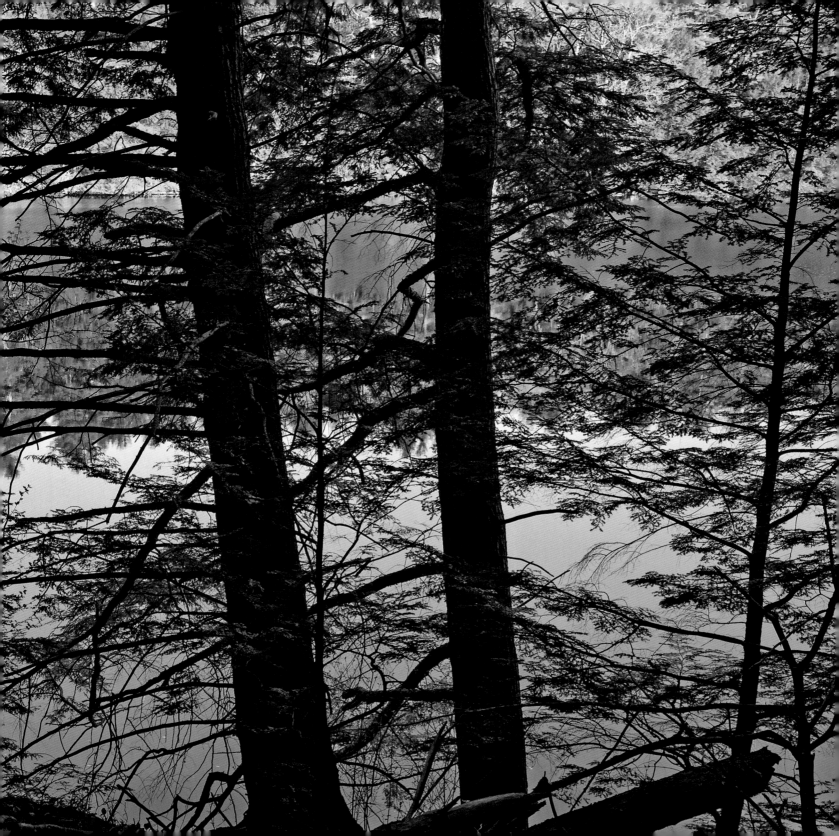

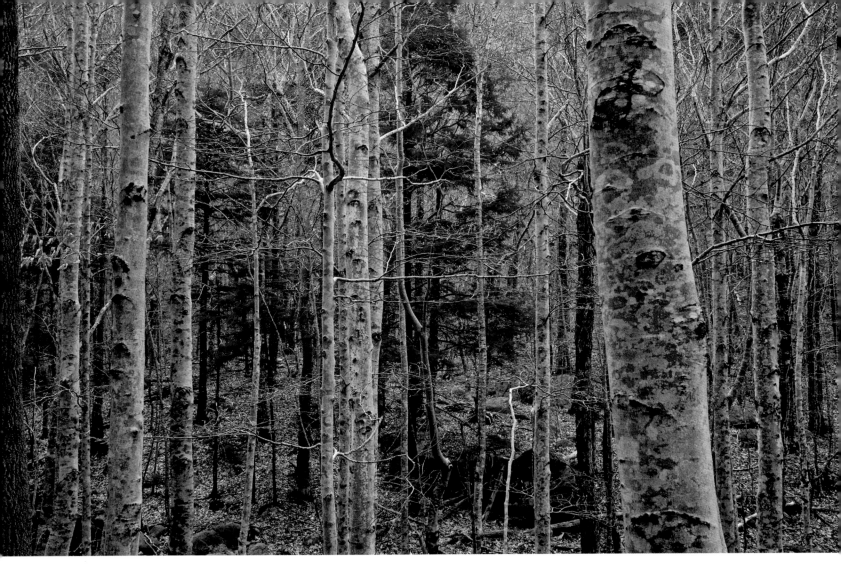

OPPOSITE Hemlocks at the northern reaches of their range in Maine grow especially well near the temperate coast, such as here at Vaughan Woods Memorial State Park along the Salmon Falls River. Woolly adelgids also do well in the temperate climate along the coast of Maine. These trees are kept alive with insecticides.

ABOVE Within an elegant beech forest, a few hemlocks rise along the trail to Jordan Pond, Acadia National Park, Maine.

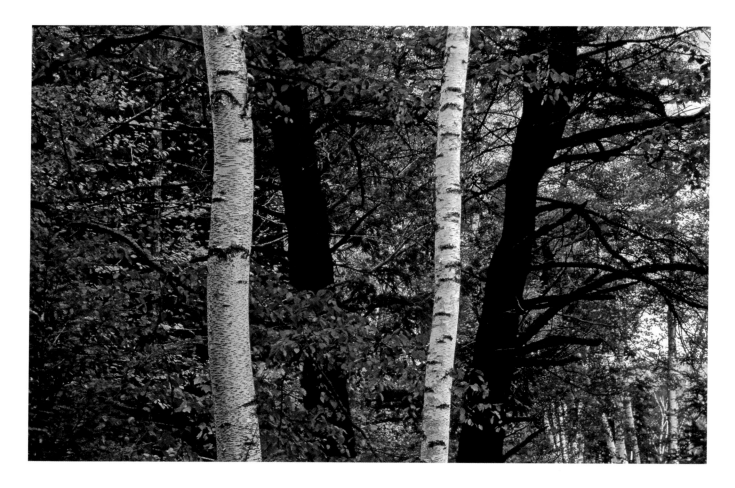

ABOVE *In the White Mountains near Gorham, New Hampshire, the bold silhouettes of two hemlocks contrast vividly with the white bark of paper birch and the crimson leaves of red maples peaking in autumn color.*

OPPOSITE *Hemlocks shade the banks of the East Branch of the Pemigewasset River east of Lincoln, New Hampshire, and provide an important ecosystem service by keeping the water cold.*

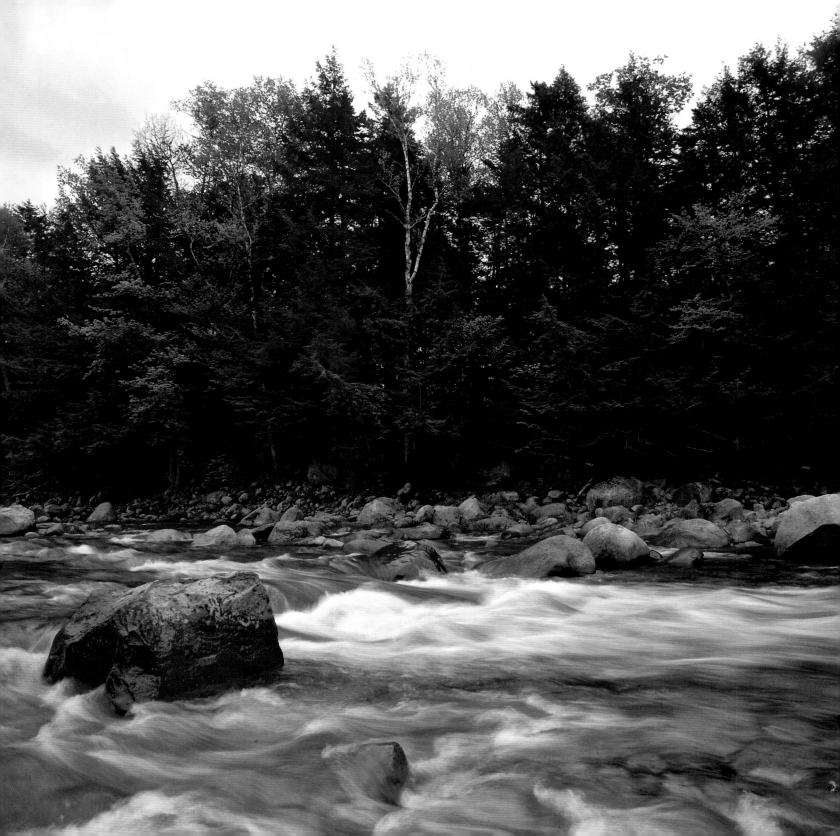

BELOW *Vermont's Williams Woods is a sequestered tract of old-growth forest with three-hundred-year-old hemlocks near the shore of Lake Champlain.*

OPPOSITE *Along the West Branch of the Farmington River in Massachusetts, beech leaves turn orange and bronze in late autumn, with a hemlock on the left.*

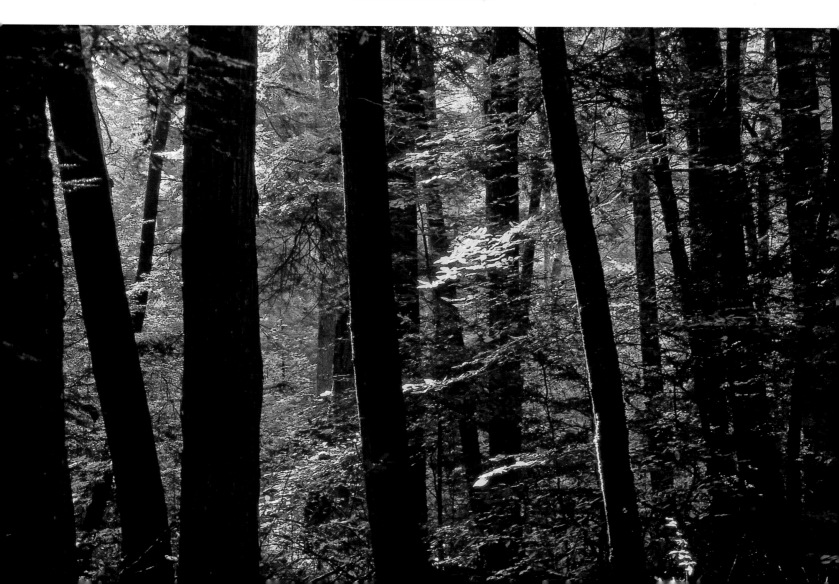

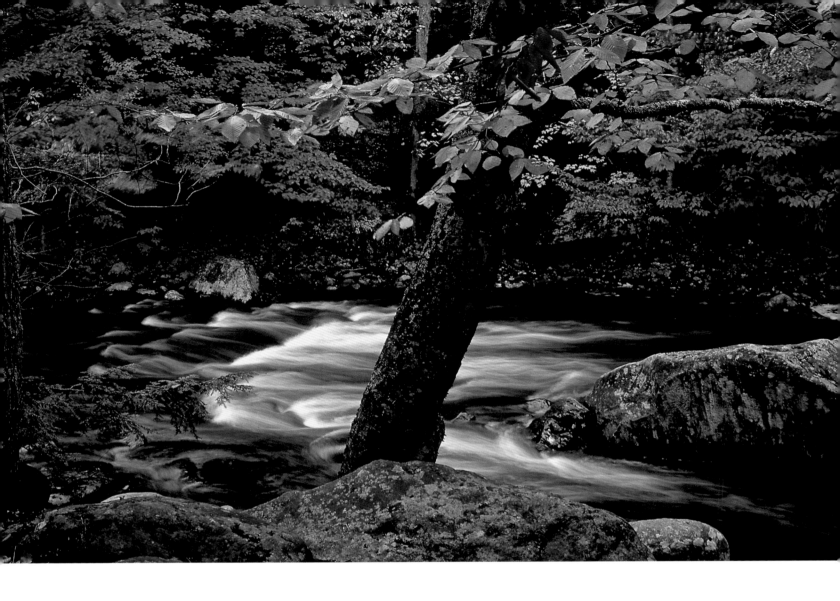

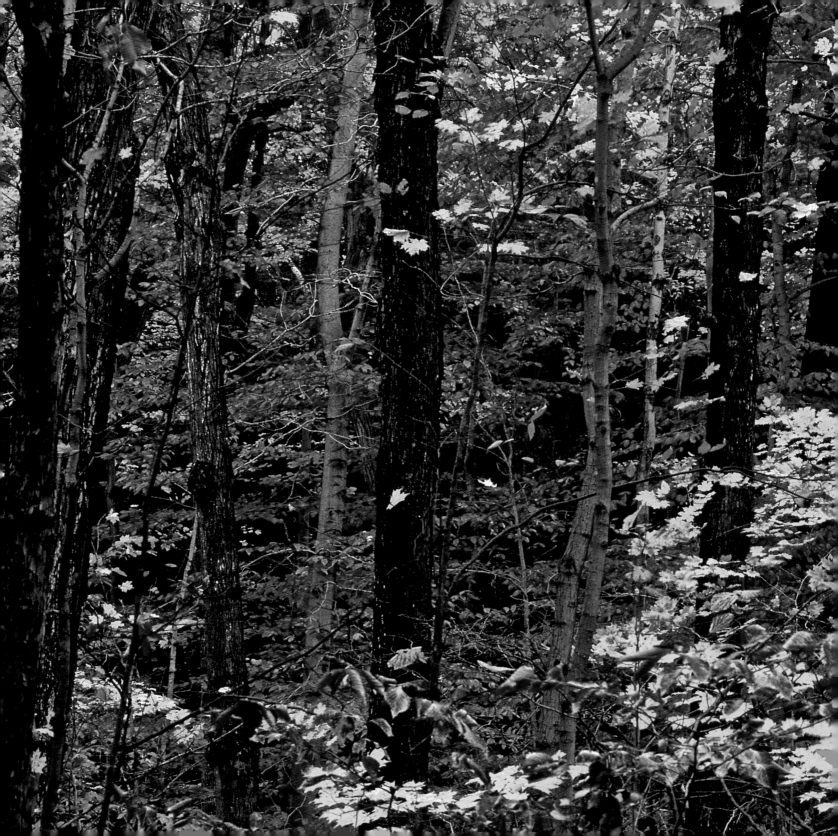

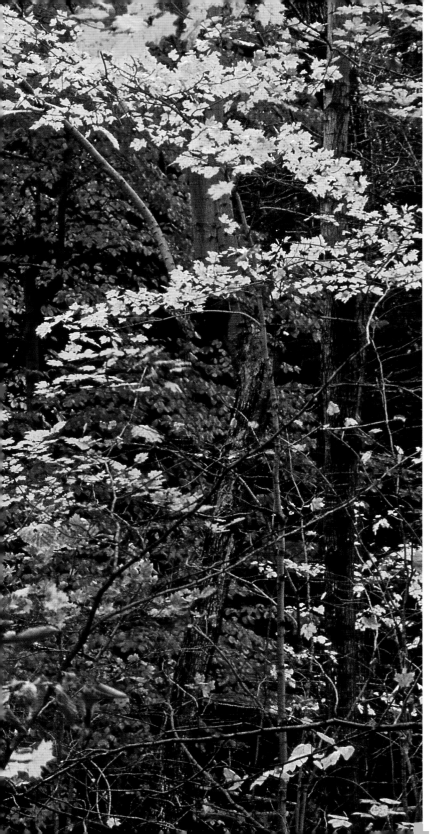

Beeches in dark orange fill the understory with brighter-leaved sugar maples, together creating an array of autumn gold at Talcott Mountain State Park, Connecticut.

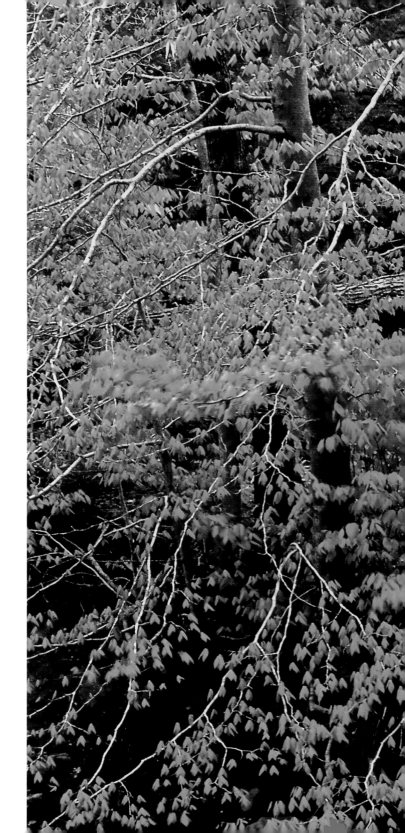

Springtime's juicy green beech leaves have unfurled at Bent of the River Audubon Center near Southbury, Connecticut.

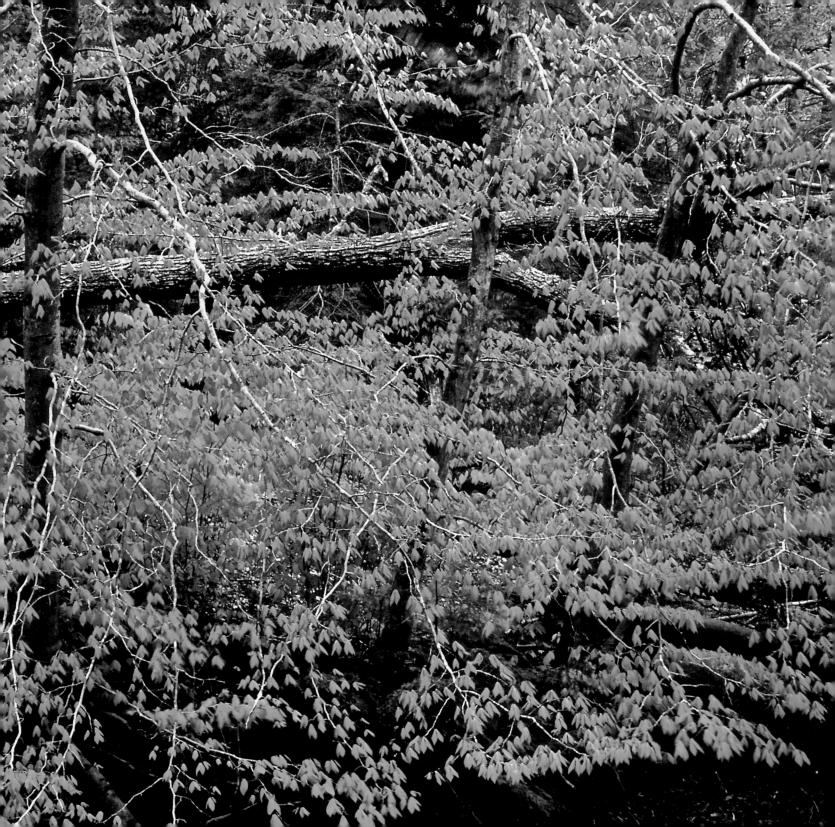

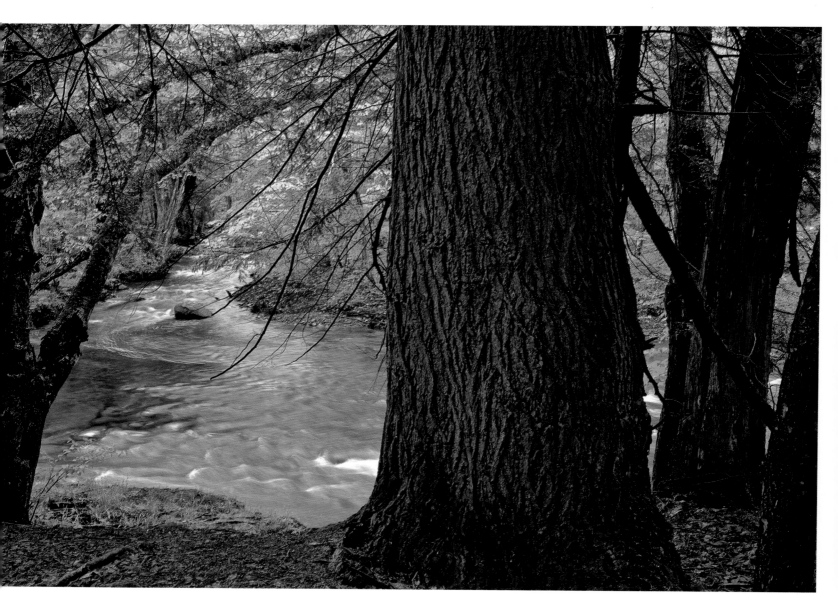

A great hemlock rises over the Willimantic River in central Connecticut, shading its waters and keeping them cool for trout and other aquatic life.

Renowned for cascading falls and flumes of whitewater,
Watkins Glen in New York also showcases old-growth
hemlocks, now treated with pesticides to repress adelgids until
longer-term biological controls might take effect.

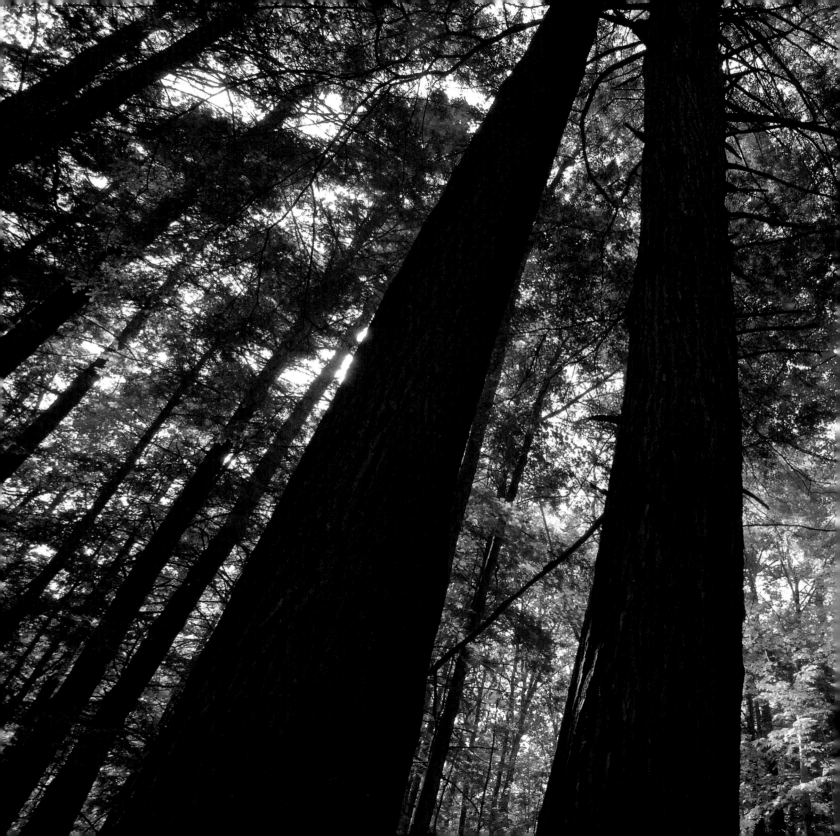

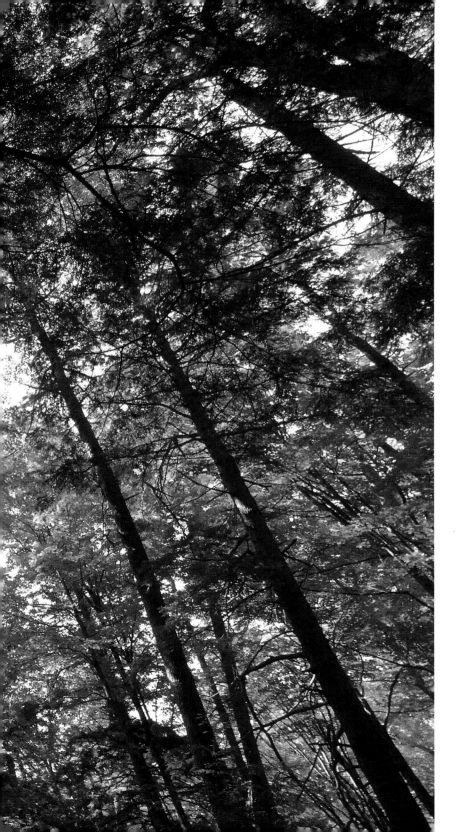

Hemlocks tower at the Nature Conservancy's Lisha Kill Natural Area, just north of Schenectady, New York.

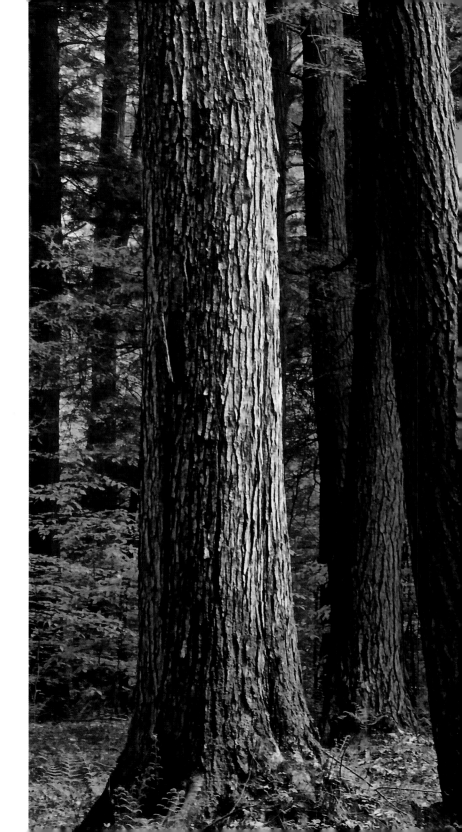

*One of the finer old-growth hemlock groves in the East lies
protected in Allegany State Park in western New York. Here, a
young beech catches precious rays of sunlight penetrating the
shade of the ancient forest.*

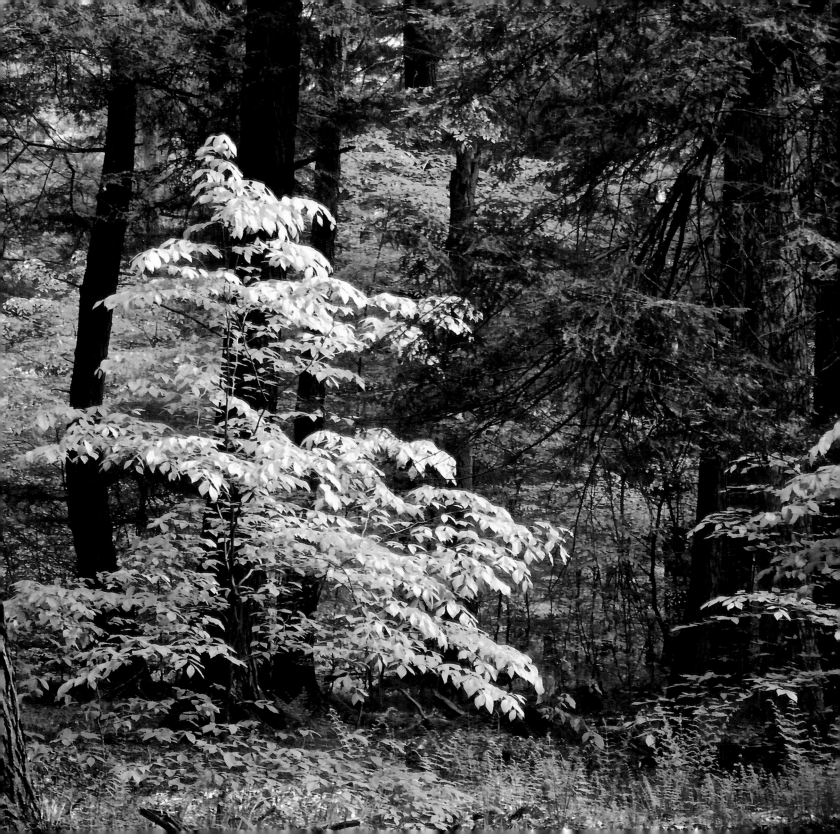

The trees in Allegany State Park are reminiscent of six million acres of hemlocks and northern hardwoods that once stretched virtually unbroken across the Appalachian Plateau of southern New York and northern Pennsylvania. Total logging in the late 1800s was followed with heavy fragmentation by farms, roads, gas pipelines, rural development, and strip mines. Re-wilding enclaves like this one are now recovering in what was earlier called the "black forest" for the darkness of its hemlocks.

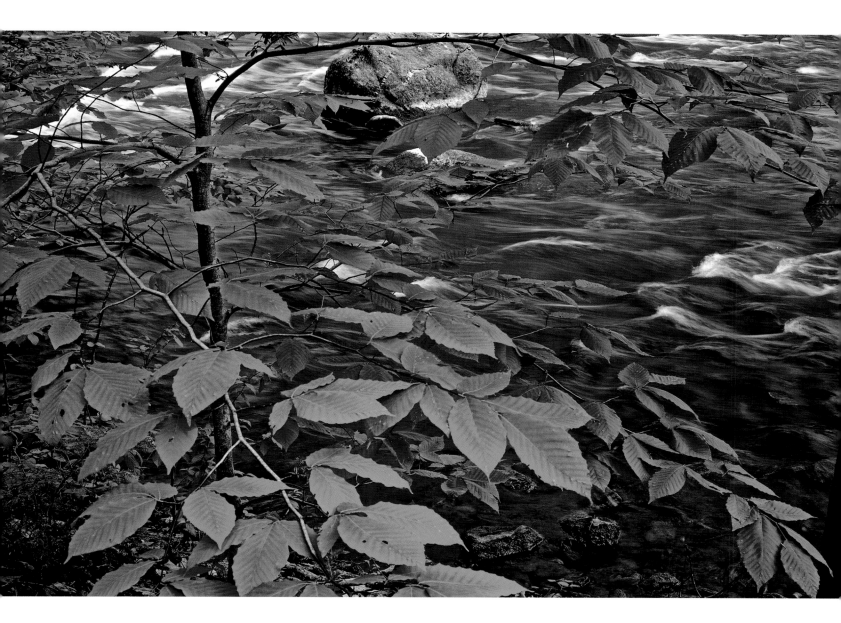

A young beech grows in cool downdrafts of the Musconetcong River in northern New Jersey—a gem of nature at the doorstep of the eastern megalopolis.

OPPOSITE *Old beeches shade the Raritan River north of High Bridge, New Jersey.*

ABOVE *A beam of morning sun penetrates the hemlock forest at Salt Springs State Park, north of Montrose, Pennsylvania.*

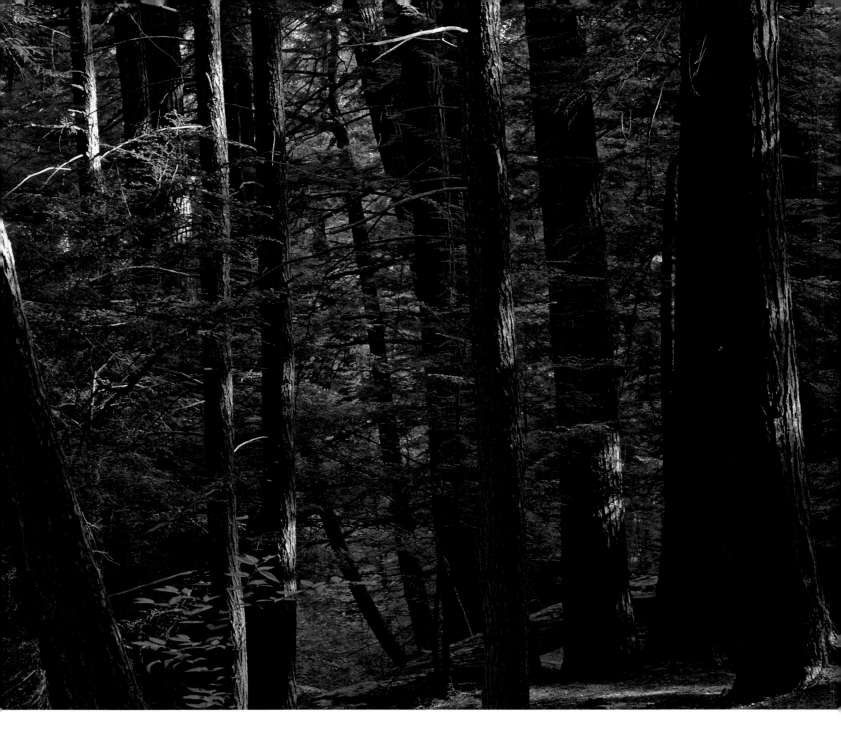

In a region with growing adelgid damage, hemlocks see only
scattered light at Salt Springs State Park, Pennsylvania.

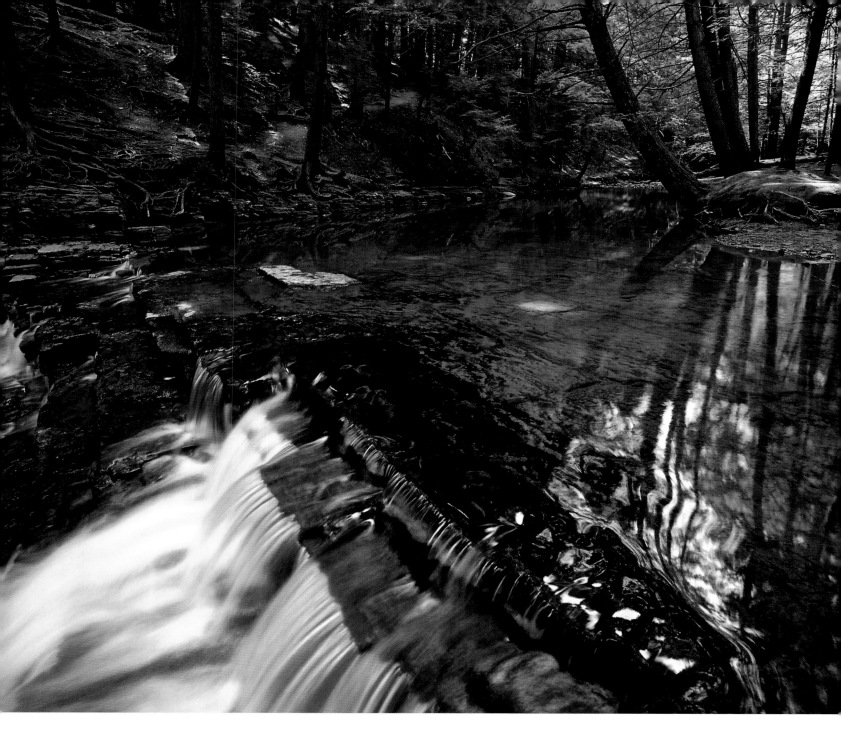

Fall Brook is kept cool by the shade of hemlocks at Salt Springs State Park.

BELOW *Hay-scented ferns brighten the ground beneath hemlocks at the Nature Conservancy's Woodbourne Preserve, south of Montrose, Pennsylvania.*

OPPOSITE *Hemlocks claim cool, shaded, recessed topography in a waterfall-accented ravine perched above Pine Creek, north-central Pennsylvania.*

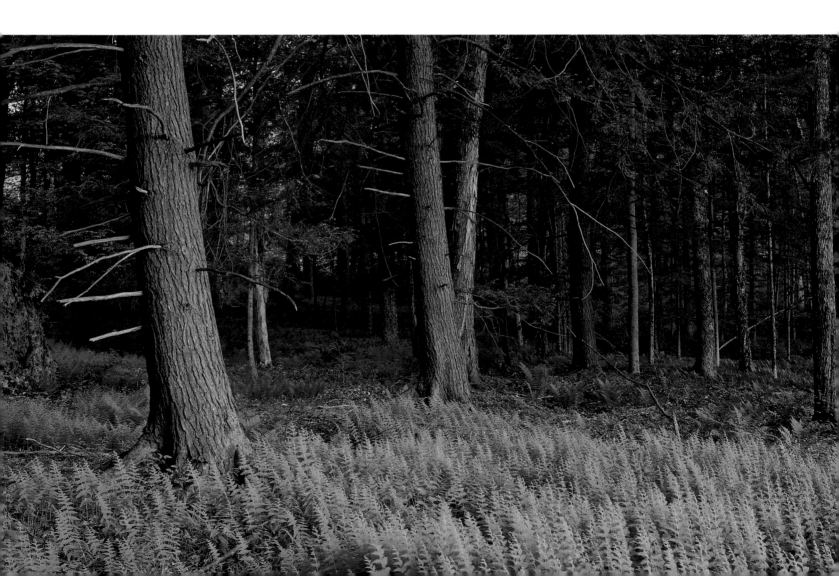

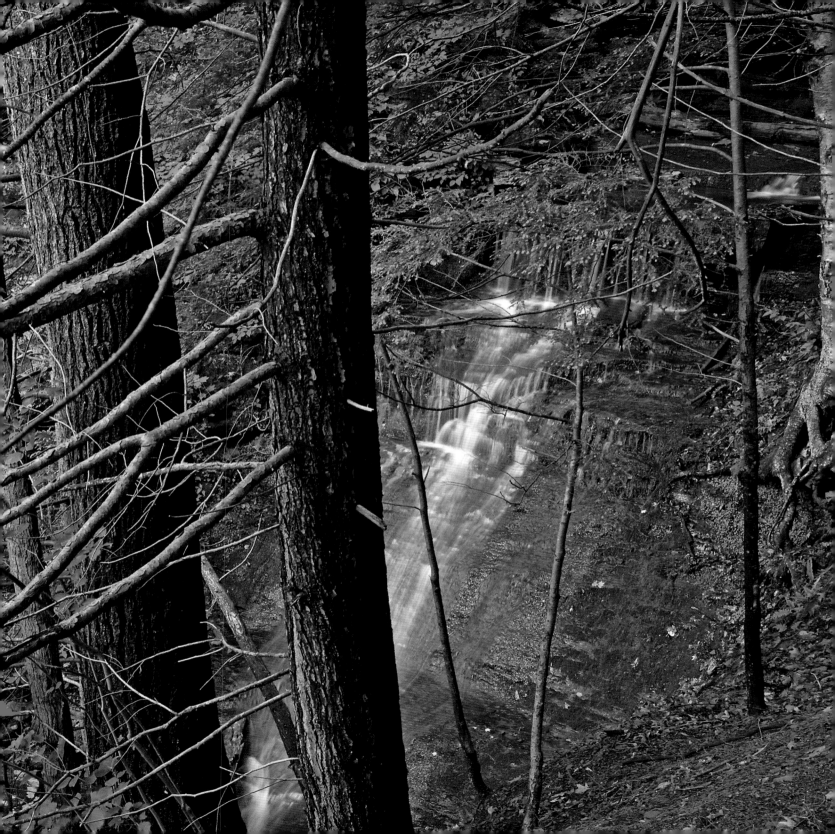

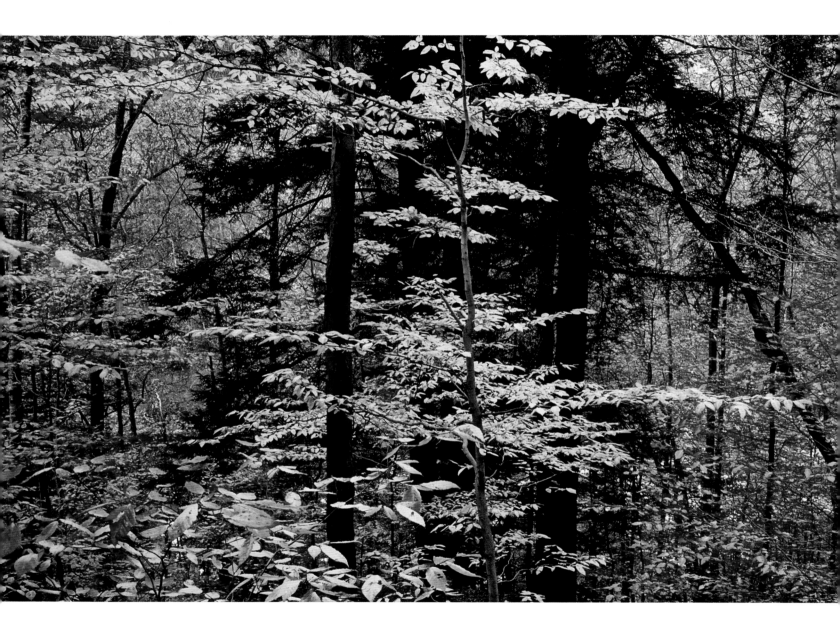

The rich green of hemlocks contrasts with the autumn
brilliance of younger beeches in Worlds End State Park, north-
central Pennsylvania.

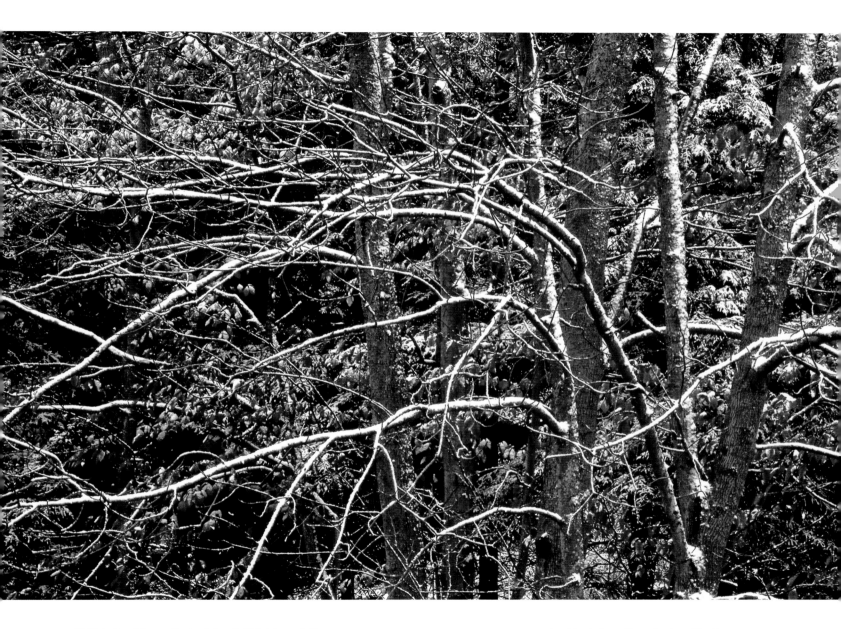

Well into the winter months, beech trees hold their leaves in the Lycoming Creek headwaters of northern Pennsylvania.

OVERLEAF *Aged hemlocks are the centerpiece of the Alan Seeger Natural Area, a 390-acre Pennsylvania parcel bypassed by loggers in the nineteenth century. Some trees there are being treated to counter adelgid infestations.*

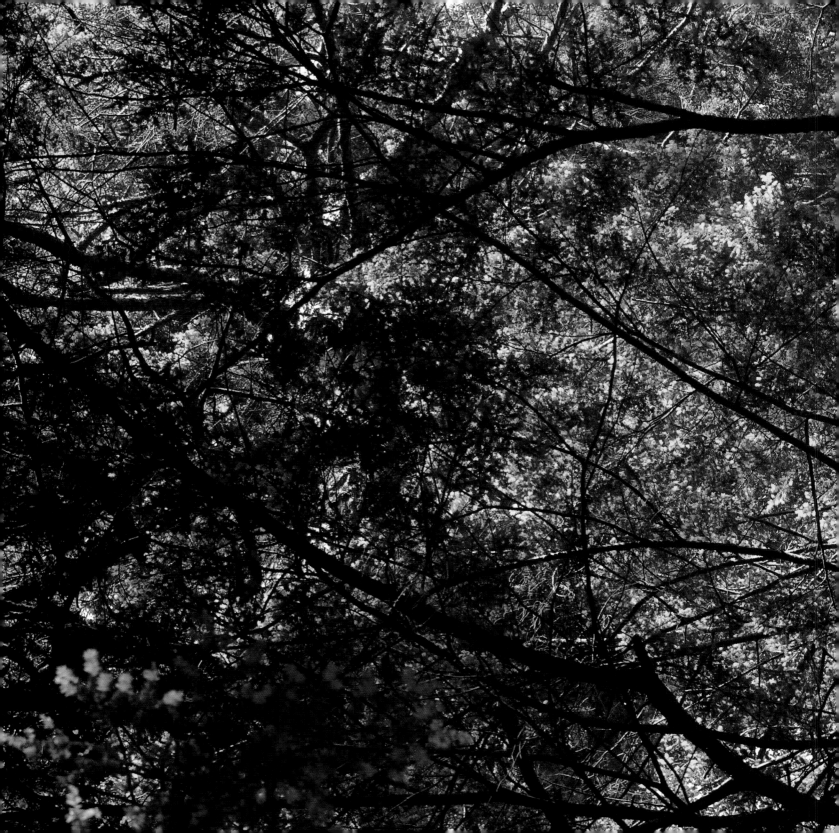

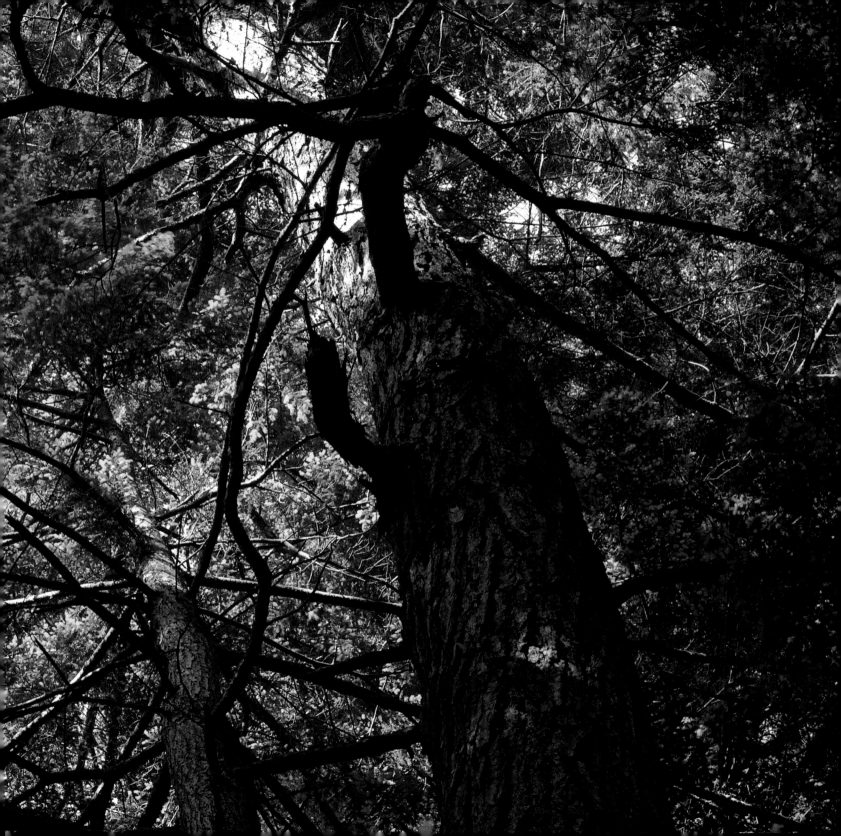

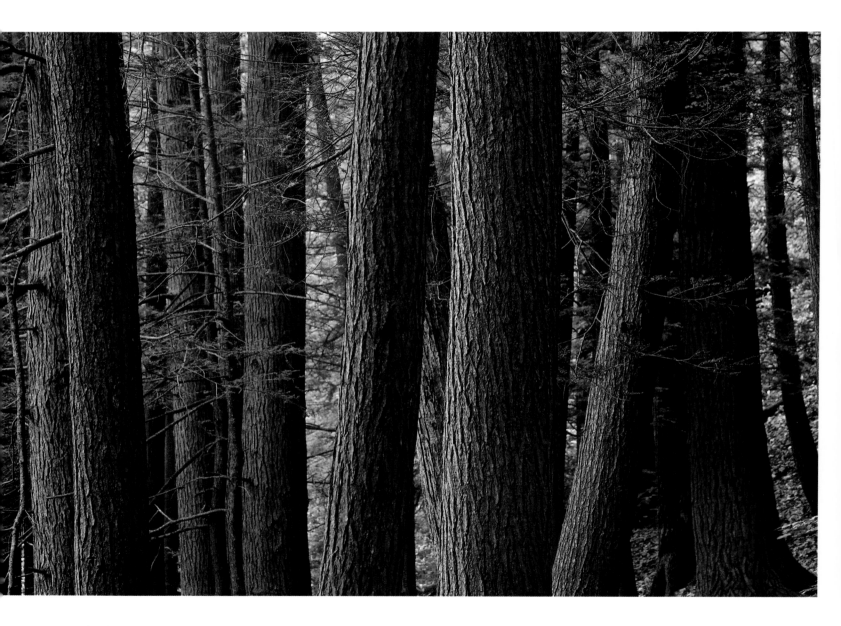

These hemlocks survive at Alan Seeger Natural Area, though part of the extraordinary grove has been decimated by the adelgid.

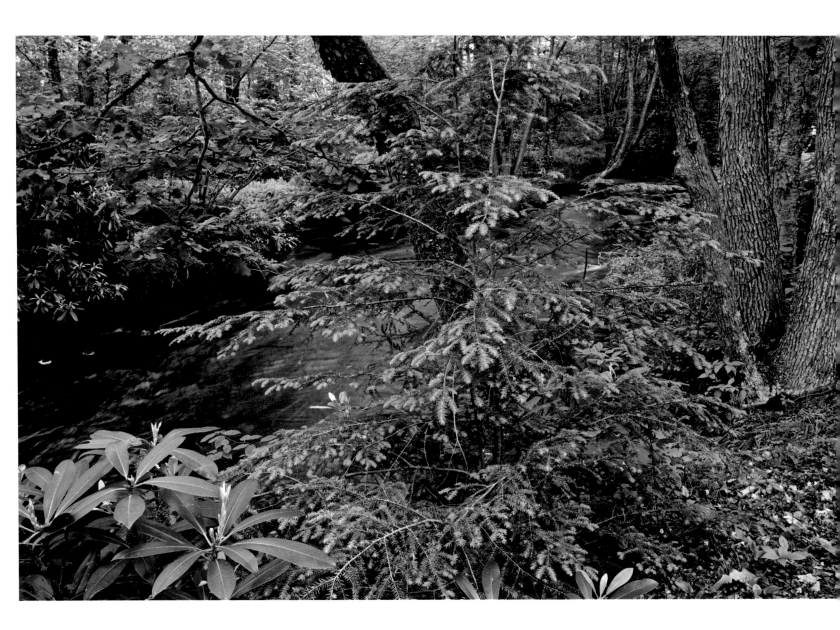

*Standing west of the fatal line of woolly adelgid advance
in 2013, this young hemlock dips its roots in stream-fed
groundwater at Black Moshannon State Park, north-central
Pennsylvania.*

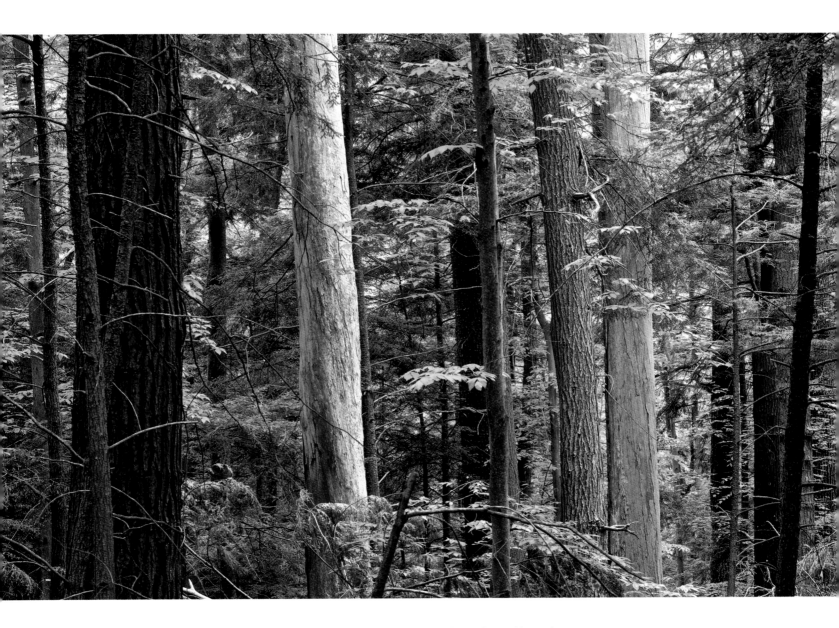

OPPOSITE *Golden-brown trunks of hemlocks reflected in pools and riffles of Black Moshannon Creek, Pennsylvania.*

ABOVE *With fifteen hundred acres of uncut old-growth conifers and hardwoods, Cook Forest in northwestern Pennsylvania is perhaps the largest and finest surviving eastern hemlock preserve. As a stopgap measure, thousands of trees are being chemically treated in hopes of sustaining them until introduced adelgid predators become effective.*

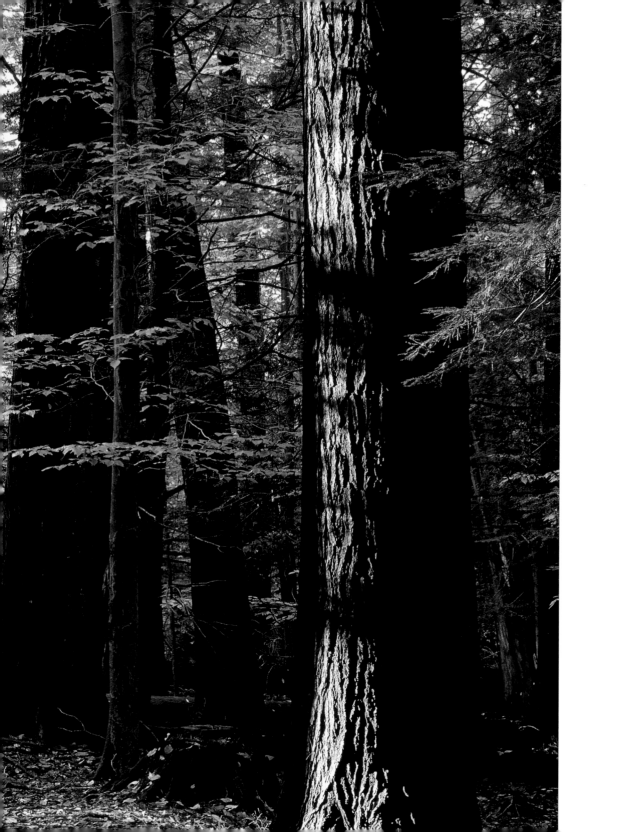

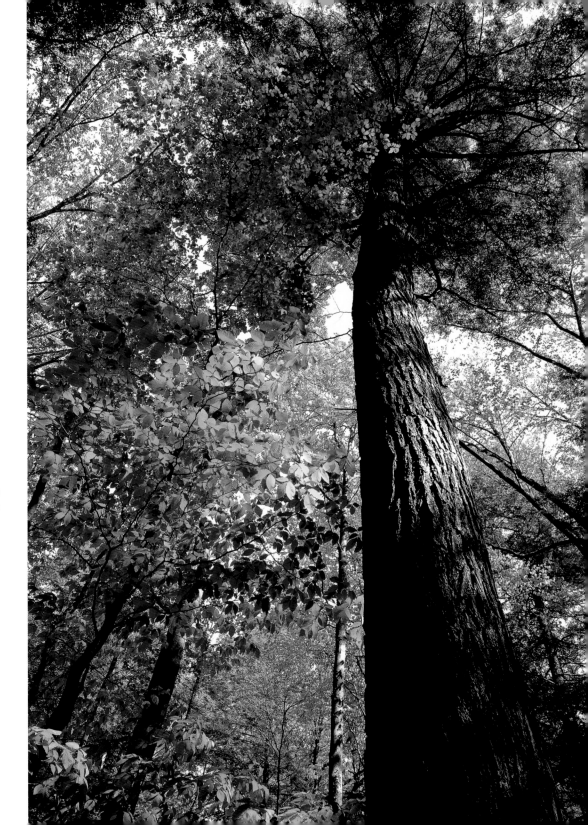

LEFT *Cook Forest's mix of hemlocks, white pines, beeches, and other hardwoods were spared from cutting in the nineteenth century and later set aside as one of Pennsylvania's greatest state parks. The Longfellow Trail, Seneca Trail, and other paths lead to trees that have endured for centuries.*

RIGHT *Pushing toward the sky, a hemlock in Allegheny National Forest has so far survived the arrival of the adelgid. The four-thousand-acre Tionesta Scenic and Research Natural Area is the largest virgin forest in Pennsylvania, though losses mount from the adelgid and beech bark disease.*

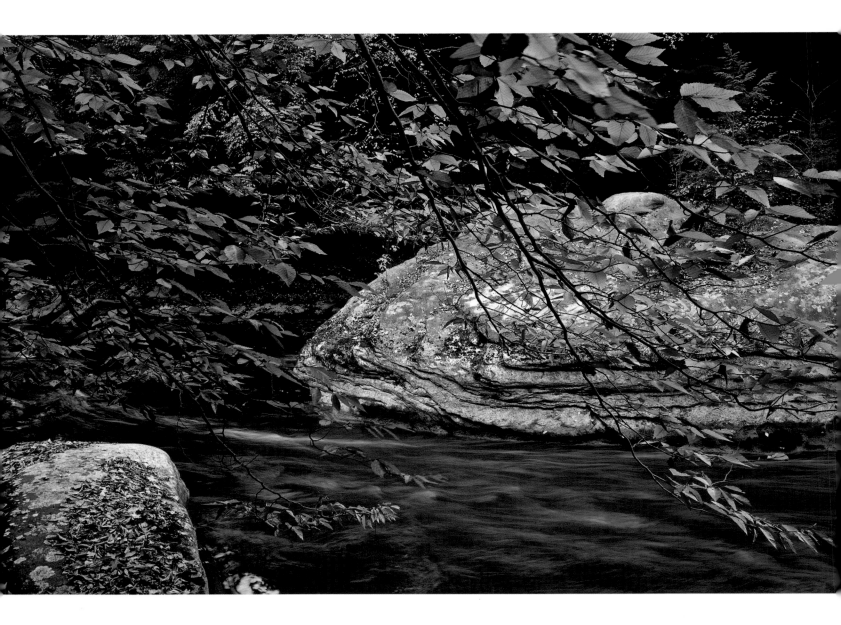

With leaves turning in autumn, weeping beech limbs overhang Slippery Rock Creek at McConnells Mill State Park, western Pennsylvania.

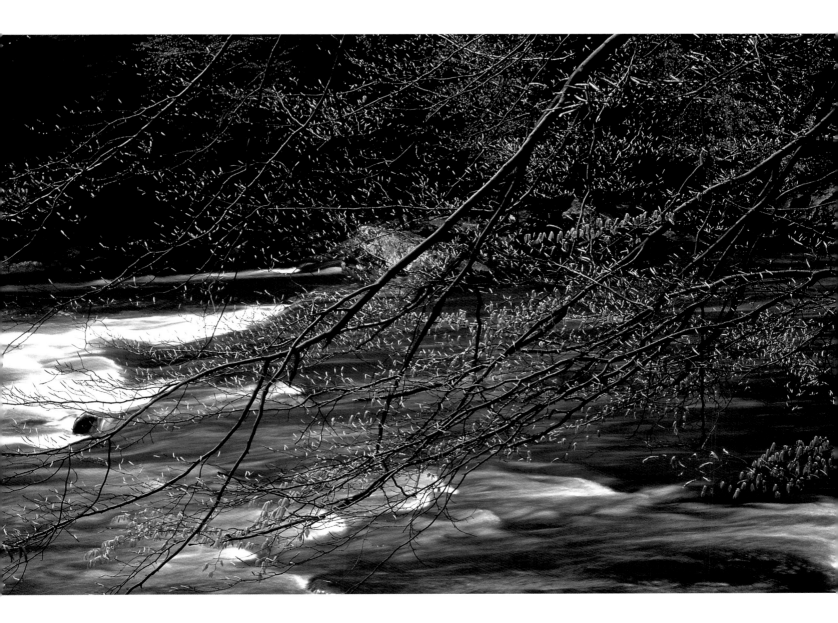

*The beech's sharp buds in early spring are ready to burst with
new leaves along Slippery Rock Creek.*

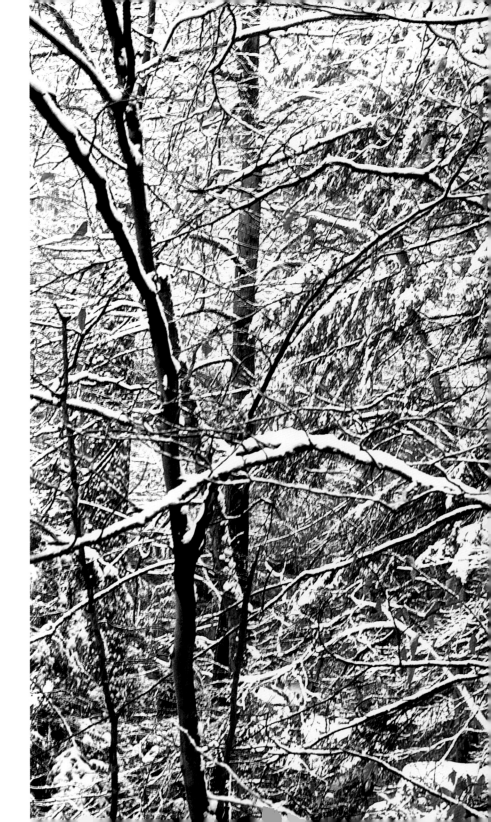

Snowfall blankets the beech and hemlock forest of McConnells Mill State Park in western Pennsylvania. In the Northeast, severe winter cold snaps tend to retard, but not eliminate, woolly adelgids.

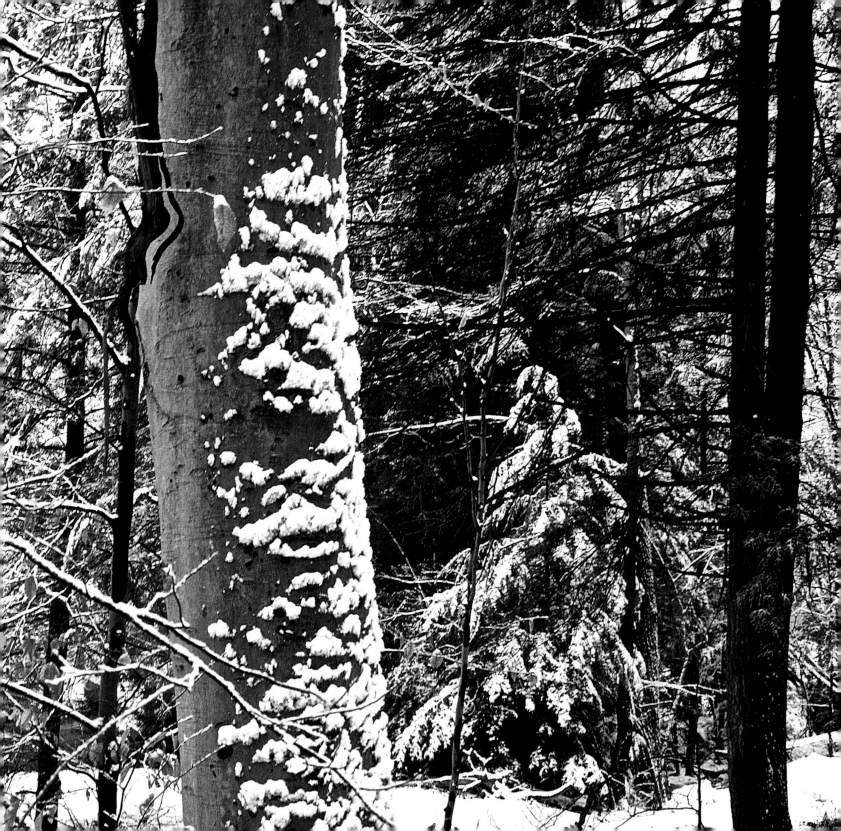

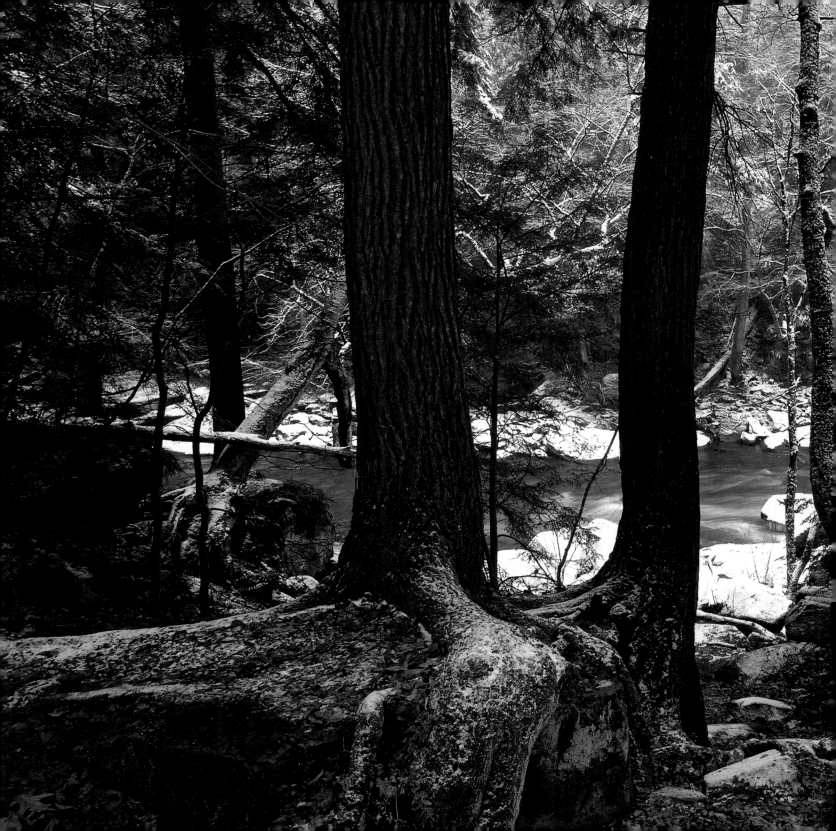

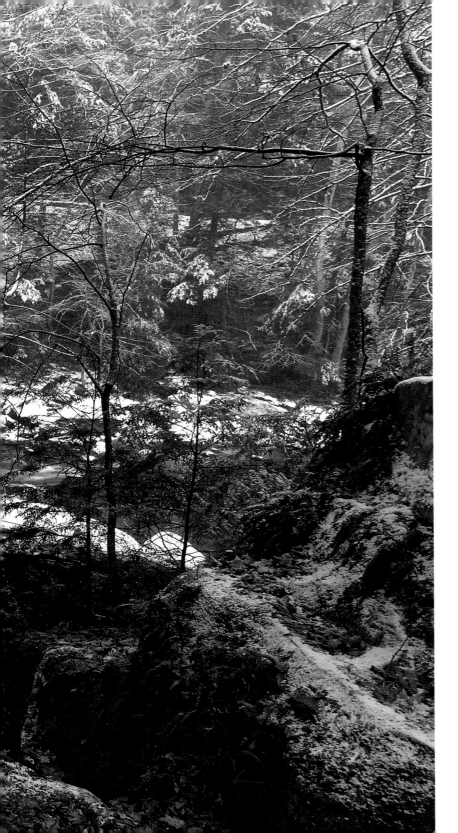

Early-season snowfall whitens hemlocks that grip rocks tightly at McConnells Mill State Park.

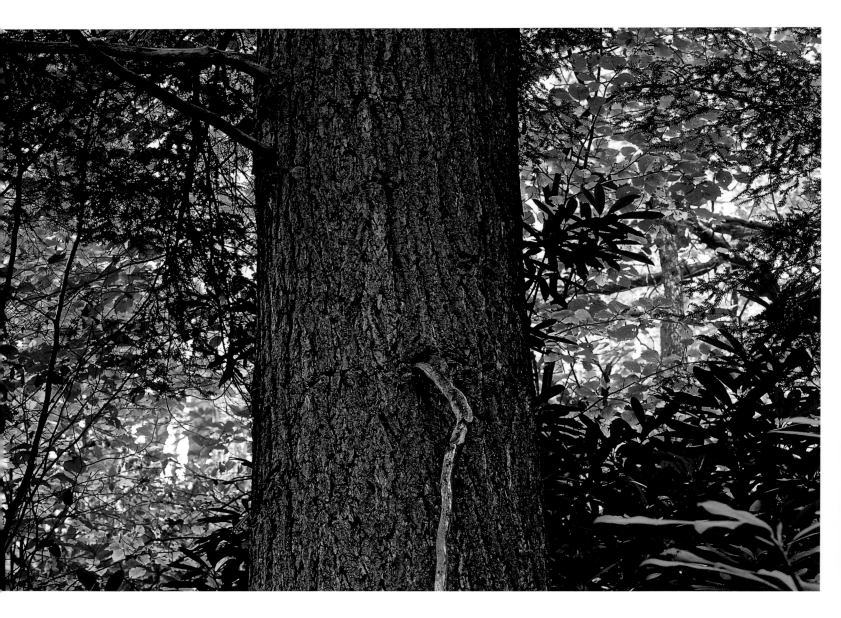

*Forbes State Forest in southwestern Pennsylvania and
its fine stands of hemlocks lie on the western slope of the
Appalachians—spared, as of this writing, from extensive losses
to the adelgid.*

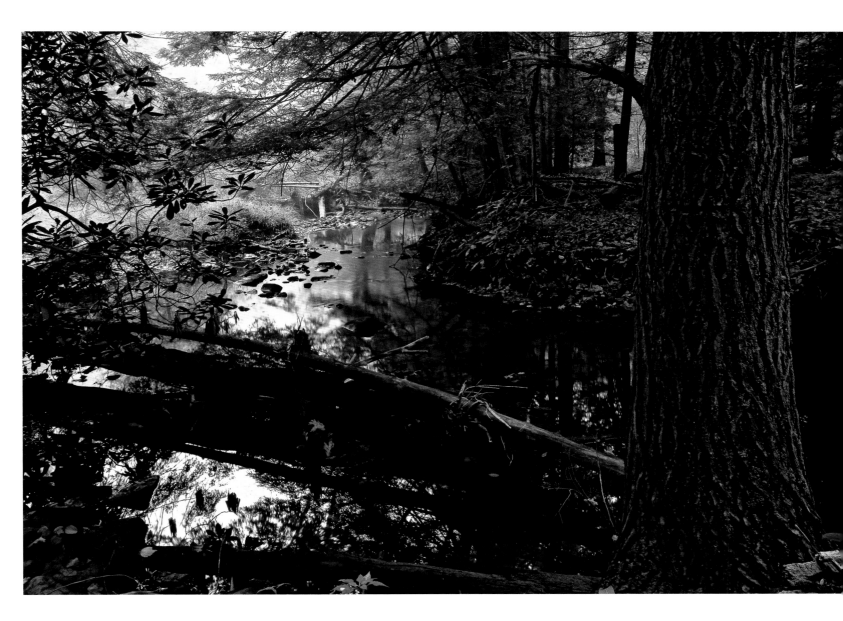

Quebec Run winds serenely through hemlock groves in Forbes State Forest.

ABOVE *Linn Run State Park in southwestern Pennsylvania shelters groves of beeches not yet affected by disease.*

OPPOSITE *At Ohiopyle State Park in southwestern Pennsylvania, a maturing beech spreads its limbs over a thicket of rhododendron above the banks of the Youghiogheny River.*

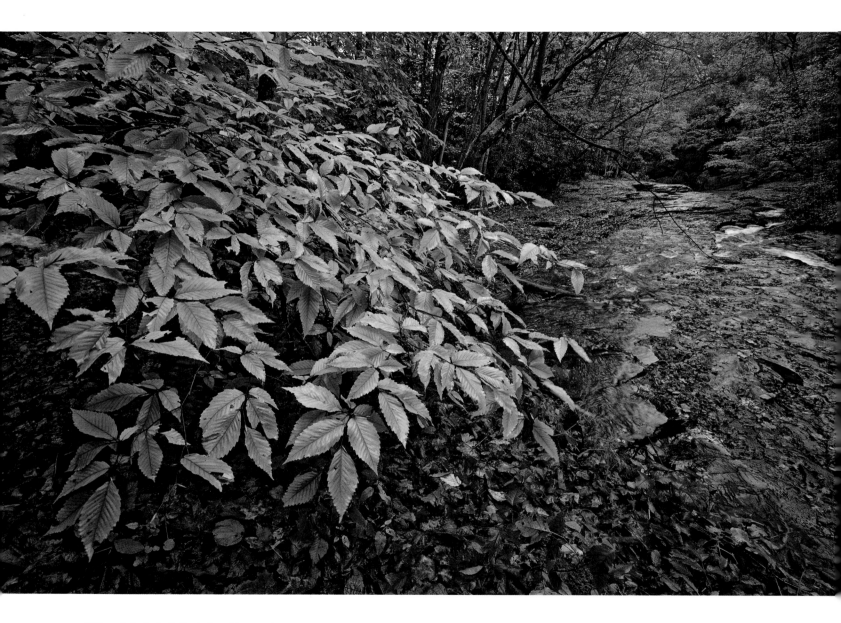

With a splash of color in the darkened forest understory, a
young beech glistens with moisture after a summer rainstorm
along Meadow Run in Ohiopyle State Park, Pennsylvania.

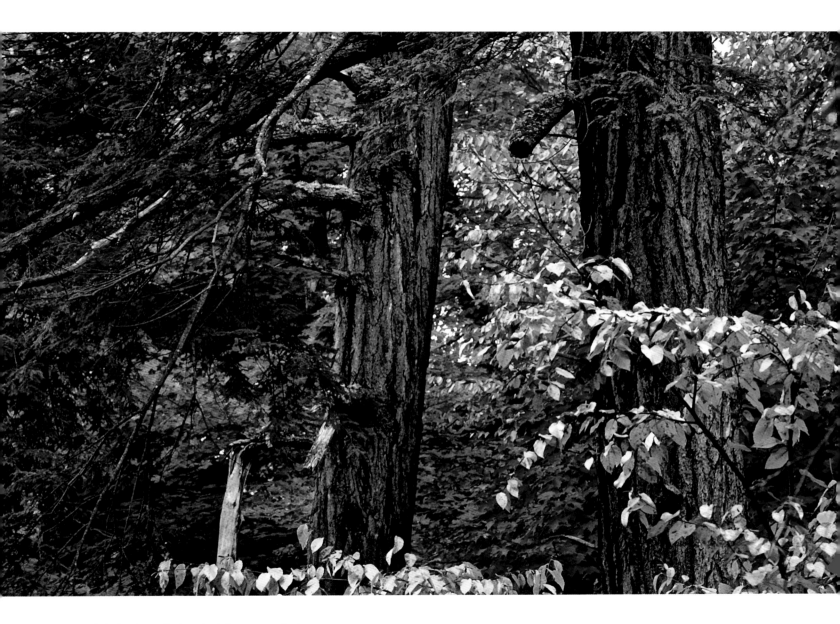

Hemlocks, beeches, and red maples define autumn splendor at Swallow Falls State Park, Maryland.

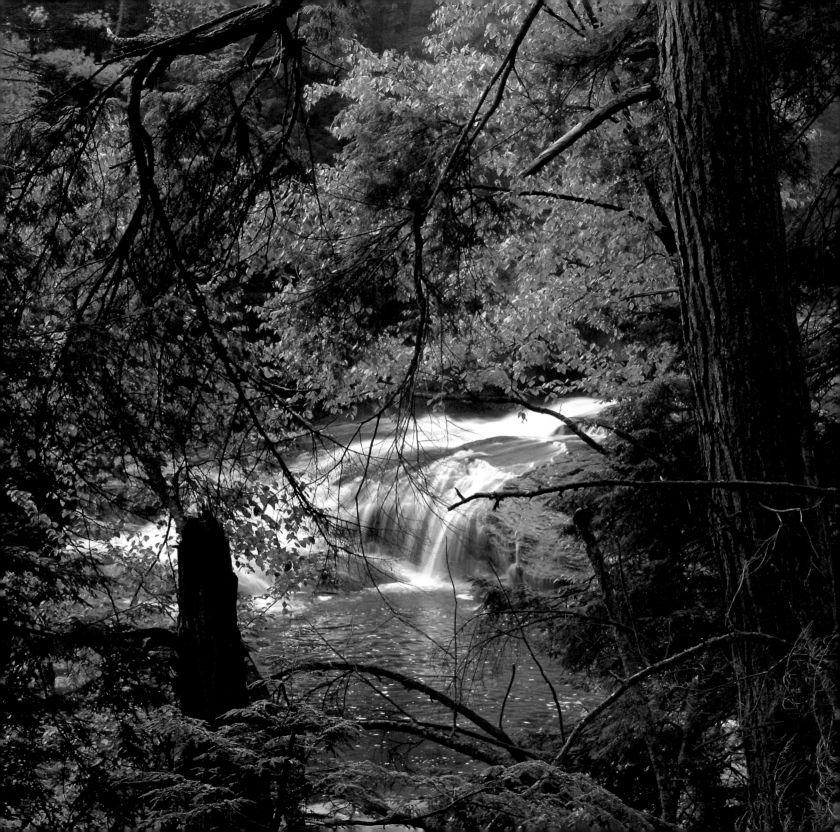

At Swallow Falls, old hemlocks tower along the upper Youghiogheny River, Maryland. Windstorms here have flattened some trees in recent years but left others standing.

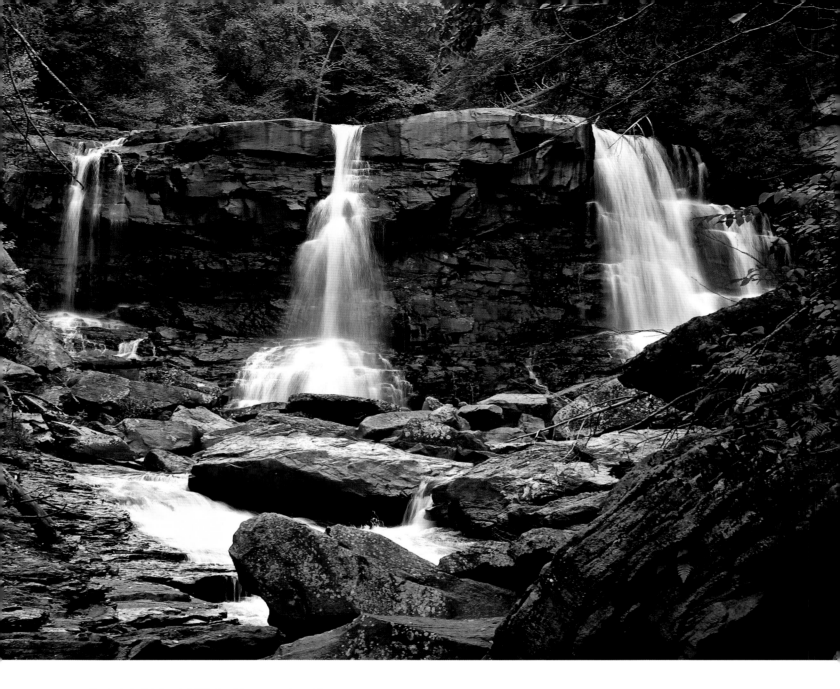

Hemlocks, both left and right in the distance, complement the
white cascade of Blackwater Falls, West Virginia.

A somber backdrop of hemlocks is highlighted with the yellow
and gold of autumn beeches at Blackwater Falls State Park.

While hemlocks are uniquely suited to shade, they benefit from sunlight, as in this recovering Appalachian forest in West Virginia. Carving this canyon over the millennia, the Blackwater River was named for its amber tint, the result of tannin leached from hemlocks and spruces.

Evening light catches the rich greenery along Giant Hemlock
Trail, Cathedral State Park, West Virginia.

Two companion hemlocks, with a beech in the background, rise up in Cathedral State Park. Though only 133 acres, this park ranks as the largest virgin forest in West Virginia, with hemlocks reaching ninety feet.

This mature beech tree is so far unaffected by disease at
Patapsco Valley State Park, east of Baltimore, Maryland.

At a small nature preserve north of Fredericktown in eastern Ohio, beech trees gain ground, spreading in the shade of oaks and hickories that pioneered the reclamation of abandoned farm fields. The amber-bronze leaves color the gray autumn forest through November.

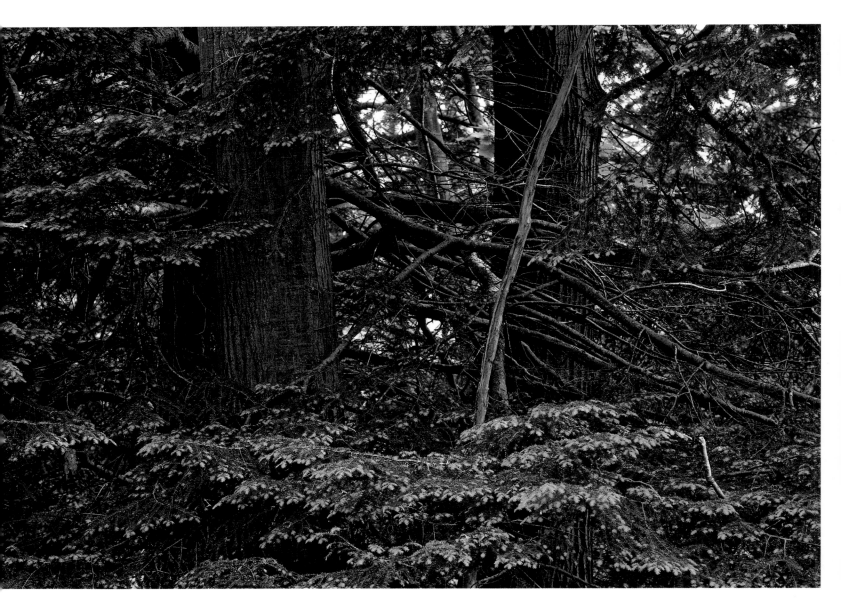

Though nearing the western limits of their range, robust hemlocks sprout new growth in Manistee National Forest near Lake Michigan.

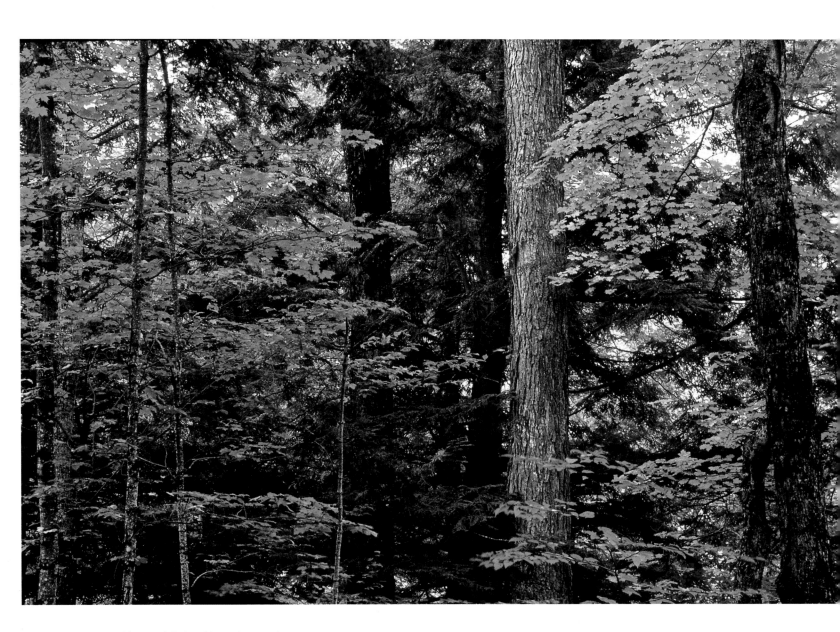

A topographic anomaly in the Midwest, the Porcupine
Mountains rise from Lake Superior, where cool enclaves nourish
groves of hemlocks and beeches. While most other northern
Michigan tracts of forest were cut over, a remarkable thirty-
five thousand acres here were spared.

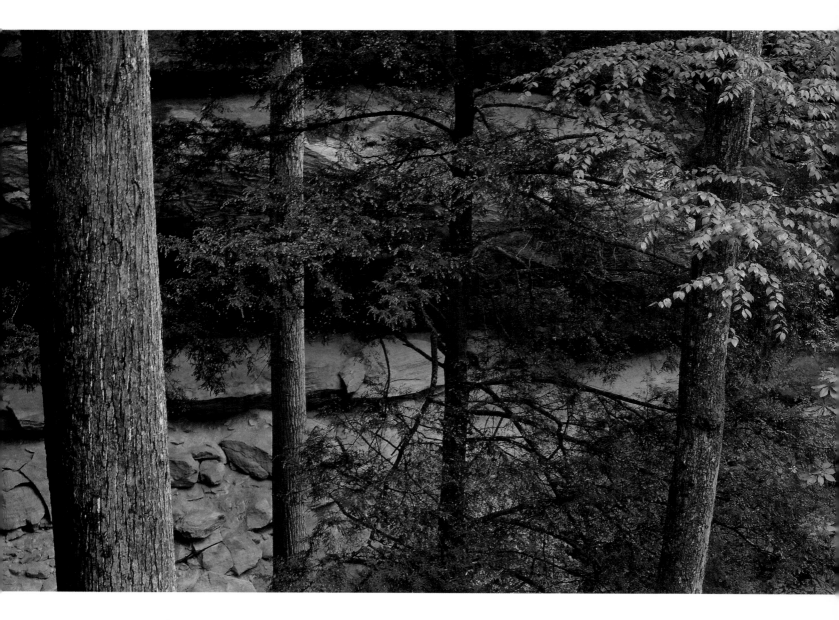

ABOVE At Grays Arch in Red River Gorge, Daniel Boone National Forest, Kentucky, a hemlock benefits from cool shade cast by the spectacular geological formations.

OPPOSITE Exposed to sun, limber branches of beech trees make a yellow-green veil along Sheltowee Trace in the Red River Gorge Geological Area.

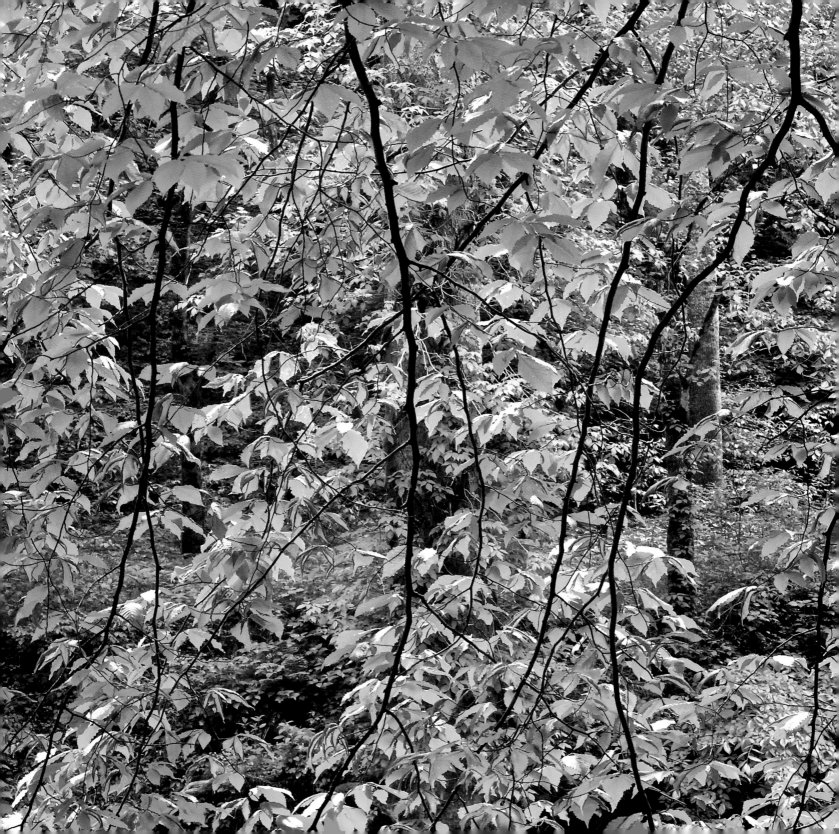

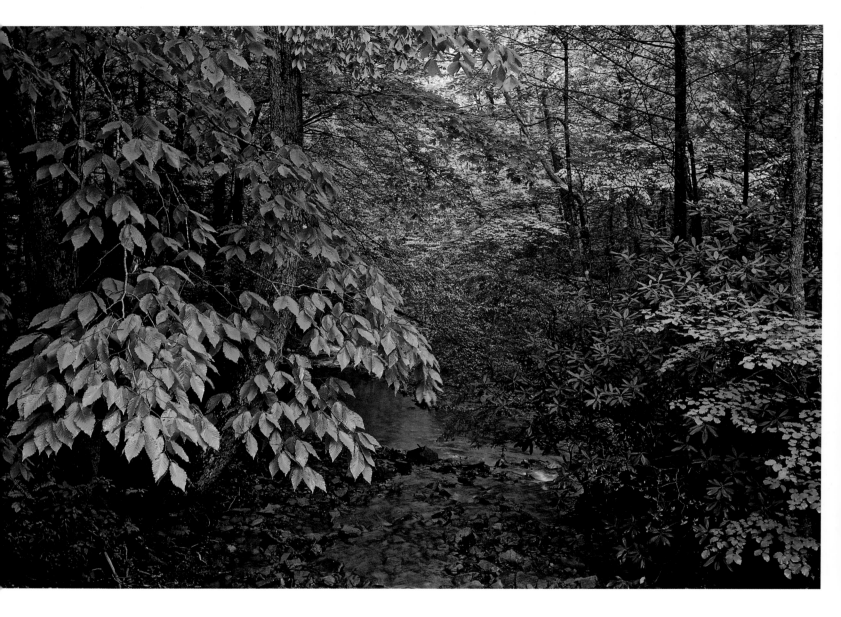

Beech trees grace a tributary of the Jackson River in George Washington National Forest, Virginia.

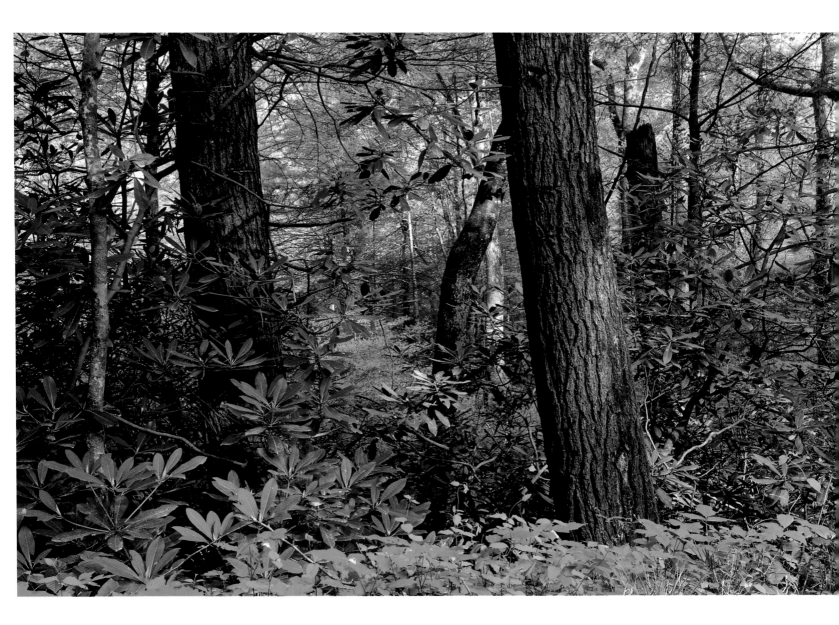

Rhododendrons thrive beneath elegant old hemlocks on slopes leading down to Wilson Creek, Pisgah National Forest, North Carolina.

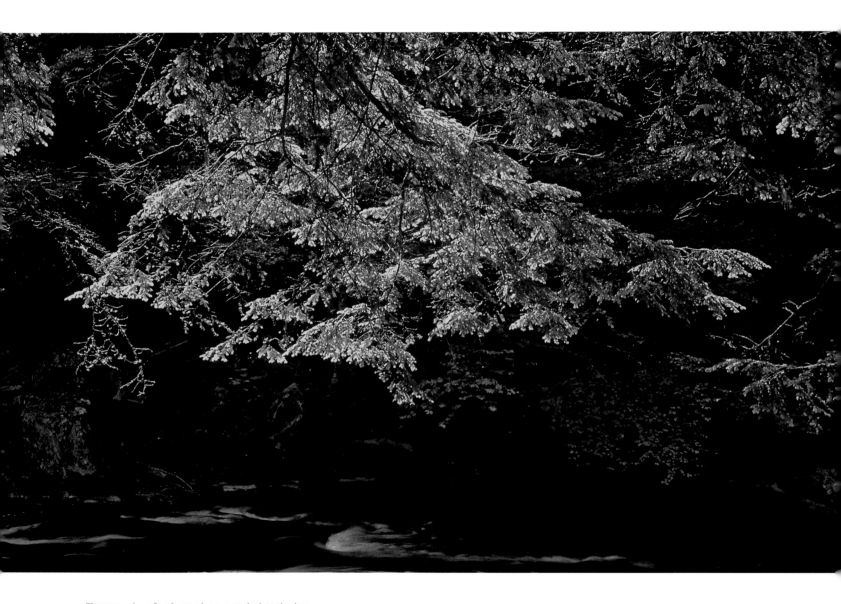

The warm glow of early morning sun angles into the deep recesses of Linville Gorge in North Carolina, backlighting the finely textured needles of a hemlock.

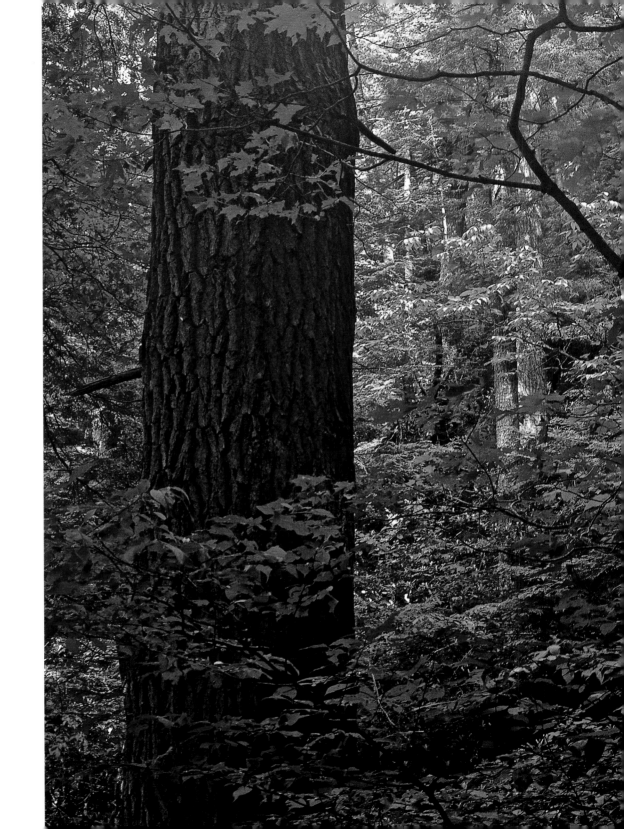

This hemlock along Ramsey Prong in Great Smoky Mountains National Park appeared to be thriving in 2006 but soon died from woolly adelgid infestation.

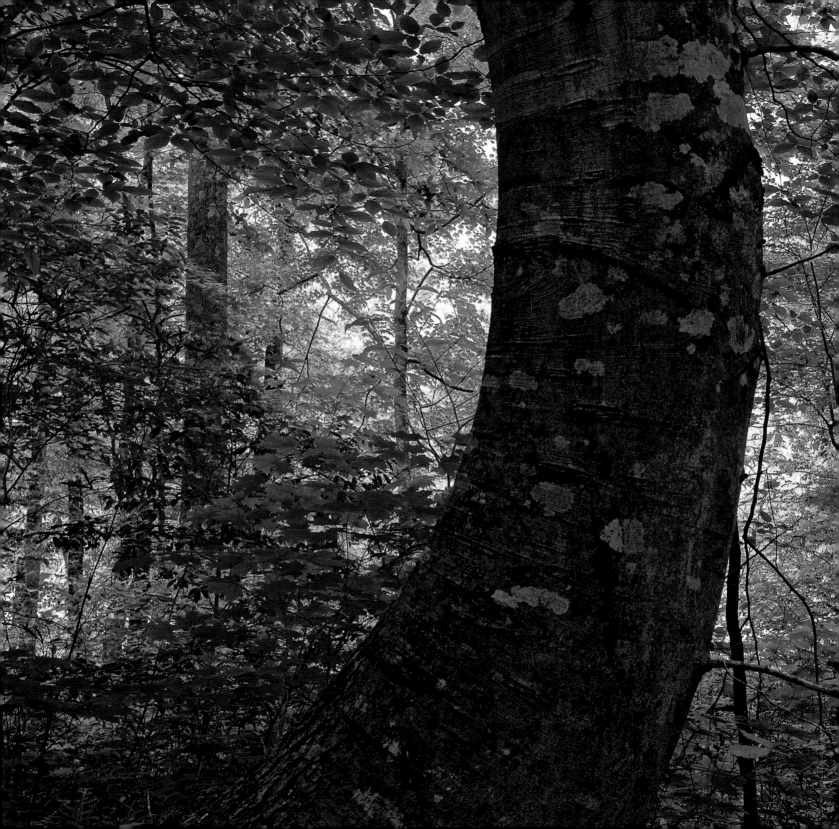

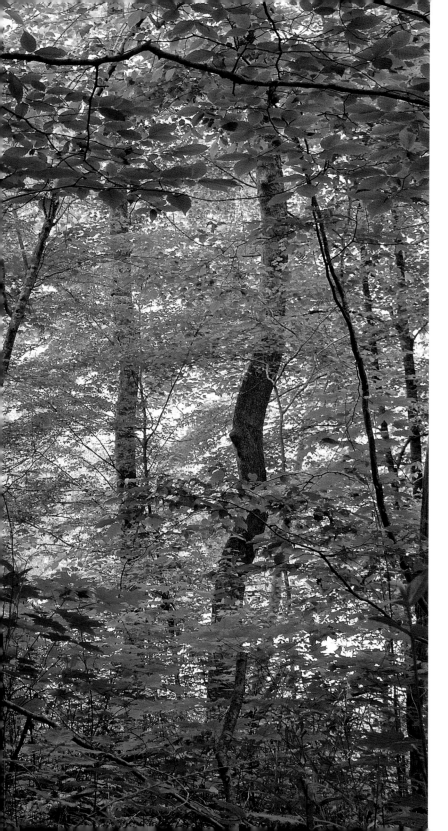

Spotted with lichens, a mature beech curves upward in Big South Fork National River and Recreation Area, Tennessee.

OPPOSITE *Hemlocks frame the view to the Whitewater River, Nantahala National Forest, North Carolina.*

ABOVE *Hemlocks—distinguished by their straight trunks, finely textured foliage, and pyramidal shapes (unlike the pines in the upper right)—are scattered among deciduous trees along Clear Creek near the Obed River, Tennessee.*

*Their spectacular canopy catching the summertime sunrise,
beeches stretch upward along the Chattooga River at the South
Carolina–Georgia border.*

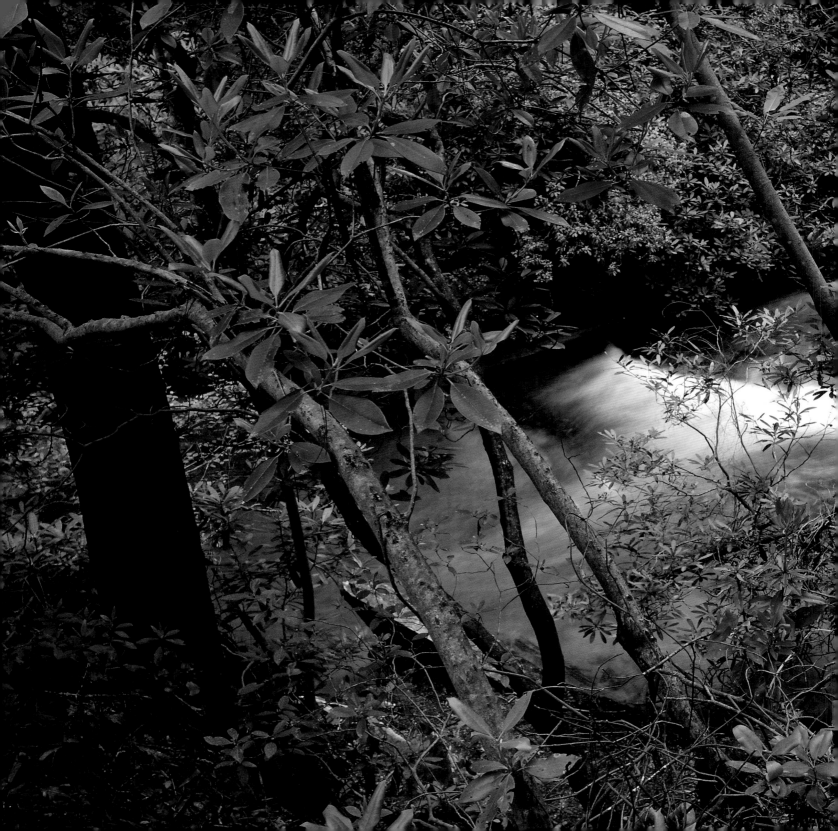

The classic duo of hemlocks and rhododendrons blanket steep slopes of the southern Appalachians above Panther Creek, a Chattooga River tributary in northeastern Georgia.

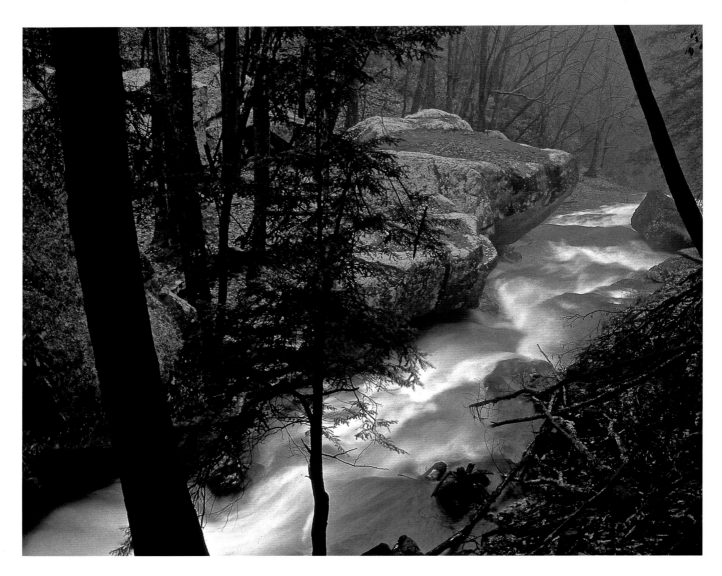

ABOVE *In the wilds of northern Georgia's Cloudland Canyon State Park, and misted by a recent rainstorm, Daniel Creek rushes through ravines scattered with hemlocks at the southern end of the conifer's range.*

OPPOSITE *At Savage Gulf State Natural Area in Tennessee, hemlocks have grown to 150 feet—the tallest outside the southern Appalachians' Blue Ridge province. Thousands of trees are being treated here in the hope of thwarting the adelgid's advance. Hemlocks in this overview of the gulf are the darker trees with pointed tops.*

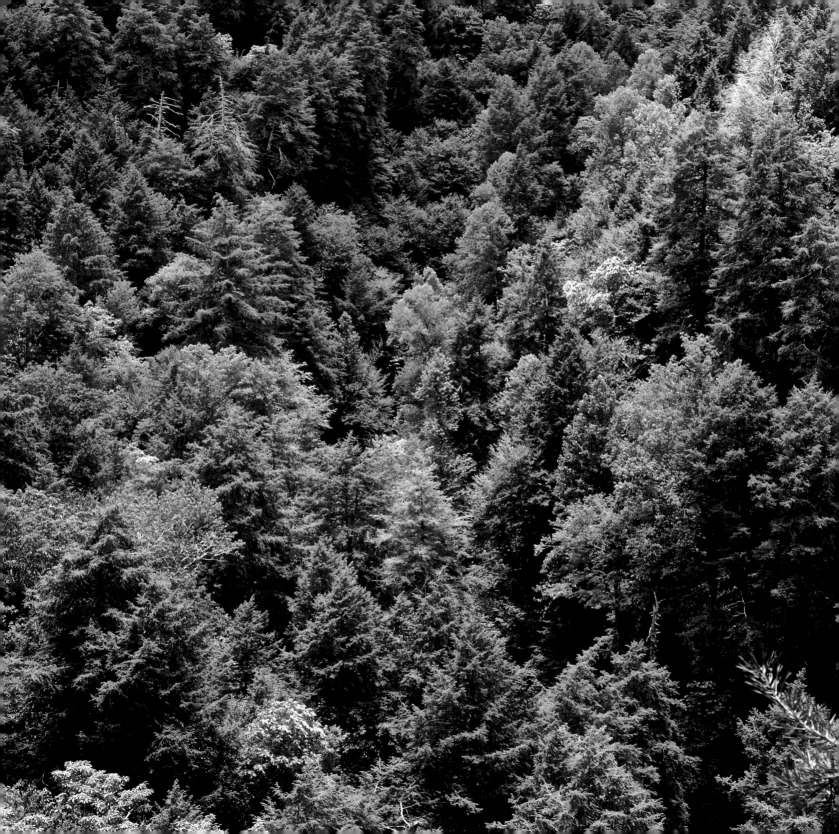

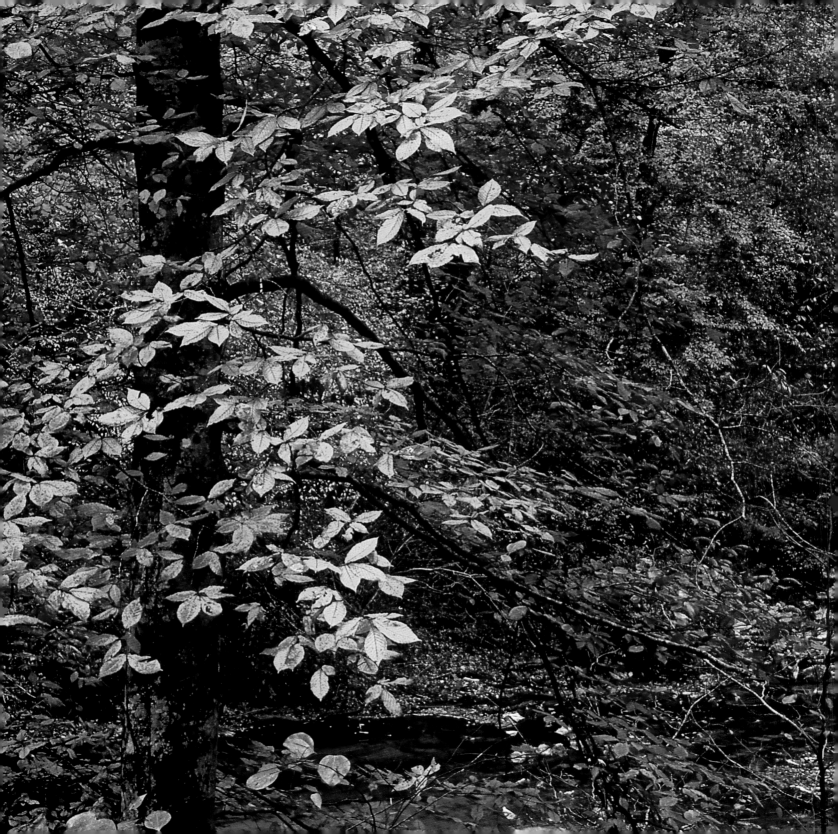

OPPOSITE *At the southern extreme of the two-thousand-mile-long Appalachian Mountain chain, beeches brighten the autumn forest above Sipsey Fork of the Black Warrior River, northern Alabama.*

ABOVE *Full-bodied hemlocks, rising on the right, mix with balsam firs and the obelisk forms of white spruces along Tenderfoot Creek in Wisconsin.*

OVERLEAF *At a remote lakeshore along the border of Michigan and Wisconsin, hemlocks have been protected in the Nature Conservancy's Tenderfoot Reserve.*

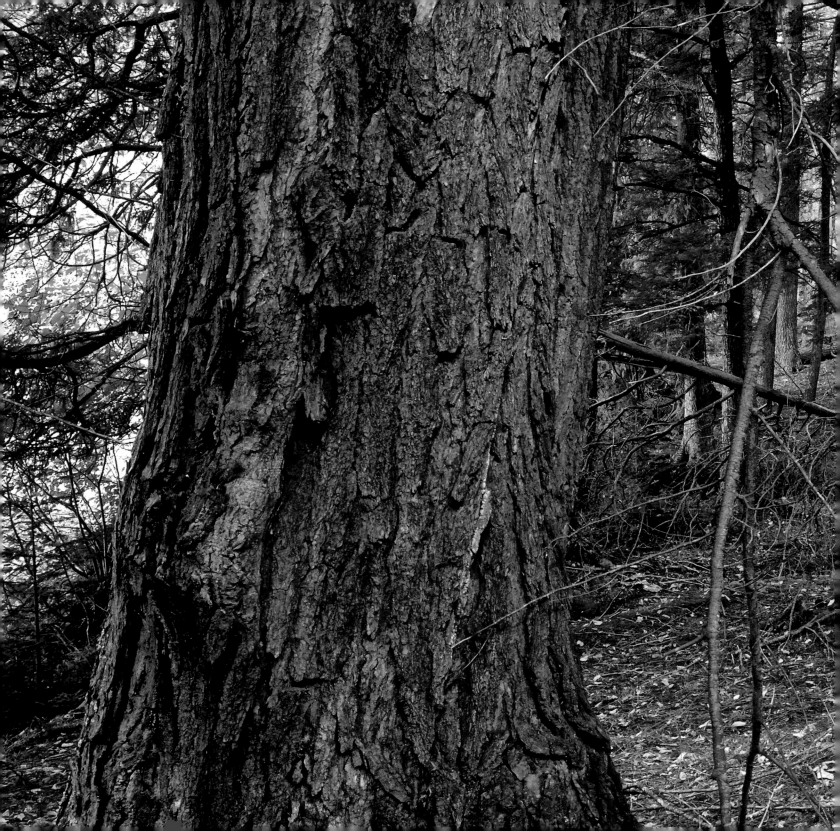

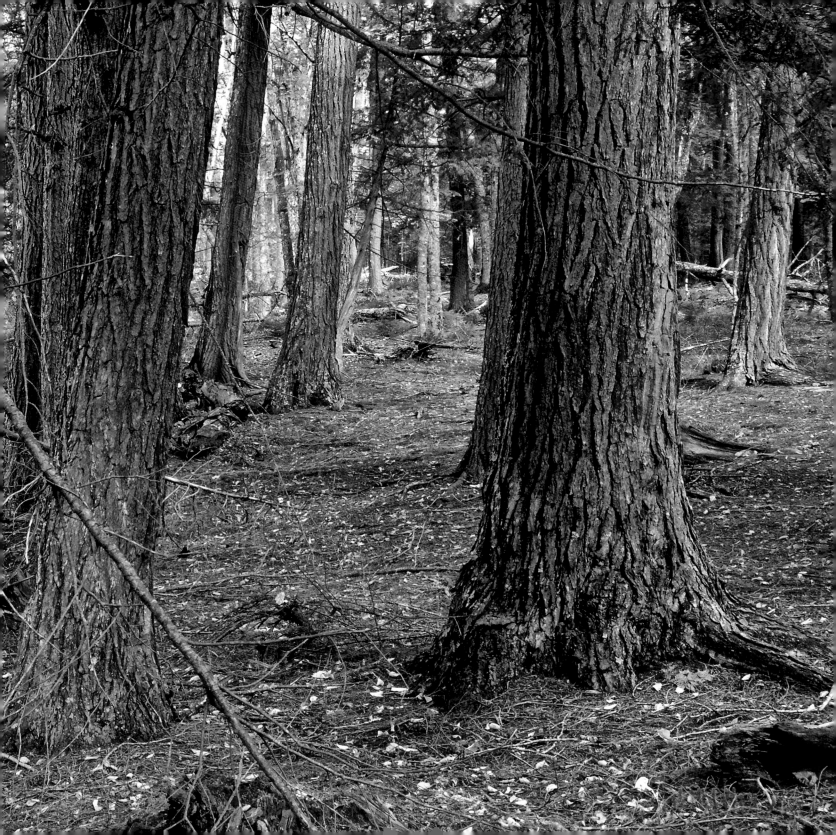

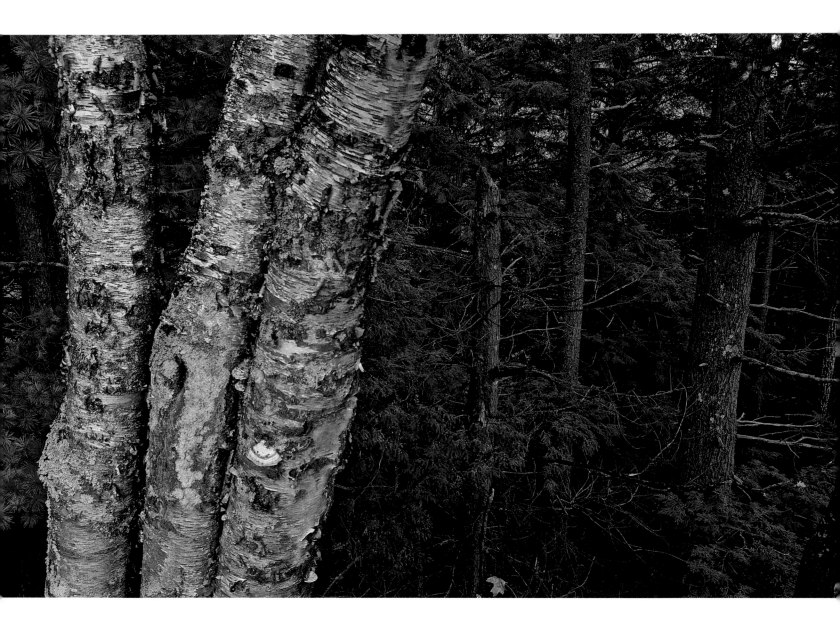

White paper birches contrast with deep green hemlocks in a wooded canyon leading down to Lake Superior at Bayfield, Wisconsin, near the western limits of the hemlocks' range.

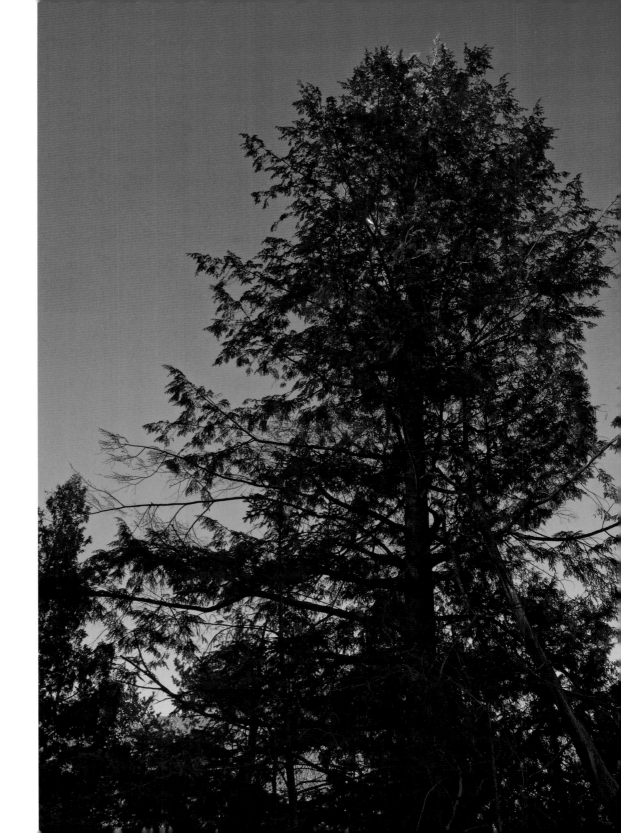

Perhaps the westernmost of all Tsuga canadensis, *this tree within Hemlock Ravine State Natural Area, south of Duluth, Minnesota, clings on borrowed time to soil where recent floods have cut deeply into steep slopes.*

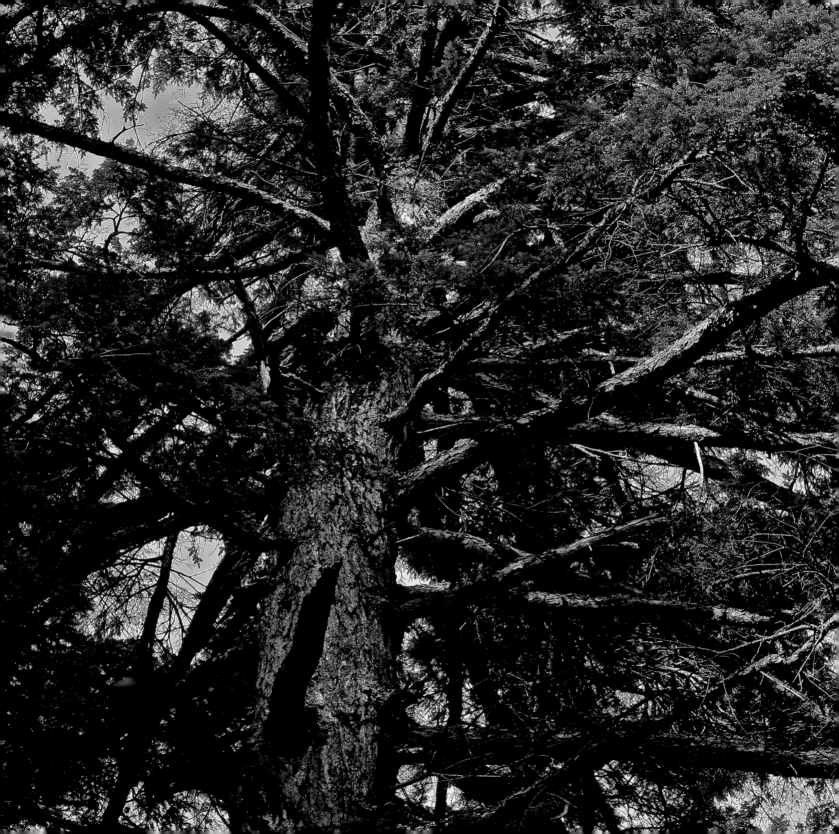

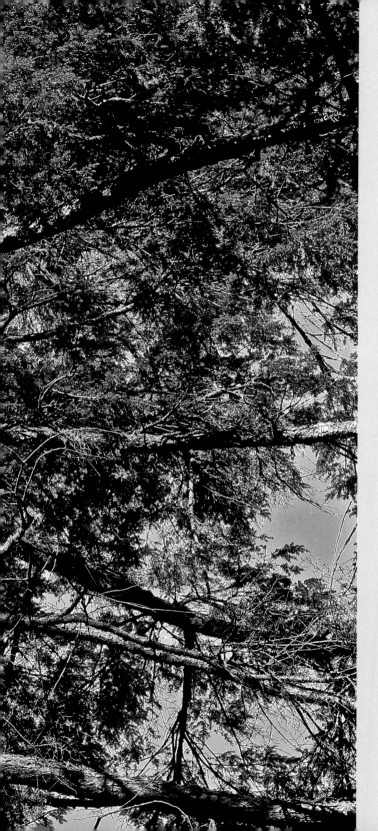

Chapter Four
The World Transformed

Geologists tell us that Pangaea was earth's single land-mass, predating the continents we know today. Their modern separations by whole oceans occurred as continental plates cracked apart and then drifted, afloat on semimolten magma circulating beneath the earth's crust. Those separations, inch by inch over the course of two hundred million years, allowed distinct communities of life to flourish with little interference from potentially hostile life on other continents.

However, the advent of global travel has broken down the great barriers of the seas. Through ocean shipping we've reinvented Pangaea in new and sinister form, determined not by geography but by world economies and the profit motive. Today, life anywhere can be threatened by the sudden arrival of new pests, predators, and pathogens from other continents. Exotic vectors of disease have given rise to a whole branch of science called "invasion biology," and alien species have become one of the most egregious threats to native ecosystems.[1]

Take the case of the chestnut.

Surviving hemlocks at Cathedral State Park, West Virginia.

Before 1900, American chestnuts grew tall in a range covering one-third of the East.[2] Few other plants or animals were more important to America's most expansive ecosystem. Massive in girth, the great boles rose a hundred feet and higher. Their nuts—larger, tastier, and more nutritious than the similar beechnuts—were staples to a host of forest life, filling the menus of whole tribes and of white settlers and subsequent generations who ate heartily of the big trees' yields.

But they weren't good enough for some people with money in mind, and in a half-baked commercial effort to hybridize the native tree with a Chinese species that had larger nuts, a fatal fungus of Asian origin was carelessly brought to the United States. Spread by people, birds, wind, and rain starting in 1904, the fungus killed most of the mature wild chestnut trees in America by 1920 and virtually all of them by the late 1930s. After many years, some roots remain alive and send up sprouts still seen in woodlands. But when they reach sapling diameter, the lingering fungus invades, and the chestnut trees die.

If anyone had predicted in 1900 that the ubiquitous chestnut would disappear within two decades, no one would have believed it. People couldn't have imagined eastern forests without those trees. And that's just how I felt when I learned that the hemlocks, and then the beeches, were both being decimated by vectors originating halfway around the world.

In the age of expanding globalism, it took only one boat from Japan to introduce the hemlock woolly adelgid to America and only one other boat from Europe to seal the fate of the beeches.

The hemlock woolly adelgid (*Adelges tsugae*) is an aphid-like insect half a millimeter or so across. Think grain of pepper with legs. *Sticky* legs. You usually need a magnifying glass to see these reddish-brown, purplish-black specks, so the insect itself goes unnoticed. But its ubiquitous calling card is a waxy white excretion that protects eggs stuck to the underside of needles and twigs. The white masses look like tiny cotton balls bulked together, visible in winter and spring but rarely in late summer and early fall, when adelgids estivate.[3]

The eggs hatch into temporarily mobile nymphs, descriptively called "crawlers," that infest only hemlocks. But their simplicity of diet nonetheless exerts a draconian force on entire landscapes. Diminutive but armed to the hilt, the crawler finds its favored spot and promptly uncoils a threadlike feeding tube that measures one and a half times its body length and inserts the conduit with little resistance into the tender twig at the base of a needle. Then it sucks vital arboreal fluids for the rest of the insect's life. Though the pest does not eat foliage, defoliation follows after hemlock supply lines are cut by a million wounds. From the white egg masses, newly hatched crawlers emerge and move to another needle, twig, or tree, grove by grove, state by state. They prefer vigorous hemlocks but feed on them all.

The adelgids multiply in two generations per year and are most active through winter, when few insect predators roam. Not that such stealth matters in the case of this heavily stacked deck; being native to Asia, the adelgid lacks predators here. A few flies, lacewings, and spiders might eat eggs and crawlers, but to little effect on the mind-boggling numbers that aggregate soon after the adelgids' invasion of any forest.

The insect probably originated thirty million years ago on Asian hemlocks, where, over time, adelgid

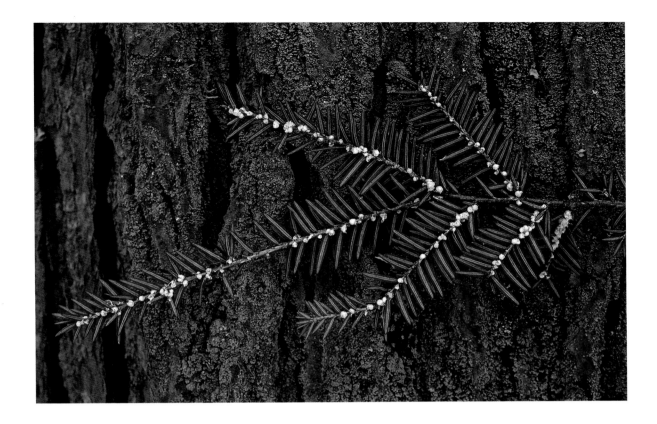

predators opportunistically evolved. Hemlocks in Asia now suffer little from this pest. Eastern hemlocks, however, had no need for predators or resistance, relying instead on the barrier of the oceans ever since the breakup of Pangaea. But then came the boat.

The woolly adelgid of eastern North America was first noticed in 1951 in Richmond, Virginia, near Maymont Park, which had been a private garden of avid horticulturalist Sallie Dooley dating to 1911. Dooley collected plants worldwide, which seemed at the time—and perhaps still today to people unfamiliar with the following sad saga—to be a harmless and even intriguing hobby.

The insect is thought to have arrived on a Japanese hemlock ordered by Dooley or another collector and shipped here.[4] Through DNA analysis, we know definitively that the crawler came from southern Japan.

At first, the consequence of Mrs. Dooley's minor market transaction, totaling perhaps a few dollars in unregulated global trade, was unimagined. The minute adelgid and its strange unisexual capabilities were regarded as a biological curiosity; then it was simply a minor horticultural pest. Flying under the proverbial radar, it multiplied slowly at first but inevitably gained ground and then furious momentum. Population growth in cases like this can rage until the ultimate limits of

Woolly adelgid egg masses adhere to the underside of hemlock twigs in the winter and springtime at the Harvard Forest near Petersham, Massachusetts.

The World Transformed

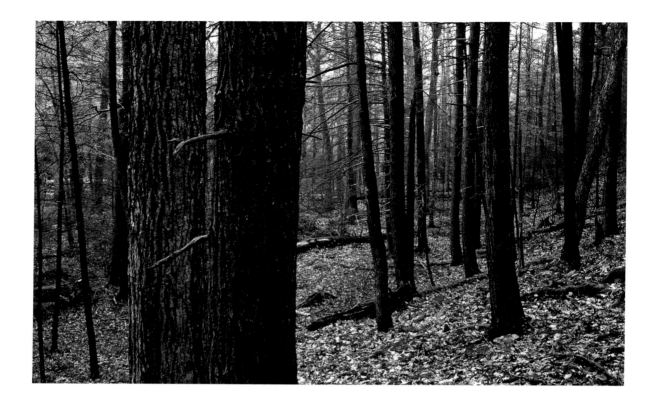

Dead hemlocks, still standing in 2014 in Ramsey's Draft Wilderness in Virginia, gave a deathly gray pall to the forest around them.

food supply are reached. In this regard, the free cafeteria of eastern hemlocks extends to twenty-three states.

As a reproductive phenomenon putting the standard rabbit metaphor to shame, the adelgids are all capable females, their eggs viable through parthenogenesis—asexual reproduction uncomplicated by issues of an opposite sex and allowing every member of the population to bear young. Just one of these pinpoint-sized beasts can produce up to three hundred eggs at a clip, lending a whole new meaning to the term "exponential growth." Harvard ecologist David Orwig estimated that ten adults—hardly visible on your fingertip—can produce more than thirty million individuals in two years.[5] Many eastern hemlocks never had a chance.

An early spring hatch, called *progrediens*, are both wingless and winged. The winged ones, called *sexuparae*, fly off to seek a spruce tree as host, though none to their liking can be found in North America, and so those individuals die. But the adelgids have this contingency covered; a second generation of wingless crawlers immediately attacks hemlocks. The late spring to midsummer hatch, called *sistens*, are all wingless, remain in hemlocks, and live nine months.

As if their population growth hadn't already run amok, adelgid fecundity is abetted by excess nitrogen associated with air pollution. Could we make it any easier for them? Along the same lines, fertilizing hemlocks makes adelgid outbreaks worse; if you have

Twilight of the Hemlocks and Beeches

hemlocks in your yard, don't try to strengthen their resistance with nitrogen-based fertilizer.[6]

The adelgid crawlers don't just spread—like their hemlock host—in a limited slow ripple. Purposefully sticky, these unnoticeable hitchhikers adhere to animal fur and feet, clothing, firewood, and cars, not to mention free travel by gravity and wind. Worst of all, the crawlers are spread by birds, whose feet unwittingly ferry the minute predators from tree to tree as the birds flutter, perch, and feed. One study found that nineteen of twenty-two bird species exiting hemlock forests carried the insect in effortless tow.[7] They leapfrog great distances on the express of a blue jay or warbler bound for the next ridge, watershed, or county.

The Japanese adelgids were first noticed in Pennsylvania in 1969. By 1985, they had reached the Hudson Valley and crossed Long Island Sound to New England. Dr. Carole Cheah of the Connecticut Agricultural Experiment Station recalled, "One day a landowner brought this strange insect to our lab and asked Mark McClure, 'What is it?'" Answering that simple question marked the beginning of Dr. McClure's remarkable commitment to adelgid research, which lasted the rest of his career. Within one year, adelgids spread across Connecticut in strong numbers.

From ground zero in Virginia, the adelgids spread north, west, and south as well. By 1995, nearly all the hemlocks in Shenandoah National Park lay dead. Rates of advance suggested that adelgids would need more than a decade to reach North Carolina and remote coves of the Great Smoky Mountains, but the pest leapfrogged south on unquarantined commercial nursery stock and infested areas heavily by 2002.[8] Most large hemlocks in the South are now history, as a result of a catastrophic cascade in which ninety thousand acres had been occupied by these conifers and seven hundred acres had survived as rare old growth following widespread logging everywhere else. Among the tragic losses, Joyce Kilmer Memorial Forest was infested—the Forest Service response too late and too little to avoid the gray pall of dead trees that overwhelmed visitors there by 2005.

With mild winters, humid summers, worsening droughts, an unregulated nursery trade, and plentiful birds to shuttle the insects around, the southern Appalachians became the hot zone of hemlock mortality. Meanwhile, adelgids defoliated the great groves of Alan Seeger Natural Area in central Pennsylvania and crossed to the Appalachians' western slope in 2009, where they were spotted in the hemlock sanctuary of Cook Forest State Park.

By 2012, half of the hemlock's total range was infested, the front advancing 7.7 miles a year on average, though migration is slower in the colder climates of the Northeast.[9] A map of the adelgid's domain now shows comprehensive coverage of the Appalachians' eastern slope from Maine through Georgia, with tentacles fingering westward to Ohio and Michigan. I've seen no adelgid evidence yet at my boyhood haunts of McConnells Mill State Park in northwestern Pennsylvania, but the insect's probably there, building irrepressible reproductive momentum. Slightly farther west, Ohio's Beaver Creek State Park also appeared unaffected in 2016—a haven no doubt temporary. Recognizing what appears to be inevitable, the Forest Service reported that the hemlock's entire range is "at risk."[10]

In New England, hemlocks persist better at the northern fringes of their range because adelgids perish in extreme cold. So plentiful hemlocks can still be seen

in Maine, northern New Hampshire, Vermont, and New York. For a hopeful time it appeared that cold winters might actually halt the insect's northward advance. But even when deterred by an Arctic cold snap, the insects are not eliminated. In the Berkshire Mountains of western Massachusetts, temperatures dipping to twenty-two below zero killed 97 percent of the crawlers, but the remaining 3 percent promptly went to work laying eggs, with the capability of again reaching carrying capacity within a few years. Furthermore, it appears that the adelgids may be genetically mutating to withstand greater cold, according to Dr. Nathan Havill of the U.S. Forest Service.

The coming years may see eastern hemlocks sequestered only in their northernmost ranges, lending unexpected credence to the tree's scientific name, *Tsuga canadensis*—an odd choice for a tree once so common all the way to Alabama. And in years to come, Pennsylvania's official state tree could become a foreign expatriate. Just to see one, we might need a visa.

The cold-weather sensitivity of eastern America's adelgid stems from the genetic makeup of ancestors that evolved in the moderate climate of southern Japan. Further imports of horticultural plants could ominously include other adelgid species or varieties genetically tolerant of cold. So matters could get even worse.[11]

And worse. Further deflating hopes for crisp winters, the epochal prospects of global warming favor the adelgid's deadly march, and they metaphorically flatten the barriers northward. Temperatures in New England forests are expected to increase by five to ten degrees Fahrenheit by the end of the century.[12] Not only will adelgids do better, but summer drought related to climate change depletes the water available to the trees.

Adequate water is doubly important for big trees, which need more of it. Also, when hemlocks are chemically treated, the uptake of pesticides is directly linked to the movement of fluids in xylem tissue, which slows to a trickle during droughts.

Thus the fate of hemlocks is cast in the double-bill horror flicks of catastrophic globalism and catastrophic global warming. These trees are further stressed by the invasion of yet more exotic plants and heavy browsing by inflated populations of native white-tailed deer.[13] And further: the elongate hemlock scale (*Fiorinia externa*), also from Japan, sucks nutrients from hemlock needles and deposits white secretions, thinner than the cotton-like balls of the adelgid. The scale kills hemlocks, though not as fast or extensively as the adelgid does.

Some scientists hoped that isolation would save a few hemlocks. Yet the demise of the great trees in the Smoky Mountains offers little reason to believe that remoteness alone will save a single tree—short of one transplanted to, say, Chile, where an organization called Camcore is actually growing hemlocks in plantations for backup security against extinction. All that said, it is still hoped that—separated by many miles of intervening lowlands—disjunct hemlock populations in the southernmost Appalachians of Alabama may remain unaffected, at least for a while. But nobody appears to be monitoring that situation or preparing to treat those hemlocks at the limits of their range.

The net result of multiple hazards to our hemlocks is what ecologist David Foster calls a "cataclysmic shift taking place in our landscape."[14] Complete or near-total loss of hemlocks can follow within four years of the adelgid's arrival, though distressed trees have managed to survive for many years in northern climes. At

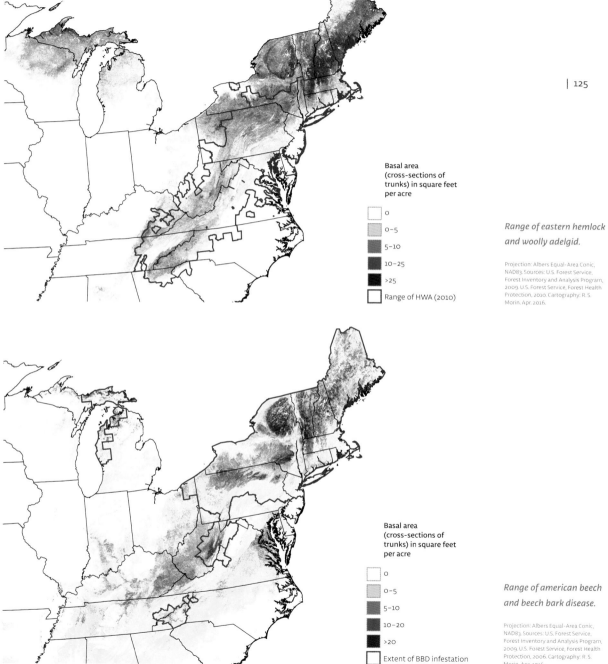

Basal area
(cross-sections of
trunks) in square feet
per acre

- 0
- 0–5
- 5–10
- 10–25
- >25
- Range of HWA (2010)

*Range of eastern hemlock
and woolly adelgid.*

Projection: Albers Equal-Area Conic,
NAD83. Sources: U.S. Forest Service,
Forest Inventory and Analysis Program,
2009. U.S. Forest Service, Forest Health
Protection, 2010. Cartography: R. S.
Morin, Apr. 2016.

Basal area
(cross-sections of
trunks) in square feet
per acre

- 0
- 0–5
- 5–10
- 10–20
- >20
- Extent of BBD infestation

*Range of american beech
and beech bark disease.*

Projection: Albers Equal-Area Conic,
NAD83. Sources: U.S. Forest Service,
Forest Inventory and Analysis Program,
2009. U.S. Forest Service, Forest Health
Protection, 2006. Cartography: R. S.
Morin, Apr. 2016.

60 percent crown loss, the trees can't recover without chemical intervention. While hope persists that resistant hemlocks will be found (see chapter 5), those are likely to be single trees or, at best, small groves here and there. Meanwhile, the adelgid eliminates most or all stands as we know them, especially south of New England. The International Union for Conservation of Nature in 2013 ominously added the eastern hemlock to its "Red List" of imperiled species, meaning "near-threatened."

When hemlocks die, their role in providing winter shelter to wildlife, their sites for nesting birds, and their shelter for denning animals all disappear. Stream flows decline, water temperatures increase, and the number of native brook trout falls. Because of overbrowsing by deer coupled with short-lived seed viability and persistent adelgid predation, hemlocks tend not to come back after being killed by these insects, and so ecosystem changes could last indefinitely.

Once dead, the hemlocks' elegant structure weakens quickly. Bark and limbs tumble to the ground. Roots rot, and within a few years windstorms bring the stark skeletons crashing down. Then, what was once a hemlock enriches the soil and sets the stage for another forest, of another kind.

As that process begins, different species of trees germinate, sprout, and shoot up in openings that have not seen sun in dozens, hundreds, or even thousands of years. Black birches often pop up first and can total 76 percent of new growth.[15] Oaks, sugar maples, red maples, white pines, and beech sprouts rush to fill sunlit gaps, and in the South, black birches, striped maples, deciduous magnolias, blackberries, and silverbells gain ground. Another woodland is born. But like the forests that followed the chestnuts, the new one is diminished by the loss of a tree that filled its own irreplaceable ecological niche and, along the way, created the primeval groves that were so deeply enchanting and memorable, on quiet summer evenings, simply to enter.

Loss of the hemlocks would be shock enough to the natural and human communities that have grown up around them, but their closest forest companions, the beeches, are also in a vortex of decline.

Cryptococcus fagisuga, a yellow, soft-bodied scale insect one-sixteenth of an inch long, was unwittingly shipped from Europe to Halifax, Nova Scotia, on a potted ornamental European beech sometime before 1890.[16] As with the adelgid, the infestation gradually gained a foothold in North America and then picked up brutal momentum. *Cryptococcus* feeds only on the American and European beech. Adults lay eggs on the bark in midsummer and die, leaving offspring to hatch from late summer through early winter. These nymphs—again called crawlers—have legs and walk. They also get blown from tree to tree. They feed by inserting a tubelike stylet into the smooth, thin, vulnerable beech bark and then sucking cellular fluids of the phloem. First-stage nymphs morph into a legless, immobile second stage and overwinter. In late spring, they molt again and become third-stage adults. These secrete a protective "wax" that covers their bodies. It looks and feels like white paraffin poured down the boles of beech trees. Out in the wilds of the eastern woods, when outbreaks reach their peak in newly infested stands, the scale's excretions make a creepy, wax-museum-like hallmark of the insect's presence, blanketing elegant trunks with a necrological coating while the trees still struggle gamely for life.

Cryptococcus is scourge enough, but the real damage occurs when fungi of the genus *Neonectria* invade the bark that's been compromised by the feeding of the scale insects and proceed to digest cellular contents of the tree's phloem or cambium, and multiply. One of these, the native fungus *Neonectria ditissima* (formerly *Nectria galligena*) is sometimes the first to infect the tree, followed by the fungus *Sarcoscypha coccinea*, which becomes the dominant pathogen. Long thought to be an exotic species, recent analysis indicates that *S. coccinea* may be native to North America.[17] It lacked its deadly purchase until the importation of *Cryptococcus*. Infected bark often bears the fungus's red sexual fruiting bodies.

Fungus-induced cankers multiply on the bark and coalesce enough to girdle the tree and kill it the same way you can do with an axe. Where cankers appear as raised lesions, it may mean that the tree has walled off and localized the infection—a sign of tolerance of the deadly invaders. But, more often, the lesions are sunken, indicating that the fungus has broached the bark barrier and reached the underlying cambium. Cankers multiply like arboreal leprosy, all the more gruesome considering how exquisitely beautiful, smooth, and sensual the bark of a healthy beech is. Early onset is sometimes seen in an oddly anemic yellow tint of late summer foliage. When 20 percent of trunk circumference is infected, or

Beech bark disease has struck these trees in the Pine Creek Canyon of north-central Pennsylvania.

The World Transformed

three-foot vertical bands of damage occur, the tree is in jeopardy. Most beeches live only five to ten years after the first *Cryptococcus* appears.[18] The deadly duo of exotic insect and fungus together destroy whole stands.

In the 1920s, John Ehrlich, an illustrious doctoral student at Harvard, named the combined *Cryptococcus* and fungal plague "beech bark disease." With painful accuracy, he predicted that it would someday encompass the entire range of the tree. As of 2007, the disease had spread to 30 percent of the beech's range. But it's worse than that; most of the best regions, where beech was dominant, are badly infected.[19]

Like the adelgid, *Cryptococcus* crawlers die in severe cold, but even at minus thirty-five Fahrenheit, some survive to resume breeding. Both the scale and the fungus are carried by wind and other means, including firewood trucking.

While the hemlock woolly adelgid spread from Virginia north, south, and west, beech bark disease spread from north to south, the two plagues racing like heinous tidal waves from two simultaneous epicenters, destined to collide and then continue on their paths, doubling damage to every forest in their way. Beeches were dying in Maine by the 1930s. Most of New England and New York were scarred by the 1960s, Pennsylvania by 1975. By 1992, the disease was confirmed in the Smoky Mountains. Spreading to Tennessee, Ohio, and Michigan, it has even ravaged low-elevation forests, which for a while had seemed to be spared.

The blight does not eliminate all beeches. Within some stands, a few trees often appear to

A tall beech on the left and hemlock on the right share rocky terrain at Ohiopyle State Park, southwestern Pennsylvania, where hemlocks are being treated for woolly adelgid and where beech bark disease has not yet encroached.

Twilight of the Hemlocks and Beeches

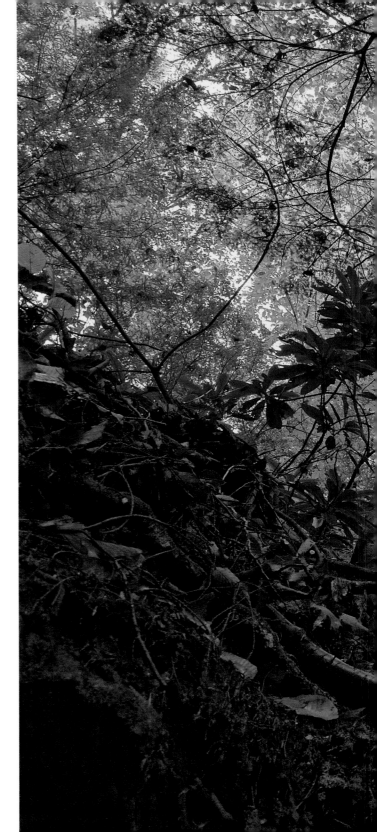

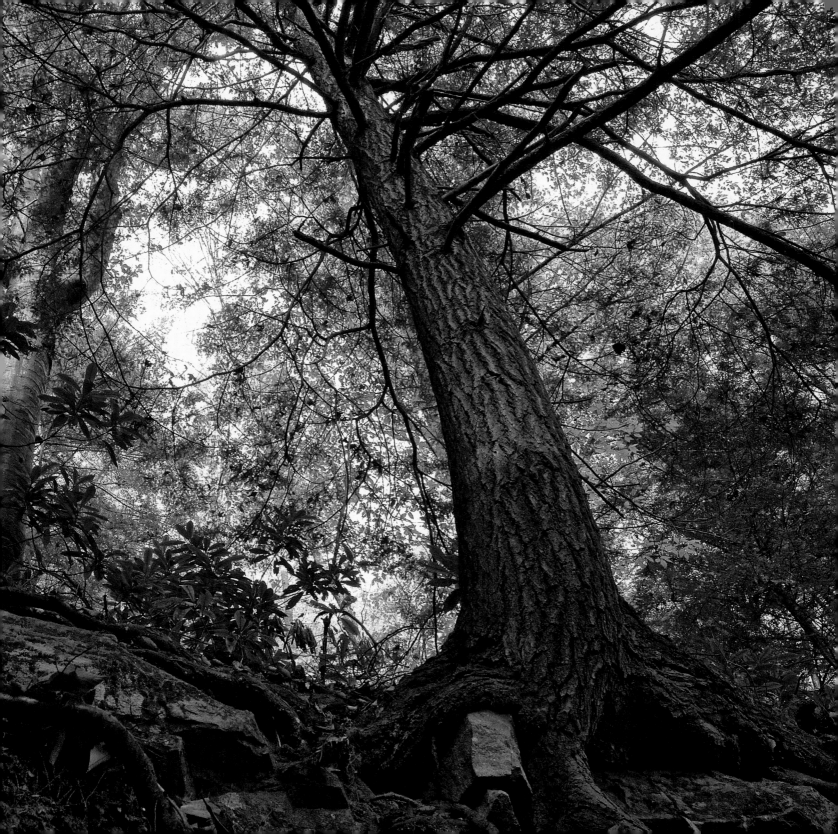

be resistant (see chapter 5). Studies by Randall Morin of the U.S. Forest Service indicate, counterintuitively, that forest coverage by beeches is actually expanding. But this is because of root sprouts. Beeches can sprout prolifically, especially in the northern half of their range. Like chestnuts, however, sprouts contract the fungus as they grow. Nearly all are likely to be disabled or dead before reaching ten-inch diameter and before producing seed.

As most of the old beeches die, fall, and quickly rot, releasing a vapor of carbon into our troublesomely warming atmosphere, memories of them likewise fade, as one generation of beech aficionados passes and their heirs are impoverished without even knowing it, having little awareness of the greatness of these once towering, smooth-barked trees.

The ships that brought the Vikings, Columbus, the Spanish, and the Pilgrims to America were followed by sailing vessels full of English, German, and then other prospective Americans from all over the globe. Those ships also brought us Dutch elm disease, woolly adelgid, and beech scale. Not to mention starlings, nutria, zebra mussels, Asian clams, snakehead fish, Japanese beetles, fire ants, tiger mosquitoes, forty-five species of unwelcome earthworms, Scotch broom, gorse, kudzu, and hundreds of other invasive species, including—get this—Burmese pythons up to twenty-three feet long, which have escaped bizarre Florida pet collections in significant numbers and are reproducing in the wild. The curse of globalism now imports Ebola and Zika viruses and worsening unknown pathogens, pests, and plagues from every continent but icy Antarctica, which doesn't have much to give.

And it's a two-way street. Native species adored in America wreak havoc on other continents—gray squirrels in England, crayfish in Africa, and raccoons as masked bandit emigrants from the United States raiding garbage cans in Germany and hissing when, in self-defense, Germans interrupt them. Largemouth bass sourced in America earn their name by ravaging native fish on every continent but two.

Facing such an onslaught, native life almost everywhere is threatened by unleashed agents of the new globalism. Yet faint and winding paths are opening for the protection and restoration of North America's great ecosystems. Let's look next at how it might still be possible to save and replace a sample of our wild hemlock and beech forests.

Hemlocks killed by the woolly adelgid still stand above the Horsepasture River, Pisgah National Forest, North Carolina.

Twilight of the Hemlocks and Beeches

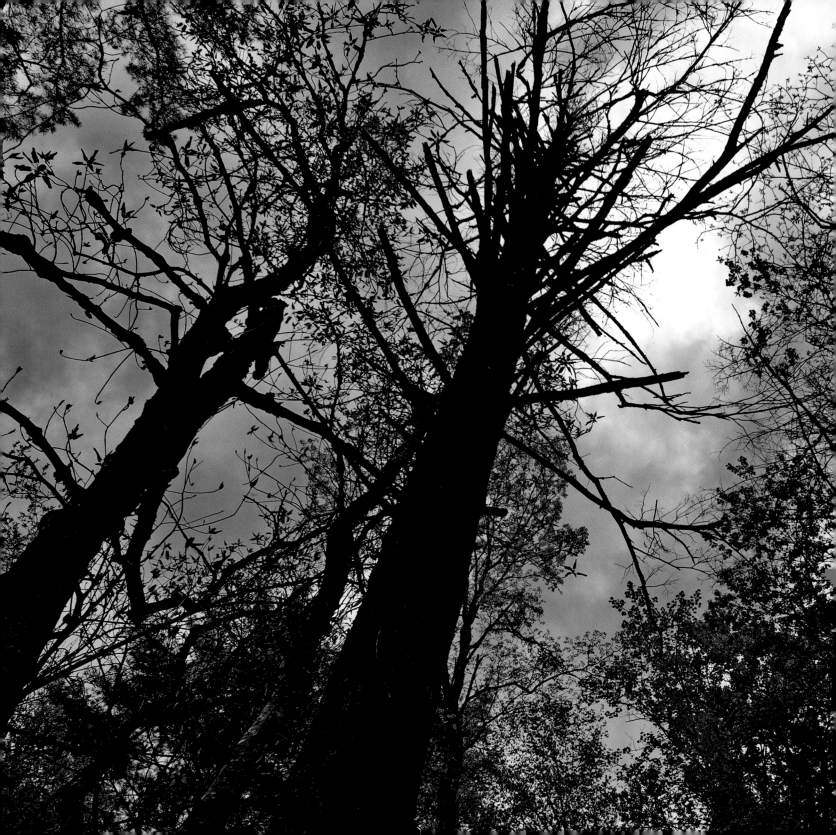

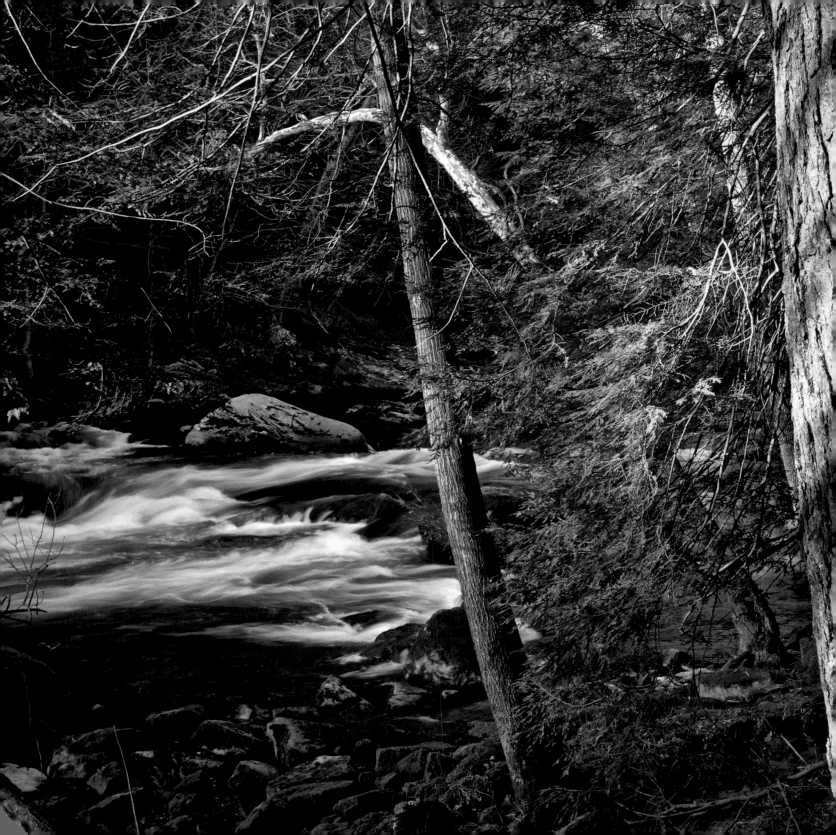

Chapter Five
Survival and Restoration

From modest New World footholds, the insects and pathogens killing our hemlock and beech forests grew into formidable biological forces across eastern North America. Now, faced with not just the threat but the inevitability of species and ecosystem collapse, what's being done to curtail these agents of destruction? Can we hope to rescue or sequester even token samples of the great trees we have known? Looking further, can we set the stage for restoration of a forest that has been so important and beloved by so many?

This chapter addresses prevention of future problems, chemical treatment with insecticides as a stopgap measure, resistance to disease, hybridization, and biological controls whereby another insect or fungus might neutralize the threat.

First, problems always get bad before they get worse, so we need to guard against additional threats. The woolly adelgids of tomorrow should be stopped. But they're not. Case in point: the emerald ash borer, first noticed in 2002, now devastates ash trees in an ineluctable epidemic throughout the East.

Hemlocks at McConnells Mill State Park remained free of adelgid damage as of 2016, though the exotic insect's arrival was expected.

Scientists writing in *Ecological Applications* reported, "The most serious and urgent near-term ecological threat for many United States forests and urban and suburban trees is the recurrent introduction of insects and pathogens from other continents." Economic damage totals billions of dollars annually, and 63 percent of the nation's forestland is at risk for additional mortality from exotic pests. Further, alien biota is "the only forest disturbance agent that has proved capable of nearly eliminating entire tree species."[1]

To get a better grip on the tenuous fate of our forests, we need to vigorously enforce limits on the import of wood products and live plants arriving on our nation's shores. But current laws, institutions, policies, funding, and staffing are all woefully inadequate to this task. In some cases—such as international trade agreements—the trends of recent decades toward freer trade have been moving boldly in the wrong direction, opening our borders to anything that anyone might consider an economic endeavor. The burden of payment needs to shift from those who suffer after pathogens are introduced to the importers of exotic plants and wood, which, if not stopped, should be limited, screened, and treated. Solutions are more complex than this modest chapter can explore, but they need to be pursued.[2]

Even with focused efforts, we will never be entirely successful in keeping disease vectors out. So, as the next line of defense, we need to aggressively eradicate, isolate, or disable troublesome pests when we first find them. Recognizing that beech bark disease has leapfrogged to campgrounds, partial solutions can be as simple as banning transport of firewood.[3] We can clean our boats, fishing gear, and waders of waterborne hitchhikers before going to the next river or lake, and we can take precautions against other exotic threats. One indication of the impediments blocking this seemingly innocuous goal, which you'd think should surely gain consensus: the same year that adelgids were discovered in Great Smoky Mountains National Park, they were found to be widespread in landscaping nurseries. The commercial movement of infested plants jump-started adelgids ahead of their expected rate. That's probably how adelgids *got* to the park and to other forests south of Virginia. Yet, even knowing this, efforts to enact quarantines repeatedly failed at local, state, and national levels. Regulations were unpopular, of course, in the nursery business. Observers, including Rusty Rhea of the Forest Service, further suspected that the problem was exacerbated by nurseries' panicked rush to sell their hemlock stock before any pending quarantines were imposed. Partial quarantines were eventually enacted, but only for states beyond the adelgid's current reach, such as Ohio.[4]

For the woolly adelgid, it's too late for sensible though politically vexing prophylactic approaches, and the question is how to address the advancing epidemic.

Both scientists and managers are clear that chemical treatment of hemlocks with insecticides is the only reliable way to save selected trees. Persistent retreatment has proved effective. However, owing to the vastness of the problem, this is not an option for whole landscapes. At best, the chemicals buy time so that we can retain key hemlock populations to build upon after effective but still undetermined defenses at the ecosystem level are found.

The pesticide of first choice is imidacloprid. A systemic insecticide, it's taken up by the plant and

circulated through the woody tissues, without internal harm, and transported to the outermost twigs, where adelgids consume the toxin and die. It moves slowly through the plant's conductive fibers, offering protection for seven years, according to studies in Great Smoky Mountains National Park. Imidacloprid tablets are inserted into the soil at the base of the trees, or the pesticide is more efficiently injected directly into the bark. Spraying is troublesome, as the adelgid's woolly coat sheds water, and rain washes away the topical sprays, so they pollute surroundings more easily.

Far more expensive, but capable of tipping the balance between life and death for heavily infested trees, dinotefuran moves quickly through trees' vascular systems, killing adelgids within weeks but losing effect sooner than imidacloprid. Arborist Will Blozan reports that this agent can work very fast, that relative moisture doesn't matter, and that the chemical appears to actually give hemlocks an unexplainable boost of growth. Yet it is seldom used. To be safe, any insecticide must be applied correctly and only in targeted areas.

Sometimes treatments appear to eliminate all adelgids on the specifically treated hemlocks. The healthiest trees respond best, but victims with extensive needle loss can still transport lethal doses of insecticides to the canopy. Treated hemlocks often produce new growth on most branches.[5]

The pesticides, however, cost money and require labor and repeated application indefinitely. Imidacloprid is among the most widely used pesticides worldwide in agriculture and landscaping, but tighter restrictions are being considered because broadcast spraying by crop dusters in the West and unregulated household use on flowering plants have been implicated, along with other

factors, in the alarming "colony collapse disorder" of bees.[6] In 2016, the state of Maryland banned household use of this and other neonicotinoid pesticides after the International Union for the Conservation of Nature's Task Force on Systemic Pesticides reviewed 1,121 scientific papers and concluded that poorly regulated use of this and similar pesticides kills pollinating bees.[7] But application to hemlocks does not cause this problem, as hemlocks wind-pollinate without the aid of bees or other insects. The amounts of pesticide in the foliage are far below mammalian toxicity for animals such as deer that browse the needles. Addressing concerns about runoff, downstream surveys of treated areas show all samples well below Environmental Protection Agency benchmarks.[8] Ultraviolet light from the sun causes the pesticide to degrade rapidly.

Nonetheless, some people concerned about birds, fish, insects, soil microbes, and water supplies reject all chemical options, noting a sordid history of unanticipated effects from DDT on down. But others argue that chemicals applied to hemlocks are safe, and that they are the only means of forestalling imminent and total hemlock mortality until a benign solution surfaces. Dr. Mark Faulkenberry of the Pennsylvania Bureau of Forestry considers targeted chemical applications to be safe, though the cost mounts for large-scale applications and long-term treatments.[9]

Caring for the finest remaining hemlock groves in the East, Cook Forest State Park in Pennsylvania has treated several thousand trees beginning in 2013. Cold winters in 2014 and 2015 reduced adelgid numbers, buying time. "We're probably going to lose a lot of hemlocks, but if we don't do anything, we'll lose them all," said park naturalist Dale Luthringer.

At Ohiopyle State Park in the southwestern corner of Pennsylvania, the most critical of six hundred acres of hemlocks are being treated. "We plan to do this indefinitely until a better alternative is available," said park naturalist Barbara Wallace. At Woodbourne Preserve, in the opposite quadrant of the state, the Nature Conservancy treats hemlocks every three years, keeping ahead of the adelgids by killing 90 percent each time. In the old groves of Zoar Valley and Watkins Glen, the New York State Department of Environmental Conservation treats hundreds of trees. At Kentucky's Cumberland Falls, state park crews treat hemlocks at the East's second-largest waterfall.

Across its half-million acres, Great Smoky Mountains National Park has applied imidacloprid to 250,000 trees since 2002—12 percent of the hemlocks in the park, including 26,000 in 2015 alone. Park forester Kristine Johnson said she saw a dramatic difference between treated and other areas; nearly all the hemlocks were dead in untreated zones.[10] The U.S. Forest Service identified 175 hemlock conservation areas in North Carolina alone; special efforts there combat the adelgid through chemical and biological means. The agency allocated $200,000 to $300,000 per year for each national forest in the South. The best results occurred where trees grew in the open, without crowds of other hemlocks around them. In a large project at Savage Gulf State Natural Area near the southwest end of hemlock territory, Tennessee State Parks hired Appalachian Arborists in 2015 to treat 8,500 trees.

The 75 largest hemlocks in the United States—all in the southern Appalachians—were not effectively treated, and by 2007 all were dead but one—the 5-foot-diameter, 158.7-foot Cheoah in North Carolina,

tended by the Highlands-Cashiers Land Trust and old-growth aficionado Will Blozan, who called Cheoah "the most medicated tree on earth." This tallest and largest remaining eastern hemlock still lives as of 2017 only because of the treatments. Other four-hundred-year-old hemlocks in the same grove are dead or dying because of inadequate amounts of insecticide being applied under poorly defined limits (referring to volume of chemical applied per acre).[11]

Great Smoky Mountains National Park found that treatments lasting seven years average $14 for a large tree.[12] This is far cheaper than removal of a dead hemlock, which typically runs several hundred dollars, and often far more than that where it is required, such as at campsites or near houses where deadfall might be a hazard.

For beech bark disease, no satisfactory chemical applications are known. Efforts have been thwarted by the failure of insecticides to reach the troublesome *Cryptococcus* in the tissues where it feeds, by the waxy covering that later shields the insects, and by the brevity of the crawlers' vulnerable period—only a few weeks. Some landowners and researchers report temporary success with a horticultural oil that suffocates the insects. The fungal half of beech bark disease is even more irrepressible than the insect.

Given that chemical application is at best a short-term fix dependent on toxins, hope lingers for the best scenario that one might imagine at this late hour: trees that show natural resistance to the pests.

Resistance is a classic principle of evolutionary science. Through genetic variability, some individuals have the wherewithal to resist or tolerate certain agents of

harm. Plants might do this by repelling or attacking the intruder through their own microbiome or chemistry, by isolating the foreign attacker with barriers such as scar tissue or thick bark, or by inhibiting it with purging flows of sap. Defensive traits embedded in the plant's genetic code are transferred to offspring, which survive to reproduce while other individuals do not, gradually equipping the evolving species with new defenses. Western hemlocks, for example, are thought to be resistant to the native adelgid in the Pacific Northwest, and Chinese hemlocks to adelgids in Asia. Those trees evolved over time in tandem with the pests. Unfortunately, most eastern hemlocks show no resistance to adelgids, though a few exceptional trees have been found.

At the Delaware Water Gap, a stand of hemlocks surrounded by adelgid infestation for more than twenty years shows little damage. Monitoring these, Richard Evans of the National Park Service casually threw out the name "bullet-proof stand" one day, and it stuck. "Working with these trees and with this problem is humbling," Evans reflected in an interview with me. "There are so many variables that it's difficult to pinpoint cause and effect. That stand grows at the base of Kittatinny Ridge, with a cool microclimate and groundwater, which would both help." But a lot of other hemlocks have perished elsewhere at the base of Kittatinny, which loosely continues under other names for much of the length of the Appalachians. Outside the "bullet-proof" stand but within the Delaware Water Gap National Recreation Area, Evans found 30 percent hemlock mortality from the adelgid, while the other 70 percent invariably sustained damage throughout the two decades that the "bullet-proof" stand endured. If

not full-blown resistance, something interesting was clearly going on there.

Entomologist Richard Casagrande and others at the University of Rhode Island took cuttings from those and other trees, induced rooting, and found "putatively resistant" individuals with lower adelgid settlement compared to other cuttings. When the presumably resistant hemlocks were exposed to adelgids, they "continued to grow throughout the three years of observation."[13]

Looking for chemical clues, Alexa McKenzie at the University of Massachusetts reported in October 2014 that the twigs of apparently resistant hemlocks had higher concentrations of terpenoids, which are presumed to repel adelgids.[14] Further testing in other labs will confirm whether the trees that Evans found at the base of Kittatinny Ridge are resistant or not. Mark Mayer of the New Jersey Department of Agriculture is aware of three New Jersey locations that may also have resistant trees. Yet, by any measure, the number of resistant hemlocks is extremely small.

Searching the southern Appalachians, Will Blozan of the Eastern Native Tree Society has found no trees that appear resistant. Yet the hopeful scenario holds that additional surviving hemlocks will be found, and that they will breed and spread. Many scientists want to believe that the species could filter through a constricted genetic bottleneck, like sand trickling through an hourglass, and emerge on the other side with a growing population once again. "But let's not kid ourselves," Blozan cautioned. "Recovery will take a long time."

How such a diminished inventory would recolonize the eastern landscape is a good question. Perhaps it will take two thousand years, as it did after the great

die-off fifty-five hundred years ago. Or perhaps an army of Johnny Appleseeds will propagate resistant stock, though no precedent exists. In Oregon, efforts are being made to outplant endemic Port Orford cedars that are resistant to an exotic fungus-like pathogen, but even in that tree's small range, the effort appears trivial on an ecosystem scale. And will the number of surviving hemlocks be so few that the genetic pool will be too limited for long-term viability? No one knows.

Prospects for resistance in beech trees are better; 1 to 5 percent qualify as "super beeches" apparently capable of surviving, if not avoiding, the onslaught.[15] At the low end of the resistance odds, 1 percent often appear to be totally immune to the beech scale. The other 2 to 4 percent show variable degrees of resistance to the insect or tolerance of the fungus. So a disease-free survivor can be found here and there among the dead. Sometimes these "clean" trees occur in groups of trees that are closely related genetically—clones from root sprouts of a resistant beech, or trees from seeds of a resistant parent, according to Forest Service plant pathologist David Houston and his geneticist brother, Dan.

Using DNA analyses, biologist Jennifer Koch and others have confirmed this pattern of resistance and found that it was indeed transmitted to the next generation. They suggest that selective breeding "may be an effective means to improve populations" and that eliminating diseased trees and leaving those that appear resistant may be "an effective management option."[16]

David Houston suggests that the coming decades and centuries may see a "sorting out" of healthy trees whereby the resistant and tolerant individuals survive and propagate. In a strange twist of biogeography, beeches within fifty miles of the Atlantic coast appear to be less diseased than those farther inland.[17] Outstanding groves survive on islands such as Martha's Vineyard. An unexpected hypothesis is that air pollution from the Northeast megalopolis retards the growth of the damaging fungus. But no one, of course, is recommending air pollution as a solution.

Taking the resistance issue into the lab, geneticists hybridize plants by mating partners that show survival proclivities. Hybrids can also be bred by matching vulnerable species with closely related species known to be resistant. If just enough DNA comes from the resistant relative, such as Chinese hemlock, nearly native offspring can be spiked with resistant genes. Following this path, geneticists for decades have sought to cross the American chestnut with its Chinese cousin for a cultivar resembling the American in every way, but with the desired resistance. Recent innovations of a different type have yielded a "transgenic" variety by introducing an agrobacterium that disables the fatal effects of the fungus.[18]

However, crossbreeding with the eastern hemlock has proved impossible owing to its limited range of DNA. This is probably the result of our species' divergence from the proto-hemlock so long ago and to an accumulation of reproductive incompatibilities, and perhaps also to the big die-off fifty-five hundred years ago and to another one ninety-eight hundred years ago, with related bottlenecks of genetic variation. Eastern hemlocks will not hybridize with western or Carolina hemlocks either.[19] *Caroliniana*, it turns out, is surprisingly amenable to crossing with its distant Asian relative for a potentially new hemlock of the future. However, the brave new world emerging from

a genetics lab has its own troubling implications. "Do we really want yet another exotic species—this one of our own making?" asked David Foster of the Harvard Forest.

Fearing an endgame here, the Pennsylvania Bureau of Forestry investigated the introduction of western hemlocks as a "potential replacement" for eastern hemlocks.[20] Climatic requirements seemed to match, but because of unknown subtleties, our western species does not favor the East; in eastern arboreta, they struggle. If replacement of eastern hemlocks were the goal, the Chinese *Tsuga* would make more sense; it closely resembles the eastern hemlock and grows well in test plots such as the Arnold Arboretum's Hemlock Hill, where it was successfully introduced after the woolly adelgid was discovered there in 1997. But, as Dr. Foster asked, do we really want an Appalachian forest made of Chinese trees? If that's our best option, perhaps we should just throw in the towel and move on to black birches and sugar maples.

To treat the beeches' woes, a creative hybridization approach is being taken. From resistant trees, Forest Service pathologists have collected scion wood as twigs, grafted them onto beech rootstalk, and then grown the trees in orchards. The grafted scions carry the scale resistance of their parent tree. Subsequent flowers—when pollinated from other resistant trees—produce seeds with increased resistance. It would be easier to simply collect the seeds of the surviving beeches and sow them, but they come from crosses with nonresistant trees; the scion graft offers a more reliable genetic transfer. Aiming to plant this seedling stock experimentally, Pennsylvania forest pathologist Thomas Hall said, "Hopefully, the more tolerant genetic

strain will take off, and in time—perhaps a hundred years—we'll see a strong population of resistant trees."

Looking beyond insecticides, resistance, and hybridization, most scientists recognize that the best possibility for attacking hemlock woolly adelgids—and perhaps the only real option in the wild—is biological control. This involves the introduction of organisms that prey on the adelgid or in other ways prevent it from reproducing—letting nature, with a bit of arm twisting, do the work. The trees' biological allies in most cases are exotic themselves, taken from the adelgid's homeland, where predators had time to evolve. In Japan, an oribatid mite and lady beetle prey heavily on adelgids, keeping them at "innocuous" levels, according to Mark McClure's early observations.[21]

Importing insect predators to North America introduces more alien species, and history is replete with good intentions gone bad, especially among vertebrate introductions. But the modern safety protocols and permitting procedures of the U.S. Department of Agriculture are intended to avoid such pitfalls and have largely done so with carefully introduced insects.[22] Researchers seek allied organisms that will not pose unintended threats and that are likely to die out themselves if their prey vanishes.

Various predatory insects have been captured, brought to America, quarantined, and tested in labs. Six species of adelgid-eating beetles have so far been approved and introduced in the wild. Some have apparently become established, with reproducing populations.[23] The *Sasajiscymnus* (sa-saj-e-SKIM-ness) lady beetle, which looks like a tiny black ladybug, was brought from Japan and now occupies fifteen states,

with "good potential for producing localized reductions in pest levels," according to the Forest Service in 2004.[24] Now considered a better choice, varieties of *Laricobius nigrinus* from Japan and the Pacific Northwest have been released in eleven eastern states. "We've dedicated our resources roughly fifty-fifty between chemical and biological approaches," said Rusty Rhea of the Forest Service's Southeastern Region, "and we're trying to shift more to the biological."

Complicating matters, it's not only the adelgids that suffer from cold winters but also their introduced predators, and so a strain of *nigrinus* from Idaho has been drafted for winter hardiness, though it's difficult to capture, and even it may lack sufficient hardiness for the recurrent polar vortex that descends on New England. All *Laricobius* species seem to dislike captivity and are difficult to rear, but that wouldn't matter so much if populations take off on their own.

Insect-killing fungi also offer potential, according to the Forest Service article "Biological Control of Hemlock Woolly Adelgid," which states that "both predators and pathogens will be required" to suppress adelgids. Ecologist David Orwig said, "If anything can kill adelgids at a broad ecosystem scale, it's likely to be a fungus," and he pointed to the current status of the gypsy moth (see chapter 6). However, pathogens of this type come with cryptic life histories and risks, and are not yet sufficiently lab-certified for introduction. "After fifteen years of research, we still aren't anywhere near having a fungal agent ready to deploy," reported Rusty Rhea. Further fungal work may be the most important but underutilized approach in the adelgid war.

Connecticut was the first state to implement biological controls on a large scale and the first to report hemlock recovery. *Sasajiscymnus* was released in 1995, when some 90 percent of the state's hemlocks were infected with adelgid, many so extensively that recovery seemed hopeless. By some observations, beetles were later found to persist at 65 percent of the release sites.[25] While several warm winters have favored adelgids, other cold winters have knocked them back. In an interview, Dr. Carole Cheah recognized that "many factors are at play, but we believe that, thus far, the adelgid peaked in Connecticut in the late 1990s. We need funding to investigate effects at a statewide or ecosystem scale, but the beetles appear to be effective at least at the local level. I'm hopeful that we might see a long-term reprieve for Connecticut's hemlocks." Not the least of the challenges is finding the tiny beetles, which congregate high in the canopy, making it difficult to survey the predators accurately—or for that matter, to see them at all.

New Jersey state entomologist Mark Mayer confirmed that the adelgid appears to have peaked there as well in the 1990s. And introduced *Laricobius* beetles appear to be multiplying. "We're finding them elsewhere in the Delaware Water Gap and beyond," he said. "Ten years ago I had little hope, but this is encouraging." Mayer noted that lady beetles from China and silver flies from the Pacific Northwest may also have potential for consuming adelgids.

Richard Evans of the National Park Service recalled, "Early efforts released a few hundred beetles at each location, with little result. Later we released thousands, and with those kinds of numbers, the beetles seemed to take off."

The Maine Forest Service released *Sasajiscymnus* at state parks along the coast, where hemlocks and adelgids were both plentiful owing to mild temperatures,

and where hemlock mortality has been high. Forest entomologist Colleen Teerling said, "No one really knows if the biological controls are going to work, but they appear to be the only long-term solution possible."[26]

At the other end of the adelgid's range, the Great Smoky Mountains National Park started releasing predatory beetles in 2002. In 2015, the park reported that "preliminary monitoring results are encouraging."

While anecdotal evidence points to at least nominal success with biological agents at a local scale, especially in the North, the prospects for widespread success remain, at best, unknown. In the South, hemlocks are handicapped by warmer winters and summer droughts, making any remedy an uphill battle. Will Blozan pointed out that the reproductive prowess of the adelgid exceeds that of the predatory *Laricobius* by an order of magnitude or more, making it impossible for beetles to quell an infestation. Yet he maintains hope that "biological control will eventually be useful, not as an agent of preservation to save an infested forest—chemical treatment is necessary there—but rather as an agent of restoration. Once the adelgids are reduced, established beetles might be able to keep the pests from rebounding when hemlocks begin to gain ground again."

At issue here is the question of proof that adelgid predators can be effective on a geographical scale, and no such proof yet exists. But the more timely question is, with further work, can we legitimately hope for effective biological controls in the future?

While further surveys will shed light on these questions in years to come, the hemlock saga in the Pacific Northwest has played out quite differently. The woolly adelgid was first noticed there in 1907. The insect was long thought to be an Asian import, but recent DNA analysis indicates that it is "native" to North America. More specifically, it arrived from Asia long ago, before the last glaciation, possibly carried by birds, according to Nathan Havill.[27] Over the eons, both species of our magnificent hemlocks in the Northwest adapted to the pest with host defenses, resistance, and local predators, all in some effective combination not yet understood. For whatever reasons, hemlocks in the Northwest go unharmed, though this might not be the case if another species of adelgid were to arrive.

When Connecticut entomologist Mark McClure brought western hemlocks east and exposed them to local adelgids, the trees did not become infested. Other experiments have confirmed this resistance, even without the presence of adelgid predators. Hopefully, this means that western hemlocks would hold their own in the frightening event that eastern adelgids are accidentally transmitted to the Northwest, which may require only one car or one bird but which, remarkably, has not yet occurred, near as we know.

Population biologist Joseph Elkinton of the University of Massachusetts has worked extensively with western and eastern hemlocks and their respective adelgids to decipher complex predator-prey relationships. He believes that an "extensive suite of predators," rather than evolutionary resistance to adelgids, keeps the pests in check in the Northwest and may be principally responsible for both native western and some arboreta-introduced eastern hemlocks there being relatively adelgid-free. Additional findings in the Northwest's virtual multistate laboratory of hemlock success could reveal ways that eastern hemlocks might gain similar advantages. "There's a lot we don't yet know," Elkinton said in an interview with me, "and to

establish an effective suite of predators in the East could require many species and decades of work."

Uncertainties aside—and without many options from which to choose—the U.S. Forest Service's 2005 "Pest Alert" bulletin called biological controls "the best option for managing hemlock woolly adelgid."[28]

Regarding beech bark disease, biological controls have been explored but found impractical or ineffective. *Chilocorus stigma* is a native that feeds on the troublesome scale, but not to the extent needed.[29] Likewise, a fungus, *Nematogonum ferrugineum*, parasitizes the beech bark fungus but promises little chance of controlling it. A challenge in attacking fungi is their ability to adapt to counteragents. The Forest Service considers propagation of resistant seed stock—such as through the scion-grafting work—to be the most viable means of retaining beech forests.[30]

In order to introduce predators, or even to monitor what's effective and what isn't, or to do virtually anything, including insecticide treatment for imperiled trees in the landmark groves that remain, arborists and researchers must first secure funding, a perennial challenge. Facing a crisis back in 2003, for example, scientists at Great Smoky Mountains National Park managed to eke out an allowance of $40,000 to wage heroic efforts against the adelgid. At the same time, Congress approved $16 million for a controversial $600 million road over the Smoky Mountains—an eminently unneeded but politically greased freeway aimed chiefly at making it faster to drive to the park, if not simply to line the pockets of paving contractors.[31]

Funding shortfalls hamper the research efforts of the U.S. Forest Service and its Hemlock Woolly Adelgid Initiative—the closest thing we have to a strategic plan in the greater adelgid war. Overshadowing everything else at that agency, wildfires in 2015 consumed half the Forest Service budget, up from 16 percent in 1995. Nonfire personnel had been slashed 39 percent.[32] Furthermore, the fires will only get worse with global warming. Within the remaining budget, controls on exotic pests such as adelgids compete for smaller and smaller slices of the pie. A group of dedicated Forest Service scientists and managers do their best to press onward with research, outreach, and treatments.

Similar funding challenges affect everyone involved. Connecticut is a state where people love hemlocks unconditionally, but, as Dr. Cheah explained, "We have not had the support to continue the release of adelgid predators, or for that matter to simply monitor them, even though they appear to be effective." Dr. Foster of Harvard Forest noted the difficulty of just engaging enough entomologists to work on hemlocks, given the funding differential for commercial and commodity work. It's relatively easy, for example, to fund research on blights that threaten wine grapes, corn, or Douglas firs in monocultural plantations owned by industrial timber corporations in the West.

While investigating these issues, I had to wonder: What organization, agency, or coalition is taking responsibility for the plight of our hemlocks, beeches, and other pest- and pathogen-ridden forests? Who systematically evaluates the research and monitoring that's most important to our trees' survival? Who leads the essential fight for better rules on imported wood and living plants, and for enforcement of quarantines? Who lobbies for adequate funding to do what is immediately

needed and to find suitable long-term paths forward? The U.S. Forest Service and its Hemlock Woolly Adelgid Initiative fill these roles in part, and nongovernmental organizations have been effective in some local areas in raising funds for treatments. But focused leadership on the efforts and on the overarching challenges that lie ahead may be needed from both public and nongovernment sectors.

Reasons for the scarcity of organizations stepping up to this plate and for everyone's inability to deal fully with the hemlock and beech crisis are manifold. They include the enormous expanse of geography at risk, the missing trigger to enact decisive change, the impediments to ownership of an issue so big, the absence of glory and easily achievable success that private and public funders often prefer, the dominance of other pressing matters that may have even greater urgency and longer-standing constituencies, and, perhaps at the core, the overwhelming difficulty of the problems. As Jeff Lerner of the nationwide organization American Forests put it, "To solve the pest and disease problem, we're not sure what can be done to make a difference at a large enough landscape scale."

Yet a forest that is known and cherished by so many lies dramatically in the balance, and its ultimate fate could slip through the figurative cracks of public discourse, advocacy, policy, and action.

The near-complete die-off of hemlocks some five thousand years ago may be exceeded in the coming years. Consider that the climatic limitations of the hemlock's "Great Depression" of the past were tempered in the coolest enclaves of the deeply folded Appalachians, where a few trees survived, and that no such refuge

appears likely from the sticky, infectious reach of adelgid crawlers. On the other hand, as hemlock forests decline, the adelgids will ultimately decline with them—especially if predators abound—possibly leading to a new "balance" in a dramatically reduced forest. Could the leveling off of adelgids in Connecticut and New Jersey possibly be a sign that the pest is "running its course" and stabilizing at a level that reflects a less appetizing inventory of remaining hemlocks?

Many questions cannot be answered. Possibilities for resistance and biological controls are real but tenuous. As Dr. Elkinton cautioned, "We're not on the verge of any huge success. This may take a lot of time."

Hope for hemlocks and beeches now appears to lie in chemical treatments that borrow time, with the longer-term goal of resistance and effective introduced biological predators. If hemlocks and beech trees are to survive, it appears that the efforts of state and federal agencies to find solutions must be supported over a period of years, decades, and lifetimes.

"For the long term, we have to work toward genetic and biological controls that will become effective," said veteran old-growth champion and adelgid battler Will Blozan. "In the meantime, we need to chemically treat select trees and stands. Once the adelgid invades in the forests of the South, the hemlocks die quickly. If we don't keep these trees alive now, there's no point in seeking further answers to this problem. We have the tools, the opportunity, and the time to maintain a seed source and a remnant forest today. This is something we must do."

Hope lies around many corners, but not even a miracle can sustain the hemlock and beech landscape with any semblance of the beauty and ecological functions that have defined these forests for thousands of years.

Even the brightest prognosis describes our two species more as patients on CPR than as foundational bulwarks in a thriving ecosystem. The forests shown in the photos of this book could virtually all become visions of the past, as we collectively enter a twilight zone in which abundance, health, and vigor are reduced to a small fraction of what we've known.

Those of us who have known these forests will miss them. Taking a larger view, the fate of these trees raises the specter of other plant and animal species that are even more endangered by a host of problems other than the woolly adelgid and *Cryptococcus*—an unraveling of the natural world that constitutes one of the greatest tragedies of our time.

It's essential that we pursue creative strategies to address the epidemics facing our hemlocks and beeches. But, perhaps even more important, vital actions can be taken to avoid yet greater losses of our forests in the years, the decades, and the centuries to come. This is the topic of the next chapter.

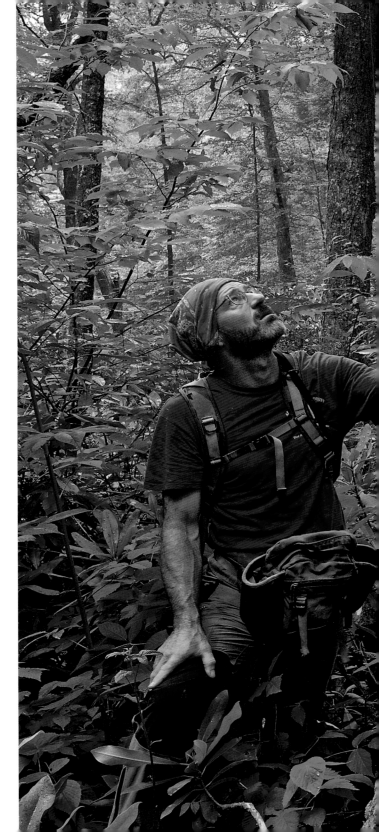

Arborist and co-founder of the Eastern Native Tree Society, Will Blozan monitors the health of the Cheoah Hemlock, which he and the Highlands-Cashiers Land Trust have treated to combat woolly adelgid. This tallest and largest of all eastern hemlocks, clinging to a rugged Appalachian mountainside in North Carolina, is still alive only because of adequate treatment with insecticide.

Twilight of the Hemlocks and Beeches

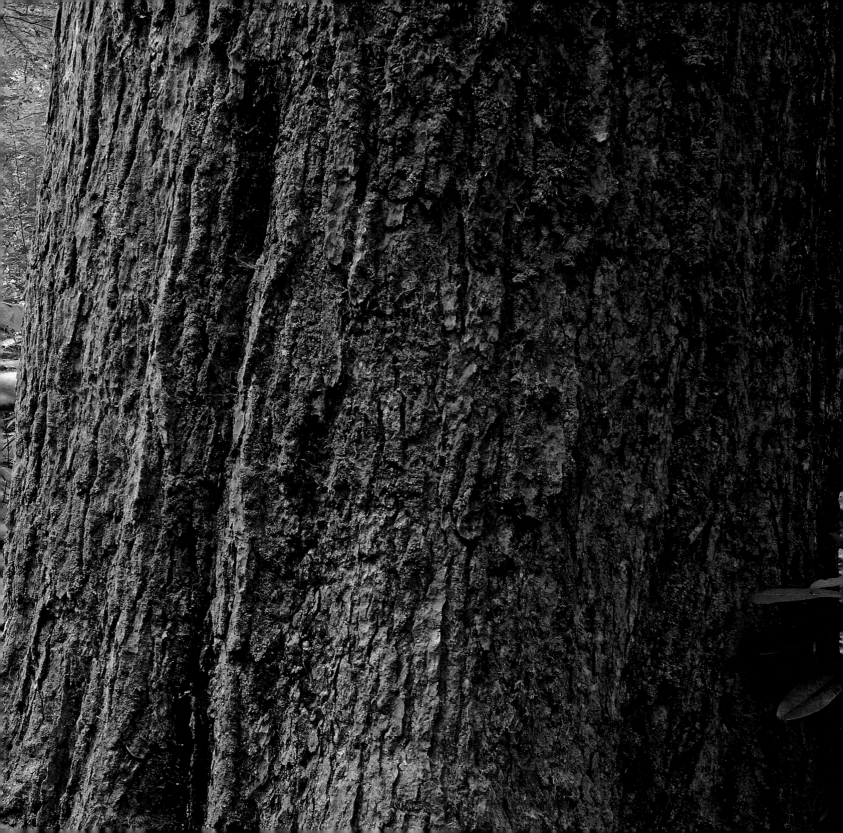

Chapter Six

Lessons from a Beloved Forest

Just out of college, I found myself living in a cabin along Pine Creek in northern Pennsylvania, doing what I could, as a recently graduated landscape architect and young citizen activist, to protect from development, gas drilling, and damming that soulfully enchanting stream. I lived along a tributary aptly named Trout Run, under hemlock trees, in a cement-floored cabin built at the site of a Civilian Conservation Corps work camp dating to the 1930s.

A storage area within the barnlike structure was filled with a long-forgotten stash of lumber, mostly rejected odds and ends, but among them I spotted an arrow-straight board twelve feet long, two sturdy inches thick, and eighteen inches wide. Though haggardly covered with a crumbly veneer of cement and the accumulated dirt of decades, it held unmistakable gravitas in the company of lesser planks. It had been used, I deduced, as a form for pouring the footing and floor of the building where I lived—a function for which the impressively dimensioned piece was profoundly overqualified.

Mature hemlocks still stand at Swallow Falls State Park, Maryland.

Knowing that the region's sawmills had probably not seen a log capable of producing this board's width for eighty years, I took a putty knife and wire brush to see what lay underneath the calcified surface. The wood emerged as reddish brown, prone to splintering where I gouged too deep. Just from scraping I could tell that the knots had aged with the hardness of rocks. The wood suffered some slight cracks along the length of the grain—a defect, I later learned, called ring shake.

The board was hemlock.

The tree it came from had no doubt been magnificent.

With deeper respect now, and a sense of mission rising in my mind, I took stock of my find and decided to honor it the best way I could.

After trimming the split ends and sawing the remaining board in two for a workable length, I positioned the fat five-foot twins next to each other and imagined just the two of them as the surface of a full-width table built on a colonial design I had seen in Williamsburg while on a college field trip a few years before. I cut the base and supports, drilled the wood, tapped in dowel rods to assemble my reincarnation of the great tree, sanded all that I had scraped, and slapped on a coat of clear varnish that enriched the hemlock's warm glow, highlighted the grain, and darkened my creation to look as old as the tree itself.

Immediately, the table became the centerpiece of my kitchen, and then—when I went on the road for twenty-two years writing books—of my sister's kitchen. Now, forty-six years after I made it, the table is again essential to every meal in my home. At the moment, it sits beneath my computer. Daily, it reminds me to respect the great tree that once grew in a mossy refuge among the mountains of Pennsylvania, long before the threat of a tiny alien insect arose.

The first lesson here is one of appreciation, and it's one that I've carried to the woods in my search for beautiful photos of surviving hemlocks and beeches during today's era of heartrending loss. A healthy forest was required to produce the tree that became my table, and so the second lesson here is one of caution, care, and stewardship. The forests that remain will fail to thrive if we fail to care for them well, and our record so far has not been good.

Hemlocks and beeches are not alone in their rapid decline within our eastern forests.

The white ash—a tower of strength throughout Appalachia and the substance of every baseball bat swung in my youth—is being devastated by the emerald ash borer, an invader from Asia first found in the United States in 2002. In a shockingly short time, near-total loss of these muscular trees, and of the green and black ashes, was under way from New York to Minnesota. Entomologists traveled to China to collect borer-eating insects, which are now being introduced, but little chance remains that mature ash trees will be spared. As they die, and as the borer's food source wanes, it's hoped that the introduced predator will keep the borer's population in check while a new ash forest grows in a delicate and diminished balance.

The American elm, which once graced eastern floodplains and was planted by the millions to shade the streets of towns large and small, followed a similar path to the kindling pile. An exotic European beetle chewed through the elms' bark, carrying with it a fungus from Asia. Like the one-two punch of beech bark disease, the

elm's dark duo, aided by a native bark beetle, annihilated both wild and domestic trees. Large specimens remain only in isolated or treated locations. Geneticists have sought to make a resistant cultivar by inoculating tens of thousands of seedlings with the disease and then crossbreeding the most resistant offspring, but a new elm forest in the wild is unlikely.

Butternut trees produced egg-shaped fruits that my father pointed out to me on walks in the Appalachians of Pennsylvania when I was a child. Devastated by a fungus of likely exotic origin, the butternut became the first tree nominated for the endangered species list. Dogwoods—their springtime blossoms incomparably flowering the eastern understory—are afflicted by an alien fungus, anthracnose, and have been withering since the 1980s.

The gypsy moth, metamorphosing from a bristly-haired caterpillar, was introduced from Europe in 1868 with trumped-up prospects of weaving commercial silk. Feral populations slowly gained momentum and then exploded in fury a full century later to denude oaks in wide belts across the East. The caterpillar rarely kills trees outright but grossly weakens and eventually levels many of them by repeated defoliations. In the 1970s, residents of charming neighborhoods carried umbrellas during repulsive outbreaks that literally covered the ground with caterpillars, the scene horrifically beyond any sensible notion of fecundity. The grim trajectory was surprisingly interrupted when, in 1989, a fungus native to Japan, used in a Massachusetts entomological lab way back in 1910, was noticed killing the moths in the wild. The spread of the fungus led to a dramatic downturn in the epidemic; however, new outbreaks continue to occur and the final outcome is unknown.

While most exotic invaders attack one or just a few kinds of native trees, the Asian longhorn beetle, found in 1996 near Brooklyn warehouses stacked with wooden pallets from China, attacks sugar maples and many other species, and its lack of discrimination poses what might be the most ominous threat of all to America's native forests.[1]

Some four hundred alien insect species are known to have arrived in North America during the past two centuries.[2] The National Park Service reported that 380 exotic species of biota affect native plants and animals in the Great Smoky Mountains alone, and the number is growing. The problem extends far beyond trees. Salamanders, crouching under leaves that obscure the amphibian's status as the most abundant vertebrate in eastern forests, now suffer from a fungus bestowed on us by the transatlantic pet trade.

Taking all this and more into account in *The Dying of the Trees*, Charles E. Little identified the cumulative effect as a "pandemic in America's forests" owing to exotic pests and pathogens, but perhaps more fundamentally to air pollution and damaged or poisoned soils. When trees are weakened by air pollution, acid rain, soil depletion, and a warming climate, their vulnerability to opportunistic pathogens increases acutely.

Upwind air pollution from virtually the entire urban, industrial, and agricultural belt of the Midwest handicaps the eastern forest in sinister ways. Pelted for decades by acid rain originating with coal-burning power plants, red spruces in Vermont perished through the 1970s and '80s. Rebounding growth in 2013 may be attributable to the Clean Air Act amendments of 1990, which eventually reduced the acidic sulfur and nitrogen pollution.[3]

Twilight of Another Realm

Throughout the Appalachians, acid rain can damage the waxy surface of leaves, rendering them vulnerable to unfriendly fungi and bacteria. On the forest floor, natural or deposited aluminum, nickel, zinc, and lead are relatively inert, but when activated by acid rain they can be absorbed by roots in toxic concentrations. Moreover, acid rain leaches calcium from the soil and makes unavailable that essential element to plants' growth.[4]

The effects of air pollution can be as blatant as acid rain's altering the chemistry of runoff or as subtle as the thin line between resistance or surrender to exotic pests. Adelgid populations in Connecticut were found to be five times higher on hemlocks exposed to nitrogen overdoses compared to other hemlocks.[5] Meanwhile, ninety plant species in Great Smoky Mountains National Park were harmed by ozone pollution—another outcome of burning fossil fuels.[6]

Deteriorated soil is another reason for forest decline, and according to Charles Little's analysis, it's a culprit in tipping the balance toward exotic pathogens. Historic logging is the greatest cause of soil loss in our remaining forests that are not farmed or developed. We've logged nearly all the old forests that once thrived as reservoirs of biological diversity and resilience—trees of mythic size in forests that once seemed infinite. Estimates of what we've left uncut are finite, indeed, and vary from less than 1 percent to perhaps 5 percent nationwide, with whole multistate regions registering zero. With that loss went the connective tissues of the original forest ecosystems, including stabilizing relationships between species of trees, between trees and native root-zone fungi that make the trees healthy, and among trees, animals, and other members of the natural community.[7] Most eastern forests have been cut not just once or twice but often a third, fourth, or fifth time, each harvest causing more disruption and further loss of nutrients, chemicals, microbes, and fiber bases—each harvest accumulating additional errors.

Related to indiscriminate logging, the accompanying road building, tracking of machinery, and exposure to sun all compact or deplete the loose, fibrous, microbe-filled soil, which suffers in the same way your garden would if you drove bulldozers and log skidders back and forth across it. Even without considering what's been cut and taken away, those changes retard the soil's recovery to organic richness and also its crucial ability to absorb and retain water. This means further drying and receding groundwater. Rainfall on cutover land further sliced up by roads runs off quickly, causing floods and landslides.[8]

With less moisture in the disturbed and compacted soil, less water is available to trees for sap. This means that they are less able to withstand drought and more vulnerable to insect pests, which might otherwise be purged by the tree's circulation system. Soil loss also means that trees have fewer nutrients and less anchorage. They blow down more easily.

Modern logging often involves the near-total removal of tree biomass—not just logs but branches and leaves are chipped, shredded, and hauled away. Nutrients and microbes are exported from the site and what's left is damaged, leaving a starved ecosystem. While new trees green up on the cutover soil, the effect of stripping new growth time after time may have severe cumulative effects, handicapping forests that remain and making them more vulnerable to exotic pests. This long-term loss of forest and soil capability following repeated logging is something we know

relatively little about. Trial and error is our method of research, conducted on a continental scale, with the error part producing consequences for centuries or more.

None of this means that we cannot log responsibly, economically, and without significant damage. "Best management practices" are widely publicized, and advice for landowners is readily available from local agricultural extension agents.[9]

Perhaps even more important in today's world of increasing population and suburban growth, forest fragmentation takes its toll. We've parceled out woodlands through farming, highways, and land development, isolating what was once a relatively seamless forest across the eastern third of the continent. Now, remnants of ecosystems—if extant at all—are confined to blocks of a few hundred or thousand acres in scattered protected areas such as state parks. Problematic "edge effects" mean that each interface is exposed to hostile forces: wind damage where trees once sheltered one another, air pollution from the next valley upwind, and inflated populations of predators such as crows, which thrive in the fabricated world of cornfields and landfills but plunder the nests of native birds, where eggs and chicks were once secure in a forest fastness.[10]

On top of all that, consider climate change. In the unfolding drama, all the old bets on stability and on species' abilities to cope, resist, or migrate are off. The rate of change is now alarmingly greater than anything since long before the Ice Age.[11] After the last glaciation, trees adjusted to the warming earth by migrating north. But climatologists estimate that the globe is now warming at ten times its fastest rate during Ice Age recovery, with record rates in 2015, 2016, and 2017.[12] The adelgid, whose

northern reach is now constrained by cold winters, will flourish in the warming trend. The perils that hemlocks and beeches face today are bad enough, but they may be a bellwether of untold additional threats, plagues, and setbacks to come in the age of climate crisis.

None of the handicaps discussed above might kill or even show as damage in a tree today or tomorrow, but cumulative effects grow with each additional stress, such as the attack of an alien insect.

The point of this litany of human-induced forest problems is not that they are hopeless, but precisely the opposite. People created these problems and people can fix them. We have—or could regain—control over a host of anthropogenic effects that contribute to the decline of hemlocks, beeches, and many other trees, and that trigger a domino-like sequence of damage, including that of exotic pests.

The trees are the messengers. Their requirements for forest health tell us what we must do to have a healthy planet and, one might project, to sustain or reconstitute healthy lives ourselves. The forests have been fading for decades, and we've been deaf to their unwelcome call. With better ears, and with eyes on the big picture, the Union of Concerned Scientists, including half the living Nobel laureates, issued a "warning to humanity" in 1992. "No more than one or a few decades remain before the chance to avert the threats we now confront will be lost and the prospects for humanity immeasurably diminished. . . . A new ethic is required—a new attitude towards discharging our responsibility for caring for ourselves and for the earth. We must recognize the earth's limited capacity to provide for us. We must recognize its fragility. We must no longer allow it to be ravaged. This ethic must motivate a great movement, convincing

reluctant leaders and reluctant governments and reluctant peoples themselves to effect the needed changes."[13]

How does one move from a sense of futility, despair, and cynicism to hope and action, as the world's greatest scientists urged back in 1992? How can we grapple with a loss as fundamental as that of the forest that nurtures us? What defense can we mobilize against the perils of an unrestrained and careless globalism that brought us the adelgid and *Cryptococcus*? How can we reverse the persistent pollution, the depletion of soil, the fragmentation of habitat, and the heating of our climate? These questions involve far more than can be addressed in this modest book, aimed mainly at celebrating two beautiful species of trees before they're gone. But forest activists, engaged academics, enlightened resource managers, and some politicians now recognize that much can be done to positively influence the future of our woodlands. We have the ability to work toward forests that are healthy, robust, and resilient to the hazards they will inevitably face in the storm-ridden decades ahead.

First: save all the parts. To do this, we must preserve our few remaining large tracts of unspoiled forests. As Kristine Johnson of Great Smoky Mountains National Park said, "We need these large areas as reservoirs of great genetic and topographic diversity." The modern sciences of biology and genetics confirm what Henry David Thoreau so presciently observed more than 150 years ago: "In wildness is the preservation of the world."

No less, we need to reestablish linkages among these and also among smaller tracts now isolated. This can be done through easements, zoning, and cooperative agreements among landowners. We can harvest timber with sensible restraint that focuses on retaining the most desirable trees, controlling exotics, and favoring native plants while giving priority to the protection of soil and water. We can spare our most important woodlands from development through open space acquisition by governments and land trusts, and through zoning that recognizes the public need for the ecological services that forests provide. We can fight against the air pollution, strip-mining, mountaintop removal, and gas drilling that permanently scar our forests and watersheds, all for the purpose of burning more fossil fuel and thereby aggravating the climate crisis. We can work to reverse the tide of global warming that endangers not only our trees but all of life. In these and other ways, we can instill resiliency in forest ecosystems so that they can withstand at least some of the changes that—like the adelgid and beech bark disease—are now inevitable.

If the dwindling delights of the hemlocks and beeches can inspire us to do better and to address with new motivation and new resolve the problems of American forests, then our debt to these remarkable trees will be even greater than it already is. Their fading elegance is symbolic of losses of many kinds in today's world, yet that elegance can also inspire us to take action against the problems affecting all of our forests, all across our land.

Deep freezes aid surviving hemlocks by trimming populations of the woolly adelgid. However, the climate is inexorably warming, tipping the balance of survival toward the exotic pest. Here at McConnells Mill State Park in winter, a badly initialed but otherwise elegant beech rises in its hemlock forest.

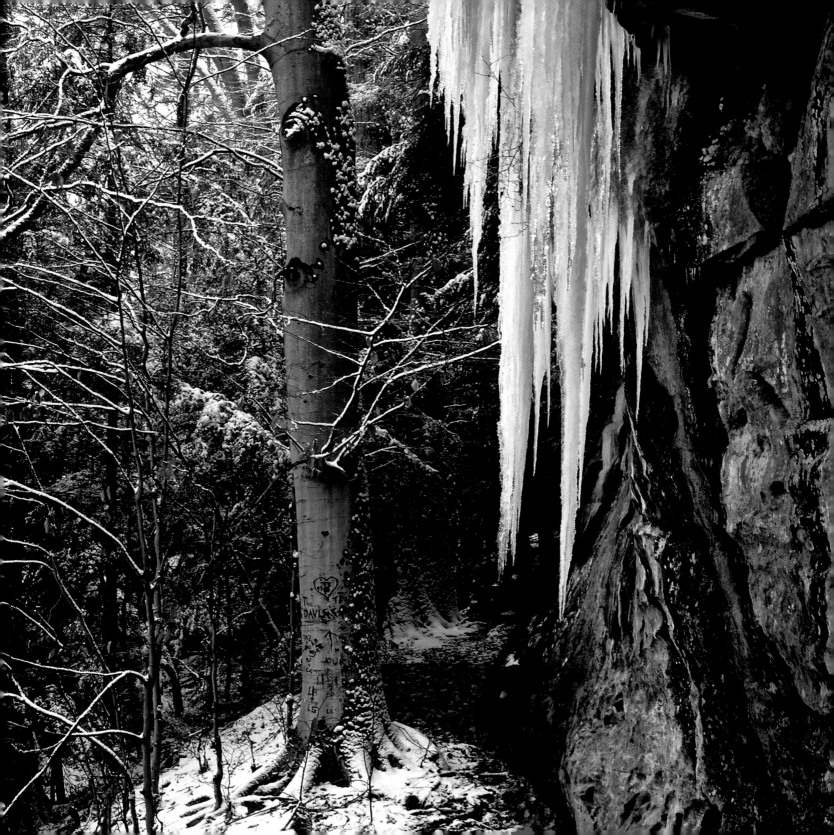

Chapter Seven

Confronting Loss
and Welcoming Renewal

When an ancient hemlock fades away and dies, its loss creates not only a blank spot in the forest, not only an empty space in our view and in our hearts, but also a gap in time. Hemlocks are among the longest-living trees in eastern America, and each one of the ancients serves as a symbol of the triumph of life against great odds for centuries.

Personally confronting this type of loss has taken me on paths I've followed before. In 1980, I journeyed from my homey hemlock hollows of Pennsylvania to the Sierra Nevada foothills of California to document the final days of one of the most magnificent rivers in our country. The Stanislaus, carving the deepest limestone canyon on the Pacific Coast and accommodating the most whitewater paddling in the West, was being dammed for no justifiable reason. Multiple attempts to save the river failed. However, those efforts marked the last time a dam fight of epic proportions was lost in America. The lessons learned at the Stanislaus and elsewhere during an era of awakening awareness about the value of natural streams led to a new way of regarding America's waterways. A

Along a Shepaug River trail in Connecticut, hemlocks survive but have been depleted by the adelgid, which has inflicted needle loss and dimmed the former vivid green of the hemlock and hardwood grove. The fate of this and countless other hemlock and beech forests in the Northeast remains unknown.

blossoming respect for wild rivers thrived, and lives on today.[1]

Years after my sojourn to the Stanislaus, I was drawn to the melting of America's remaining glaciers—the most blatantly visible sign that our climate is warming dangerously. We usually think of glaciers nearer the poles, but sunny California still had several hundred in the loftiest enclaves of the Sierra Nevada and Cascade ranges. Most glaciers there will disappear entirely within a few short years or decades. My photo book *California Glaciers* sought to capture the irreplaceable beauty of those exquisite sculptures of ice, rock, and snow before they were gone. And the glaciers are more than just spectacularly severe scenery; their melting painfully symbolizes greater cataclysms to come, including the diminishing snow cover and inadequate water for all who live down below. The glaciers' message is one of loss, but it tells us to mobilize against the causes of that loss.

As with the glaciers, the pictures of hemlocks and beeches in this book illustrate a tragically disappearing beauty, but I'm reminded with each scene that photographs are two-dimensional substitutes for the real thing. So perhaps you will want to go and witness the forests that remain during the short time that many of them will be with us. If the hemlock groves near you are already gray and rotted—or totally forgotten—go toward the western end of the tree's range. McConnells Mill State Park—my refuge and adventure outpost as a teenager in western Pennsylvania—is still healthy as of this writing, though probably not for long (if you happen to go in springtime, first wash your car and boots of possible hitchhiking adelgid crawlers!). Go to Cook Forest in western Pennsylvania or brave the ticks and rattlesnakes of Savage Gulf State Natural Area in Tennessee, where

treatments are keeping adelgids at bay. Go to the lingering groves in northern New England, or to Michigan's Porcupine Mountains, where the twin allies of isolation and frigid winters might stave off the adelgids for some years.

Beyond those remnants of forests living on borrowed time, a reminder of what we once had can be seen in Oregon, where the western hemlock is unaffected by the blight and should remain vibrant for the foreseeable future. I had the opportunity last summer to hike along the upper Rogue River, where north of Union Creek you can revel in the wilderness shade of hemlocks thriving in groves reminiscent of those I once knew in Pennsylvania.

Closer to home, and within the eastern hemlock's range, another conifer conveys a sense of hope. The Fraser firs of the southern Appalachians were dying in the 1970s. Related to the hemlock pest but attacking the trees' trunks rather than tiny twigs, the balsam woolly adelgid turned high-elevation fir forests into graveyards. Kristine Johnson of Great Smoky Mountains National Park recalled, "Three-quarters of the trees were dead, and we expected that we'd lose them all, much as we had lost the chestnuts." As it turned out, without direct intervention, the balsam adelgid began to fade, and fir seedlings began to grow once again. Though the long-term outcome is uncertain, firs are now reclaiming mountaintops with fresh young branches approaching the tops of broken dead snags still standing from the earlier doomed generation. The balsam adelgids appear to be repressed. "We don't know why this is," Johnson admitted. "It might reflect the survival of resistant trees that are now reproducing. But it's not uncommon to have an invasive insect explode in population and then

decline." One theory is that the exotic pest stabilizes at a lower level after the initial food supply is consumed.

However, the balsam woolly adelgid's deadly effects were probably abetted by air pollution from the plethora of coal-fired power plants just upwind in the Tennessee Valley. It may be no coincidence that the Smoky Mountains recovery of firs parallels the regrowth of spruces on peaks in Vermont after acid rain there was curtailed. In both places, atmospheric improvement following the 1990 Clean Air Act amendments has a strong correlation to renewed tree survival. Johnson concluded, "Everything is better when the air is better."

In the hemlock and beech forests that remain, many people hope that the merging currents of time and biological adaptation—aided by the best work that scientists can do—will carry these trees onward to become capable once again of nourishing an ecosystem and, along the way, bringing us insight, joy, and a deep appreciation of life.

Writing about our remaining old-growth forests, Bill McKibben—today's hero of the environment who leads the movement against global warming—said that the aged trees of the East, including our hemlocks and beeches, are "a marker of past glory" and "an elegy for all that once was." He envisioned forest recovery as "a promise of the future." Forest restoration can offer "a glimpse of the systemic soundness we will not see completed in our lifetimes but that can fire our hopes for the timelessness to come."[2]

Part of that future is heartlessly predictable and part is profoundly chancy. We don't know what will happen to our forests. But after ten millennia of hemlocks and beeches germinating, thriving, sequestering carbon, and growing as organic monuments to the triumph of

life, what remains of these trees will be just as beautiful as the first pioneering seedling in the wake of the Pleistocene.

Among these trees and the rest of life, further losses are inevitable, but with one foot in the eddies of despair and one in the currents of hope, all we can do is move forward, together, with the ideas, tools, and possibilities of our times. In order to make the essential widespread commitment to change, it seems that we busy and preoccupied citizens of the twenty-first century require a sense of urgency coming in a time of upheaval that threatens us at the very doorstep of our homes, communities, and forests.

That time is now.

The final message of the hemlocks and beeches is not of the past but of the future. To honor these beloved trees, we must care better for all the native forests that remain.

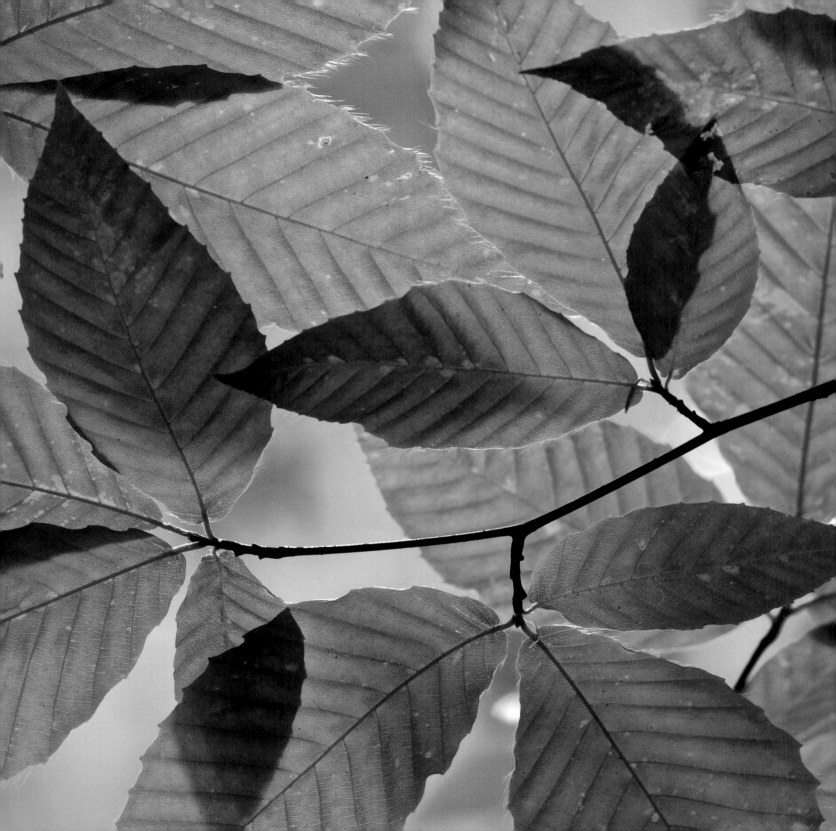

Acknowledgments

To all who helped with the creation of this book, I'm deeply grateful. Kathryn Yahner of Penn State University Press saw value in the idea and importance in its message, and she guided my work down the intricate path of publishing. John Dawes of the Foundation for Pennsylvania Watersheds helped with some of my travel expenses, and Marci Mowery of the Pennsylvania Parks and Forests Foundation made John's support administratively possible. Bert Kerstetter helped with some of my expenses in this work. Pennsylvania Department of Conservation and Natural Resources secretary Cindy Adams Dunn encouraged me in key ways.

Special thanks to Suzanne Wolk, whose contributions here went far beyond the copyediting for which she was hired. I've benefitted from her attentiveness, care, skill, wisdom, and good spirit, all with an eagle eye for content in a subject that—by my good fortune—interested her personally. The artistry of Regina Starace is evident throughout the book's design.

Seeking scientific expertise, I consulted many dozens of papers published in technical journals available on the Internet via Google Scholar, through my connection as a "visiting scholar" at the Geography Department of Portland State University in Oregon, and through the generosity of some of the papers' authors. See "Sources" below for an abridged list of some of the most important and accessible scientific articles and also several accounts in the popular media, plus brochures by several agencies, especially the U.S. Forest Service. My apologies to all the many superb scientists whose important papers I did not have space to cite here. My selection was unfairly arbitrary in some respects.

I augmented my search of technical and popular papers with many interviews of key players in the science and management of hemlock and beech forests and the threats and diseases affecting them. Readers should generally assume that most direct quotes that are unattributed to written sources have come from my personal interviews with these people. For the ample generosity, experience, dedication, and sharp intellect expressed in all of those interviews, I offer special thanks here, in alphabetical order, to Will Blozan of the Eastern Native Tree Society in Asheville, North Carolina; Ryan Borcz, manager of Cook Forest State Park in Pennsylvania; Carole Cheah of the Connecticut Agricultural Experiment Station; Glenn Dochtermann of Vaughan Woods State Park in Maine; Joseph Elkinton of the University of Massachusetts; Richard Evans of the Delaware Water Gap National Recreation Area; David Foster of the Harvard Forest; Thomas Hall of the Pennsylvania Department of Conservation and Natural Resources; Nathan Havill of the U.S. Forest Service Northern Research Station; David Houston of the Forest Service (retired); Kristine Johnson of Great Smoky Mountains National Park; Dale Luthringer of Cook Forest State Park; Mark Mayer of the New Jersey Department of Agriculture; Gene Odato of Big Spring State Park in Pennsylvania; David Orwig of the Harvard Forest; Rusty Rhea of the U.S. Forest Service Southeastern State and Private Forestry program; Noel Schneeberger of

Beech leaves, Cook Forest State Park, Pennsylvania.

the U.S. Forest Service Northeastern Area State and Private Forestry program; Colleen Teerling of the Maine Forest Service; and Barbara Wallace of Ohiopyle State Park in Pennsylvania. I regret that I couldn't talk to more experts in the field; the interviews could have gone on for years.

For additional special information and tips on where to go, thanks to Will Blozan, Kelly Donaldson (formerly of the Pennsylvania Nature Conservancy), Donald Eggen of the Pennsylvania DCNR, Emily Ellingson of the University of Minnesota, Lee Frelich of the University of Minnesota, Andrea Hill of Allegheny National Forest, Beverly Jones of Pfeiffer Nature Center in New York, AmberBeth VanNingen of the Minnesota Department of Natural Resources, and Robert Jesse Webster of Great Smoky Mountains National Park.

A number of people took time to read parts or all of my manuscript and to make helpful comments. I'm deeply indebted to all for correcting a number of my errors and for providing special expertise: Will Blozan, Carole Cheah, Richard Evans, David Foster, Thomas Hall, David Houston, Kristine Johnson, Mark Mayer, David Orwig, and Barbara Wallace. Nathan Havill's review was especially careful, sharp, and revealing. Mark Faulkenberry of the Pennsylvania DCNR also reviewed my copy with his keen perspective as an author of Pennsylvania's *Eastern Hemlock Conservation Plan*.

Let me give special appreciation here to Dr. Carole Cheah, who was forthcoming with insight from her twenty-four years of experience. Her close review saved me from a number of mistakes, and she carefully and kindly enhanced my manuscript. Likewise, Dr. Houston went beyond any call of duty in his review of my beech material.

From his own pioneering scientific articles, Randall Morin of the Forest Service produced maps, and then generously adapted them as a basis for the ones you see here.

My old pal, Bob Banks, helped get me to hemlocks in Wisconsin, as did my best-ever paddling buddy, Travis Hussey in Maine. David Foster, David Orwig, and Clarisse Hart warmly welcomed me and Ann at the Harvard Forest and shared their illustrious heritage of engagement with hemlocks and beeches.

Having more experience and exposure to eastern old growth than anyone I know, and in a class by himself in many arboreal respects, Will Blozan of the Eastern Native Tree Society and of Appalachian Arborists in Asheville provided insight, knowledge, and perspective, offering comments sourced in a lifetime of experience and commitment to the health of these forests. He personally guided Ann and me on a tour to the revered Cheoah Hemlock in North Carolina. He and Jess Riddle compiled the authoritative report on superlative hemlocks: *The Tsuga Search Project*. Let me just say it: Will Blozan is a legend in his own time.

Going way back to the fundamentally motivating gift of growing up where these trees and forests could enrich my life and ultimately set me on the path to write this book, I can only thank my parents, Jane and Jim Palmer, whose intuition and foresight in choosing a good place to live gave me the chance to run wild in the woods from the first days I could run.

No acknowledgment of any accomplishment by me, however modest, is complete without recognition of Ann Vileisis, my wife, who made this book better in uncounted ways with her ideas, brilliance, editing skill, support, and gracious company as we explored these forests—and all of life—together.

Notes

Introduction

1. David A. Orwig, "An Iconic Species," in *Hemlock: A Forest Giant on the Edge*, edited by David R. Foster (New Haven: Yale University Press, 2014), 13.
2. John Muir, *John of the Mountains: The Unpublished Journals of John Muir*, edited by Linnie Marsh Wolfe (Boston: Houghton Mifflin, 1938), 313.

Chapter 1

1. David A. Orwig, David R. Foster, and David L. Mausel, "Landscape Patterns of Hemlock Decline in New England Due to the Introduced Hemlock Woolly Adelgid," *Journal of Biogeography* 29, nos. 10–11 (2002): 1484.
2. Russell M. Burns and Barbara H. Honkala, *Silvics of North America*, vol. 1, *Conifers* (Washington, D.C.: U.S. Forest Service, 1990), 1247.
3. Mark Faulkenberry, Ellen Shultzabarger, Donald A. Eggen, and Houping Liu, *Eastern Hemlock Conservation Plan*, prepared for the Pennsylvania Department of Conservation and Natural Resources, October 2014, 5.
4. Gerald Jonas, *North American Trees* (Pleasantville, N.Y.: Reader's Digest Association, 1993), 41.

Chapter 2

1. Robert S. Lemmon, *The Best Loved Trees of America* (New York: American Garden Guild, 1946), 80.
2. Quoted in E. D. Merrill, "Hemlock—The Queen of Conifers," *Arnoldia* 6, nos. 11–12 (1946): 49.
3. Donald Culross Peattie, *The Natural History of Trees of Eastern and Central North America* (Boston: Houghton Mifflin, 1966), 41.
4. Charles E. Little, *The Dying of the Trees* (New York: Viking, 1995), 179.
5. Donald Wyman, *Trees for American Gardens* (New York: Macmillan, 1965), 233.
6. Nathan P. Havill, Michael E. Montgomery, and Melody Keena, "Hemlock Woolly Adelgid and Its Hemlock Hosts: A Global Perspective," in *Implementation and Status of Biological Control of the Hemlock Woolly Adelgid,* edited by Brad Onken and Richard Reardon (Morgantown, W.Va.: U.S. Forest Service, 2011), 4.
7. Colin Tudge, *The Tree: A Natural History of What Trees Are, How They Live, and Why They Matter* (New York: Three Rivers Press, 2005), 48.
8. Carl H. Tubbs and David R. Houston, "*Fagus grandifolia* Ehrh: American Beech," in *Silvics of North America*, vol. 2, *Hardwoods* (Washington, D.C.: U.S. Forest Service, 1990), 325.
9. Tom Wessels, Brian D. Cohen, and Ann Zwinger, *Reading the Forested Landscape: A Natural History of New England* (Woodstock, Vt.: Countryman Press, 1997), 132.
10. Laurence C. Walker, *The North American Forests: Geography, Ecology, and Silviculture* (Boca Raton: CRC Press, 1998), 40.
11. R. Talbot Trotter, Randall S. Morin, Sonja N. Oswalt, and Andrew Liebhold, "Changes in the Regional Abundance of Hemlock Associated with the Invasion of Hemlock Woolly Adelgid," *Biological Invasions* 15, no. 12 (2013): 2667.
12. Merrill, "Hemlock," 59.
13. Will F. Blozan and Jess D. Riddle, *The Tsuga Search Project: Documenting and Preserving Superlative Eastern Hemlock* (2007), http://www.nativetreesociety.org.
14. Will Blozan, "The Last of the Giants: Documenting and Saving the Largest Eastern Hemlocks," *American Forests*, Spring 2011, http://www.americanforests.org/magazine/article/the-last-of-the-giants/.
15. Blozan and Riddle, *Tsuga Search Project*.
16. Orwig, "Iconic Species," 35.
17. Ibid., 13.
18. Rutherford Hayes Platt, *American Trees: A Book of Discovery* (New York: Dodd, Mead, 1952), 39.
19. "Boone Carvings," Callaway Family Association Blog, June 28, 2004, http://www.callawayfamily.org/blog/2004/06/boone-carvings.html.
20. Anthony W. D'Amato, "Tree-Falls and Tanbark," in Foster, *Forest Giant on the Edge*, 88.
21. Margaret B. Davis, Timothy E. Parshall, and James B. Ferrari, "Landscape Heterogeneity of Hemlock-Hardwood Forest in

Northern Michigan," in *Eastern Old-Growth Forests: Prospects for Rediscovery and Recovery*, edited by Mary Byrd Davis, (Washington, D.C.: Island Press, 1996), 292.

22. Orwig, "Iconic Species," 15.

23. Davis, Parshall, and Ferrari, "Landscape Heterogeneity," 296.

24. Tudge, *Tree*, 193.

25. W. Wyatt Oswald, David R. Foster, and Jonathan R. Thompson, "Prehistory to Present," in Foster, *Forest Giant on the Edge*, 55, 57.

26. Ibid., 58.

27. Don J. Durzan, "Arginine, Scurvy, and Cartier's 'Tree of Life,'" *Journal of Ethnobiology and Ethnomedicine* 5, no. 5 (2009): 1.

28. Glen Blouin, "Medicinal Use of Forest Trees and Shrubs by Indigenous People of Northeastern North America," http://www .fao.org/docrep/article/wfc/xii/0191-a2.htm.

29. Merrill, "Hemlock," 50.

30. Nathan P. Havill and Michael E. Montgomery, "The Role of Arboreta in Studying the Evolution of Host Resistance to the Hemlock Woolly Adelgid," *Arnoldia* 65, no. 3 (2008): 7.

31. Robert Sullivan, foreword, in Foster, *Forest Giant on the Edge*, xi.

32. Chris Bolgiano, *The Appalachian Forest: A Search for Roots and Renewal* (Mechanicsburg, Pa.: Stackpole Books, 1998), 70.

33. Robert Leverett, "Definitions and History," in Davis, *Eastern Old-Growth Forests*, 12.

34. Mary Byrd Davis, "Extent and Location," in ibid., 18.

35. Lemmon, *Best Loved Trees*, 24; Jonas, *North American Trees*, 180.

36. Aaron M. Ellison, "Reprise: Eastern Hemlock as a Foundation Species," in Foster, *Forest Giant on the Edge*, 166.

37. "Eastern Hemlock," Shenandoah National Park, https://www .nps.gov/shen/learn/nature/eastern_hemlock.htm.

38. Richard M. DeGraaf, Mariko Yamasaki, William B. Leak, and John W. Lanier, *New England Wildlife: Management of Forested Habitats* (Radnor, Pa.: U.S. Forest Service, 1992), 95.

39. David Orwig, "Eastern Hemlock: Irreplaceable Habitat," *Massachusetts Sierran*, Summer 2008, 4–5.

40. Paul L. Hamelin, "Management Guidelines for Optimizing Mast Yields in Beech Mast Production Areas," report for the Vermont Fish and Wildlife Department, March 2011, 2.

41. Aaron M. Ellison and Benjamin H. Baiser, "Hemlock as a Foundation Species," in Foster, *Forest Giant on the Edge*, 102.

42. Karen Kish, "Hemlock Woolly Adelgid Management Plan," report for the West Virginia Department of Agriculture Cooperative Forest Health Protection Program, February 2007, 3.

43. Morgan W. Tingley, David A. Orwig, Rebecca Field, and Glenn Motzkin, "Avian Response to Removal of a Forest Dominant:

Consequences of Hemlock Woolly Adelgid Infestations," *Journal of Biogeography* 29, nos. 10–11 (2002): 1505.

44. J. Christopher Haney and Charles P. Schaadt discuss Bucher's article in "Functional Roles of Eastern Old Growth in Promoting Forest Bird Diversity," in Davis, *Eastern Old-Growth Forests*, 78.

45. Peattie, *Natural History of Trees*, 185.

46. Steven T. Brantley, Chelcy Ford Miniat, Katherine J. Elliott, Stephanie H. Laseter, and James M. Vose, "Changes to Southern Appalachian Water Yield and Stormflow After Loss of a Foundation Species," *Ecohydrology* 8, no. 3 (2015): 518.

47. R. M. Ross, R. M. Bennett, C. D. Snyder, J. A. Young, D. R. Smith, and D. P. Lemarie, "Influence of Eastern Hemlock (Tsuga canadensis L.) on Fish Community Structure and Function in Headwater Streams of the Delaware River Basin," *Ecology of Freshwater Fish* 12, no. 1 (2003): 60.

48. Craig D. Snyder, John A. Young, Robert M. Ross, and David R. Smith, "Long-Term Effects of Hemlock Forest Decline on Headwater Stream Communities," in *Proceedings of the Third Symposium on Hemlock Woolly Adelgid in the Eastern United States, Ashville, North Carolina, February 1–3, 2005*, FHTET-2005-01, compiled by Brad Onken and Richard Reardon (Morgantown, W.Va.: U.S. Forest Service, Forest Health Technology Enterprise Team, 2005), 42.

49. Orwig, "Iconic Species," 20.

50. David R. Foster, "Hemlock's Future in the Context of Its Past," in Foster, *Forest Giant on the Edge*, 4.

51. Ellison and Baiser, "Hemlock as a Foundation Species," 94.

Chapter 4

1. Alan Burdick, *Out of Eden: An Odyssey of Ecological Invasion* (New York: Farrar, Straus and Giroux, 2005), 20.

2. Edward K. Faison and David R. Foster, "Did American Chestnut Really Dominate the Eastern Forest?," *Arnoldia* 72, no. 2 (2014): 21.

3. Carole Cheah, Mike Montgomery, Scott Salem, Bruce Parker, Margaret Skinner, and Scott Costa, "Biological Control of Hemlock Woolly Adelgid," U.S. Forest Service, Forest Health Technology Enterprise Team, 2004, 3.

4. Richard Preston, "A Death in the Forest," *New Yorker*, December 10, 2007, http://www.newyorker.com/magazine/2007/12/10 /a-death-in-the-forest.

5. David A. Orwig, "Invasion of an Exotic Pest," in Foster, *Forest Giant on the Edge*, 124.

6. Mark S. McClure, "Nitrogen Fertilization of Hemlock Increases Susceptibility to Hemlock Woolly Adelgid," *Journal of Arboriculture* 17, no. 8 (1991): 227.

7. Orwig, "Invasion of an Exotic Pest," 124.

8. Kristine Johnson, Glenn Taylor, and Thomas Remaley, "Managing Hemlock Woolly Adelgid and Balsam Woolly Adelgid at Great Smoky Mountains National Park," in Onken and Reardon, *Third Symposium on Hemlock Woolly Adelgid*, 232.

9. Alexander M. Evans and Timothy G. Gregoire, "A Geographically Variable Model of Hemlock Woolly Adelgid Spread," *Biological Invasions* 9, no. 4 (2007): 369.

10. Cheah et al., "Biological Control of Hemlock Woolly Adelgid," 17.

11. U.S. Forest Service Northern Research Station, "Hemlock Woolly Adelgid: Landscape Estimates of Hemlock Woolly Adelgid Survival and Potential Range," last modified May 7, 2015, https://www.nrs.fs.fed.us/disturbance/invasive_species /hwa/risk_detection_spread/potential_range/.

12. Katharine Hayhoe, Cameron P. Wake, Thomas G. Huntington, Lifeng Luo, Mark D. Schwartz, Justin Sheffield, Eric Wood, et al., "Past and Future Changes in Climate and Hydrological Indicators in the U.S. Northeast," *Climate Dynamics* 28, no. 4 (2007): 389.

13. Richard Evans, "Combined Effects of Hemlock Decline, Deer Herbivory, and Exotic Plants Escalate Management Challenges," *National Park Service Northeast Region, Science and Management Newsletter*, Winter 2009–10, 4.

14. David R. Foster, preface, in Foster, *Forest Giant on the Edge*, xxii.

15. Wessels, Cohen, and Zwinger, *Reading the Forested Landscape,* 120.

16. D. R. Houston, "Beech Bark Disease, 1934 to 2004: What's New Since Ehrlich?," in *Beech Bark Disease: Proceedings of the Beech Bark Disease Symposium, Saranac Lake, New York, June 16–18, 2004*, edited by Celia A. Evans, Jennifer A. Lucas, and Mark J. Twery (Newtown Square, Pa.: U.S. Forest Service, 2005), 2.

17. David R. Houston, principal plant pathologist, U.S. Forest Service, retired, interview by author, April 2016.

18. D. R. Houston and J. T. O'Brien, *Beech Bark Disease* (Hamden, Conn.: U.S. Forest Service, 1983), 1.

19. Randall S. Morin, Andrew M. Liebhold, Patrick C. Tobin, Kurt W. Gottschalk, and Eugene Luzader, "Spread of Beech Bark Disease in the Eastern United States and Its Relationship to Regional Forest Composition," *Canadian Journal of Forest Research* 37 (2007): 726.

Chapter 5

1. Gary M. Lovett, Marissa Weiss, Andrew M. Liebhold, Thomas P. Holmes, Brian Leung, Kathy Fallon Lambert, David A. Orwig, et al., "Nonnative Forest Insects and Pathogens in the United States: Impacts and Policy Options," *Ecological Applications* 26, no. 5 (2016): 1437.

2. Ibid.

3. Jennifer L. Koch, "Beech Bark Disease: The Oldest 'New' Threat to American Beech in the United States," *Outlooks on Pest Management* 21, no. 2 (2010): 64–68.

4. Rusty Rhea, entomologist and forest-health specialist for the U.S. Forest Service in Asheville, North Carolina, interview by author, April 2016.

5. Ralph E. Webb, J. Ray Frank, and Michael J. Raupp, "Eastern Hemlock Recovery from Hemlock Woolly Adelgid Damage Following Imidacloprid Therapy," *Journal of Arboriculture* 29, no. 5 (2003): 298.

6. See, for example, Renée Johnson, "Honey Bee Colony Collapse Disorder," Congressional Research Service Report for Congress, RL33938, January 7, 2010, 11, https://fas.org/sgp/crs/misc /RL33938.pdf.

7. Darryl Fears, "Maryland's Honeybees Are Being Massacred, and the Weapon Might Be in Your House," *Washington Post*, March 24, 2016.

8. Elizabeth P. Benton, J. F. Grant, T. C. Mueller, R. J. Webster, and R. J. Nichols, "Consequences of Imidacloprid Treatments for Hemlock Woolly Adelgid on Stream Water Quality in the Southern Appalachians," *Forest Ecology and Management* 360 (January 2016): 152.

9. Ben Moyer, "Allegheny Plateau: Last Barrier Blocking Invasive Insect That Kills Hemlock Trees," *Pittsburgh Post-Gazette*, March 3, 2013.

10. Johnson, Taylor, and Remaley, "Managing Hemlock Woolly Adelgid," 232.

11. Will Blozan, co-owner of Appalachian Arborists and president of the Eastern Native Tree Society, interview by author, February 2016.

12. Robert Jesse Webster, forester, Great Smoky Mountains National Park, e-mail message to author, April 1, 2016.

13. Elwood Scott Roberts, "Evaluating Seedlings of Eastern Hemlock Resistant to Hemlock Woolly Adelgid" (master's thesis, University of Rhode Island, 2015), ii.

14. E. Alexa McKenzie, J. S. Elkinton, R. A. Casagrande, E. L. Preisser, and M. Mayer, "Terpene Chemistry of Eastern Hemlocks Resistant to Hemlock Woolly Adelgid," *Journal of Chemical Ecology* 40, no. 9 (2014): 1003.

15. Koch, "Beech Bark Disease," 64.

16. Jennifer L. Koch, David W. Carey, Mary E. Mason, and Charles Dana Nelson, "Assessment of Beech Scale Resistance in Full- and Half-Sibling American Beech Families," *Canadian Journal of Forest Research* 40, no. 2 (2010): 265.

17. Houston, interview.
18. Alexandra Wilson, "Will Chestnuts Roast on an Open Fire Again Someday?," *USDA Blog*, May 10, 2016, http://blogs .usda.gov/2016/05/10/will-chestnuts-roast-on-an-open -fire-again-someday/.
19. Nathan P. Havill, U.S. Forest Service Northern Research Station, interview by author, April 2016.
20. Faulkenberry et al., *Eastern Hemlock Conservation Plan*, 46.
21. Mark S. McClure and Carole Cheah, "Reshaping the Ecology of Invading Populations of Hemlock Woolly Adelgid, Adelges tsugae (Homoptera: Adelgidae), in Eastern North America," *Biological Invasions* 1, no. 2 (1999): 247.
22. Michael E. Montgomery, "Understanding Federal Regulations as Guidelines for Classical Biological Control Programs," in Onken and Reardon, *Implementation and Status of Biological Control*, 37.
23. Joseph S. Elkinton, Robert T. Trotter, and Ann F. Paradis, "Simulations of Population Dynamics of Hemlock Woolly Adelgid and Potential Impact of Biological Control Agents," ibid., 15.
24. Cheah et al., "Biological Control of Hemlock Woolly Adelgid," 7.
25. C. A. S.-J. Cheah, M. A. Mayer, D. Palmer, T. Scudder, and R. Chianese, "Assessments of Biological Control of Hemlock Woolly Adelgid with *Sasajiscymnus tsugae* in Connecticut and New Jersey," in Onken and Reardon, *Third Symposium on Hemlock Woolly Adelgid*, 122.
26. Colleen Teerling, Maine Forest Service entomologist, interview by author, March 2016.
27. Havill, interview.
28. U.S. Forest Service, "Pest Alert: Hemlock Woolly Adelgid," USDA Forest Service publication NA-PR-09-05, August 2005, 2, https:// www.na.fs.fed.us/spfo/pubs/pest_al/hemlock/hwa_05.pdf.
29. Deborah McCullough, Robert L. Heyd, and Joseph G. O'Brien, "Biology and Management of Beech Bark Disease: Michigan's Newest Exotic Forest Pest," extension bulletin E-2746, Michigan State University Extension Service, reprinted 2005, 1–9, http:// msue.anr.msu.edu/uploads/files/e2746.pdf.
30. U.S. Forest Service, "Pest Alert: Beech Bark Disease," USDA Forest Service publication NA-PR-03-12, March 2012, 1–2, https://www .na.fs.fed.us/fhp/bbd/beech-bark-disease-pest-alert_120329 .pdf.
31. Preston, "Death in the Forest," 70.
32. U.S. Forest Service, "The Rising Cost of Wildfire Operations: Effects on the Forest Service's Non-Fire Work," August 4, 2015, 4, http://www.fs.fed.us/sites/default/files/2015-Fire-Budget -Report.pdf.

Chapter 6

1. David R. Foster and David A. Orwig, "When Doing Nothing Is a Viable Alternative: Insights into Conservation and Management," in Foster, *Forest Giant on the Edge*, 183.
2. Orwig, "Invasion of an Exotic Pest," 120.
3. U.S. Forest Service Northern Research Station, "Red Spruce Reviving in New England, but Why?," press release, August 30, 2013, http://www.nrs.fs.fed.us/news/release/reviving -red-spruce.
4. Gregory B. Lawrence and T. G. Huntington, "Soil-Calcium Depletion Linked to Acid Rain and Forest Growth in the Eastern United States," U.S. Geological Survey report, February 1999, https://ny.water.usgs.gov/pubs/wri/wri984267/WRIR98-4267.pdf.
5. McClure, "Nitrogen Fertilization of Hemlock," 228.
6. Christine L. Shaver, K. A. Tonnessen, and T. G. Maniero, "Clearing the Air at Great Smoky Mountains National Park," *Ecological Applications* 4, no. 4 (1994): 690.
7. Leverett, "Definitions and History," 4.
8. James N. Kochenderfer, "Erosion Control on Logging Roads in the Appalachians," U.S. Forest Service research paper NE-158, 1970, http://www.treesearch.fs.fed.us/pubs/23767.
9. See Shelby E. Chunko and Wilber E. Wolf Jr., comps., "Best Management Practices for Pennsylvania Forests: Promoting Forest Stewardship Through Education, Cooperation, and Voluntary Action," Penn State College of Agricultural Sciences, 2001, http://extension.psu.edu/publications/uh090.
10. Reed F. Noss and Allen Y. Cooperrider, *Saving Nature's Legacy: Protecting and Restoring Biodiversity*, 4th ed. (Washington, D.C.: Island Press, 1994), 197.
11. Anthony D. Barnosky, *Heatstroke: Nature in an Age of Global Warming* (Washington, D.C.: Island Press, 2009), 10.
12. NASA Earth Observatory, "How Is Today's Warming Different from the Past?," http://earthobservatory.nasa.gov/Features /GlobalWarming/page3.php.
13. Union of Concerned Scientists, "1992 World Scientists' Warning to Humanity," http://www.ucsusa.org/about/1992-world-scien tists.html#.V6qoZhQomw8.

Chapter 7

1. Tim Palmer, *Endangered Rivers and the Conservation Movement* (Lanham, Md.: Rowman and Littlefield, 2004), 316.
2. Bill McKibben, "Afterword: Future Old Growth," in Davis, *Eastern Old-Growth Forests,* 363.

Sources

See the note citations for many sources of information and for further reading. Hundreds of fine articles are available regarding the current problems of hemlock and beech trees—far more than I've been able to cite here.

I found one book closely germane to my topic: *Hemlock: A Forest Giant on the Edge,* edited by David R. Foster of the Harvard Forest, with chapters by forest ecologist David Orwig and seven other esteemed scientists and experts in the field. Their work formed a basis for my understanding and writing. A wealth of other information is available from five symposia held to amass state-of-the-art knowledge about the hemlock woolly adelgid. A similar symposium was held regarding beech bark disease in 2004; see compilations online.

The U.S. Forest Service's plan for addressing the woolly adelgid is contained in an important document: "An Exotic Pest Threat to Eastern Hemlock: An Initiative for Management of Hemlock Woolly Adelgid" (2003), available online from the Northeastern Research Station, Newtown Square, Pennsylvania, with minor updates. The Pennsylvania plan of 2014 also sheds light on this problem; see *Eastern Hemlock Conservation Plan,* by Mark Faulkenberry, Ellen Shultzabarger, Donald A. Eggen, and Houping Liu of the Pennsylvania Department of Conservation and Natural Resources. For another comprehensive document, see *Implementation and Status of Biological Control of the Hemlock Woolly Adelgid* (2011), by the U.S. Forest Service, Morgantown, West Virginia.

Dozens of other scientists have written important works on these subjects; I have room to highlight just a few here.

In Connecticut and elsewhere, the early research of Dr. Mark McClure of the Connecticut Agricultural Experiment Station was foundational to much that followed in our collective understanding of the hemlock woolly adelgid. Among other articles, see his "Biology and Control of Hemlock Woolly Adelgid" (December 1987), published by the Connecticut Agricultural Experiment Station.

Following him in Connecticut, Carole Cheah has contributed a wealth of research and documentation of hemlocks and their problems. Among other articles, see "Biological Control of Hemlock Woolly Adelgid" (2004), by her and others, published by the U.S. Forest Service, Morgantown, West Virginia.

Nathan Havill's work on the genetics and evolution of hemlocks is extremely interesting; see "The Role of Arboreta in Studying the Evolution of Host Resistance to the Hemlock Woolly Adelgid," which he wrote with Michael E. Montgomery, in *Arnoldia* 65, no. 3 (2008). See also his piece with Lígia C. Vieira and Scott M. Salom, "Biology and Control of Hemlock Woolly Adelgid" (April 2014), published by the U.S. Forest Service.

Randall Morin plotted the extent of infestation of the adelgid and beech bark disease and, with others, wrote "Mapping Host-Species Abundance of Three Major Exotic Forest Pests," published by the Forest Service's Northeastern Research Station in 2004.

As principal plant pathologist for the U.S. Forest Service's Northeast Forest Experiment Station, Dr. David Houston's work on beeches and beech bark disease is

monumental. See his "Beech Bark Disease, 1934 to 2004: What's New Since Ehrlich?," available in *Beech Bark Disease: Proceedings of the Beech Bark Disease Symposium, Saranac Lake, New York, June 16–18, 2004*, published by the U.S. Forest Service Northeastern Research Station. Jennifer Koch's excellent work is evident in her article "Beech Bark Disease: The Oldest 'New' Threat to American Beech in the United States," in *Outlooks on Pest Management* (April 2010).

Ancient Forests of the Northeast, published by the Sierra Club in 2004, guides us to dozens of eastern old-growth tracts, including many hemlock and beech groves. I know of no similar guide to other regions in the East.

Preceding me in efforts to reach the general reader regarding issues of this type, Charles E. Little's 1995 book, *The Dying of the Trees*, is terrifically engaging, and I owe Little a deep debt for his motivating message of love and concern for our forests.

I was fortunate to reach a number of experts for interviews; see the acknowledgments for a list of these generous people.

Sources

About the Author & Photographer

Tim Palmer has written twenty-seven books about conservation, rivers, and adventure travel. He has spent a lifetime hiking, canoeing, exploring, and photographing forests and streams, and his passion has been to write and speak on behalf of conservation.

In 2005, Tim received the Distinguished Alumni Award from the College of Arts and Architecture at The Pennsylvania State University, and in 2011 the National Conservation Achievement Award ("Connie") for communications, given by the National Wildlife Federation. He has received numerous awards for his writing, photography, and work in river conservation.

Tim's *Trees and Forests of America* was published in 2008 by Harry N. Abrams and is recognized as the premier photo book on wild forests nationwide. His book of text and photos *The Columbia* won the National Outdoor Book Award in 1998, and *California Wild* received the Benjamin Franklin Award as the best book on nature and the environment in 2004. *Pacific High: Adventures in the Coast Ranges from Baja to Alaska* was a finalist for that award. *The Heart of America: Our Landscape, Our Future* won the Independent Publisher Book Award as the best essay and travel book in 2000. In 2015, his *Field Guide to Oregon Rivers* was a finalist for the Foreword Reviews Adventure Book of the Year and for the Oregon Book Award, and also winner of the National Outdoor Book Award.

A native of the Appalachian foothills in western Pennsylvania, Tim now lives in Port Orford, Oregon. Before becoming a full-time writer, photographer, and conservation activist, he worked for eight years as a land-use planner for Lycoming County in north-central Pennsylvania. He has a bachelor of science degree in landscape architecture from Penn State, and he is a Visiting Scholar with the Department of Geography at Portland State University and an associate of the Riparia Center in the Department of Geography at Penn State. He speaks and gives slide shows for universities, conservation groups, and conferences nationwide. See his work at www.timpalmer.org.

About the Photographs

For many years, I used a Canon A-1 camera with 17–200mm FD lenses, but most of the photos here were taken with a Canon 5D digital camera with 17–200 L series zoom lenses and a 50mm L series lens. For backpacking and other adventures when a small kit is needed, I carry a Fujifilm mirrorless digital X-E2 with its 18–55 and 55–200 XF zoom lenses.

With the goal of showing nature accurately and realistically, I limit myself to minor adjustments for contrast and color under Apple's very basic iPhoto program. I use no artificial light or filters, and do nothing to alter the content of the photos.

I don't dress my photos up, but I do search for the most beautiful scenes I can find. Most pictures were taken in early morning or evening with nature's elegant low light, which is full of color, shading, and shadows. Using a tripod, I take long exposures to keep my ISO low and to maximize depth of field. See the text of chapter 3 for additional reflections on my photography.

Index